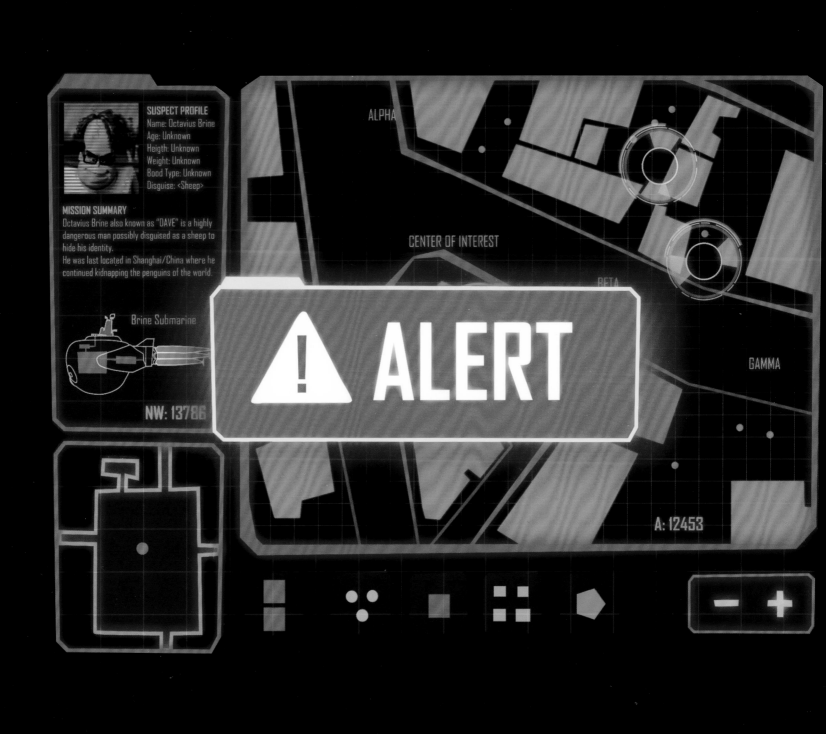

THE ART OF

DreamWorks PENGUINS OF MADAGASCAR

WRITTEN BY **BARBARA ROBERTSON**

FOREWORD BY **TOM McGRATH**

INSIGHT EDITIONS

San Rafael, California

ILT: 705.23
IST: 1648.52

CONTENTS

FOREWORD

BY TOM MCGRATH

"**H**ey, Ma! I'm starring in a movie with Benedict Cumberbatch and John Malkovich!" I say over the phone.

"I love those actors!" she spouts. "Now who's the other guy?"

I reply: "Um . . . That would be me, Ma."

"Oh, really? How?" she asks blankly. I was hoping for a "That's great!" but the "how" got me thinking . . .

It was nearly fourteen years ago that I joined Eric Darnell and Mireille Soria on the first Madagascar film. Before I was invited to partner with Eric as a director, I was tasked with storyboarding a scene where the zoo animals were washed overboard in a storm at sea.

After drawing copious swelling waves, dark stormy skies, and obligatory angles on crates plunging into the sea, I was ready to pitch the following day. Although, while having a late dinner at Timmy Nolan's, I couldn't help but feel that we've seen this in many films, many times before. Wait! All the animals from the zoo were being shipped to Africa (at the time). What if some of them didn't belong in Africa? Like penguins. What if the penguins revolted? They could commandeer the ship and turn it toward Antarctica! The crates could fall overboard during the ship's turn! Problemo solved.

Fueled by light beer and curly fries, I flipped over my placemat and thumb-nailed the scene. The next day, I woke up at 5 a.m., drove to the studio, cleaned up the sketches, wrote the lines as I blew them up on the printer, pinned them up, and pitched the scene to all.

I heard laughter. Then, I heard the question: "Who are these Penguins?"

"Well, Jeffrey . . ." I stammered with a bright red face. "They're like international POWs in a war movie. This one is Skipper, the leader. There's Kowalski, intelligence. Then, Rico, the 'can do' muscle who spits up stuff. And there's always the young naive guy—he's Private."

"No," Jeffrey Katzenberg corrected. "Why are they in the movie?"

Conrad Vernon jumped in to their defense: "Because they're funny." Although, at the time, not a good enough reason. Jeffrey was right. I had been so focused on these penguins that I forgot about our main characters, throwing in a couple drawings of crates with voiceover lines for them. Oops!

"We can cut them," Eric chimed in, "but they'll be back." Sure enough, after focusing on Alex and co., we found ways of including the Penguins in the main story, like inspiring Marty to seek out the wild, thus giving them a thread of job security. Bill Damaschke then threw down a gauntlet: Maybe the rest of the movie should be as funny as the Penguins. Soon after, they became forever embedded in the Madagascar DNA with "grit, spit, and

"IT'S NO GOOD SKIPPER... I DON'T KNOW THE CODES."

"DON'T GIVE EXCUSES GIVE ME RESULTS!"

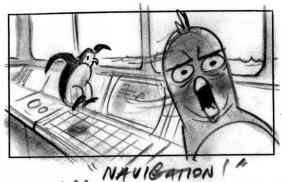

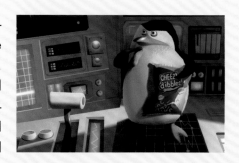

"...NAVIGATION!"

a whole lotta duct tape!" And to Jeffrey's credit, he later embraced them wholeheartedly, adding much of the funny dialogue. Ironically, Jeffrey, Mireille, and Eric had developed a completely different penguin movie in the early days of DreamWorks, so I guess you could say that Jeffrey is finally getting the penguin movie he always wanted—though not exactly in the way he had originally imagined.

Originally, we wanted actor Robert Stack to voice Skipper, but unfortunately, he passed away. Jeffrey looked at me and smiled: "You've got the part, kid." Yes. He said "kid." Love it.

This is how they were invented, but not how they were created. They were created by a studio of many talented artists, writers, filmmakers, animators, lighters, technicians, and passed along with care through four locations spanning the globe.

The Penguins have now been in three movies, three shorts, a dozen video games, a TV series, and theme park attractions, as well as Happy Meal toys (my mother's measure of true success).

And finally . . . their own movie.

In the pages of this book you will see how the filmmakers and artists have taken the Penguins to new depths. We find out how they came to be and what makes them tick. Artists have designed new characters, friend and foe, and exciting new environments unique to the world of the Penguins. From the thoughtful direction of Simon J. Smith and Eric Darnell to the creative touch of Shannon Jeffries and Ruben Perez, the Penguins have now transcended from side characters to the center stage.

Who are the Penguins? We all are: DreamWorks, PDI, the DDU in India, and everyone who has ever touched them—an elite team that can achieve the remarkable relying on our resourcefulness and determination. We are the courage, the muscle, the brain, and the heart—the whole that is greater than the sum of its parts. What began as "grit, spit, and duct tape" has undeniably become "passion, artistry, and a whole lotta talent." I am proud to be part of *Penguins of Madagascar*, this time as an actor and executive producer.

"So. That's how, Ma! Isn't it great?"

—XO Skipper (aka Tom McGrath)

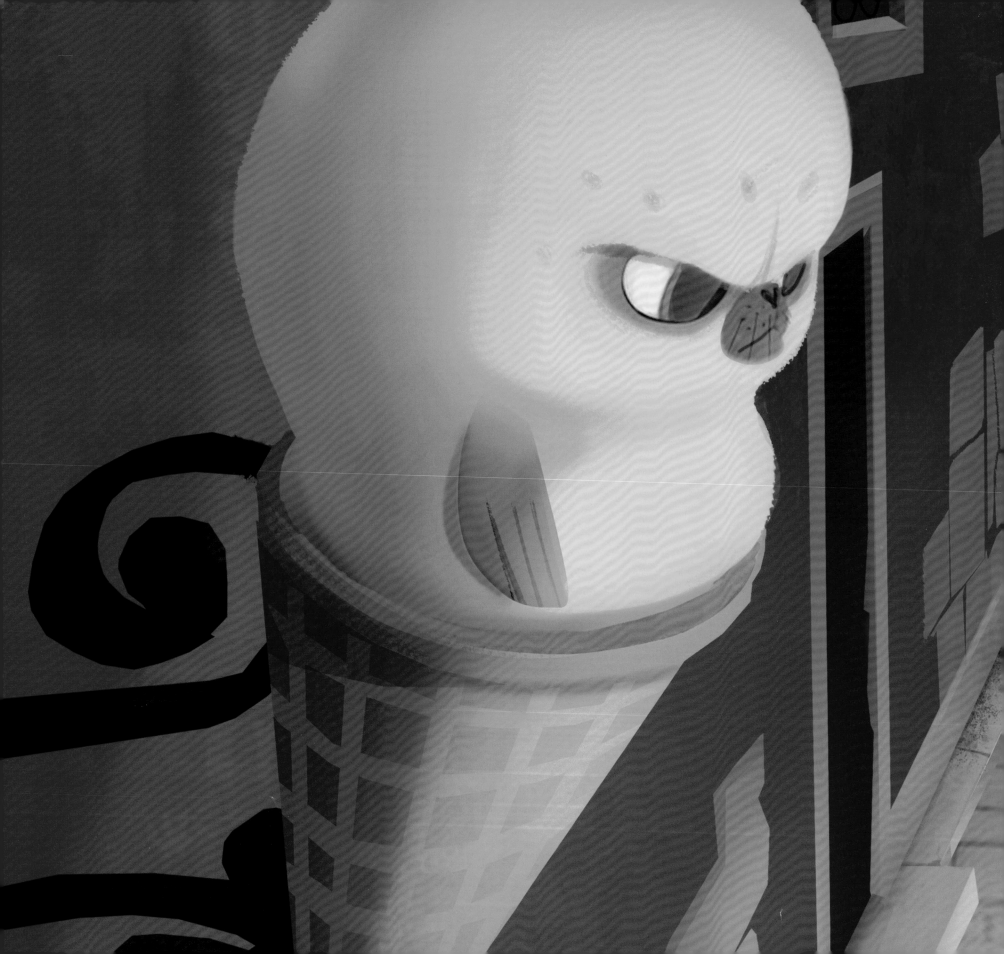

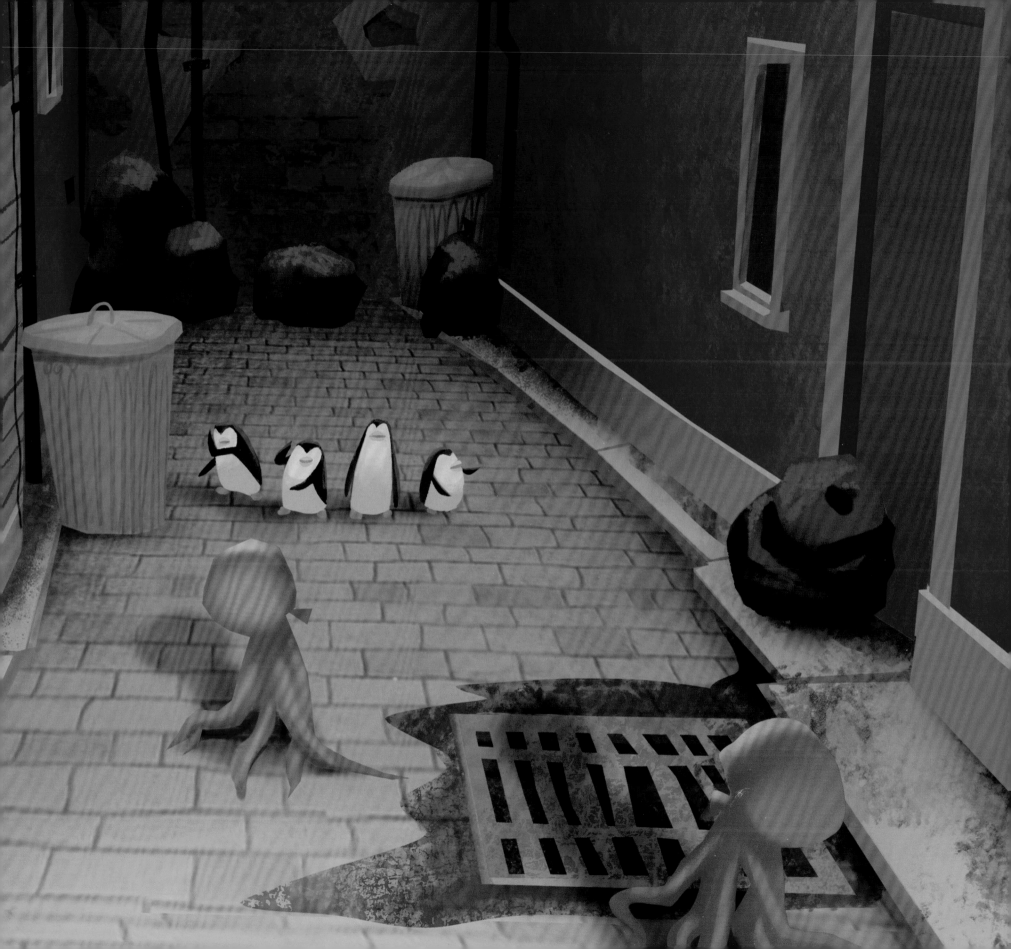

INTRODUCTION

Of all the amazing characters who have appeared in the three Madagascar films, why spin the Penguins into their own feature?

"From the moment the first Penguins sequence was pitched for *Madagascar*, we knew they were going to be breakout characters," says Eric Darnell, who directed *Penguins of Madagascar* with Simon J. Smith. Darnell, who was one of the directors and writers of the first Madagascar film, has been working with the beloved Madagascar characters and their exciting world from their inception more than ten years ago.

"Ever since *Madagascar*, audiences have found the Penguins hilarious," says producer Lara Breay. "Everyone is curious about who they are and where they come from."

The Penguins were also the unintentional catalysts in those films. The irrepressible birds are the ones who send the Zoosters to Madagascar in the first film by nose-diving a Zooster-filled airplane into continental Africa, where Alex and the animals remain for the rest of the film. In *Madagascar 3*, it is the Penguins who rescue the Zoosters in Monaco in an armored LARV (Luxury Assault Recreational Vehicle) and send them off in a monkey-powered superplane, only to crash in a rail yard near a circus train. The elitist of the elite powered such sidesplit-ting, action-packed scenes that it comes as a shock to realize there were only a few such moments.

"Three and a half years ago when I got the call asking if I would like to direct a Penguins movie, I compiled all the footage of the Penguins from the three Madagascar films," says director Simon J. Smith. "It's hard to believe, but it totaled only eight and a half minutes."

Of course, the Penguins didn't limit themselves to cin-ematic adventures. They've stayed active for five years on television in eleven-minute, award-winning episodes on the Nickelodeon channel. There, although confined to the Central Park Zoo, everything they do is treated as a

PREVIOUS PAGES & ABOVE ⟫ STEVIE LEWIS

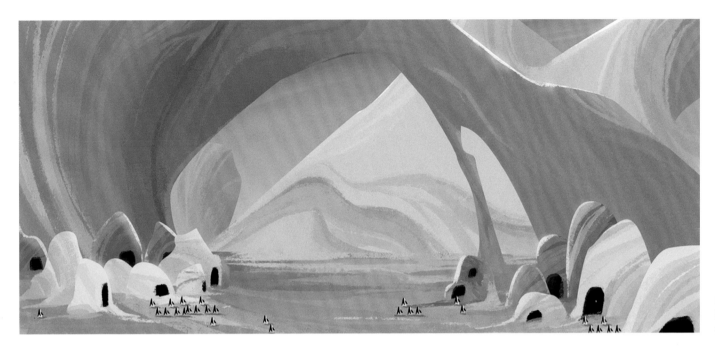

commando/spy mission, with Skipper, Rico, Kowalski, and Private each playing a role.

Now DreamWorks has sent the Penguins on a mission the popular birds have been preparing for their entire lives: starring in their own feature film.

"From the first time a sequence with the Penguins was pitched, we knew they were so entertaining," says Dream-Works chief creative officer Bill Damaschke." We thought it would be great to imagine a mega mission only they could take on the big screen."

The filmmakers' mission, though, was to find a story that suited an eighty-minute feature, a process filled with as many twists and turns as a thriller.

Because they have always been a kind of paramilitary group, and because Smith is a longtime James Bond fan, the adventure started with the Penguins in a spy movie.

"I grew up on James Bond," Smith says. "I was in England, and in the summer when it was raining all day, we'd take a pack lunch to the theater and watch James Bond double bills. It was like going on vacation. We didn't want the Penguins film to be a parody, but we thought the funniest canvas for these Penguins to be painted on would be a superspy-like canvas. They shoot first and ask questions later. And so, what if their antagonist is someone actually like a superspy?"

That antagonist became a wolf who, in a hilarious scene, the Penguins name "Agent Classified." Agent Classified—voiced by Benedict Cumberbatch—heads the North Wind team of cool, sophisticated, high-tech spies.

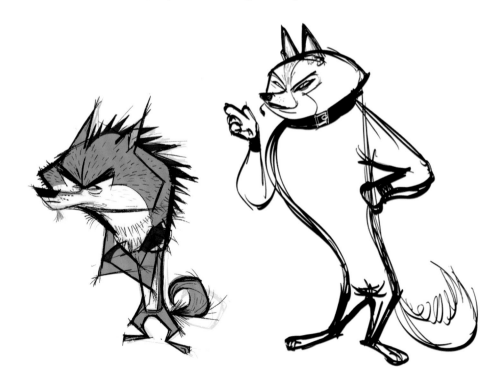

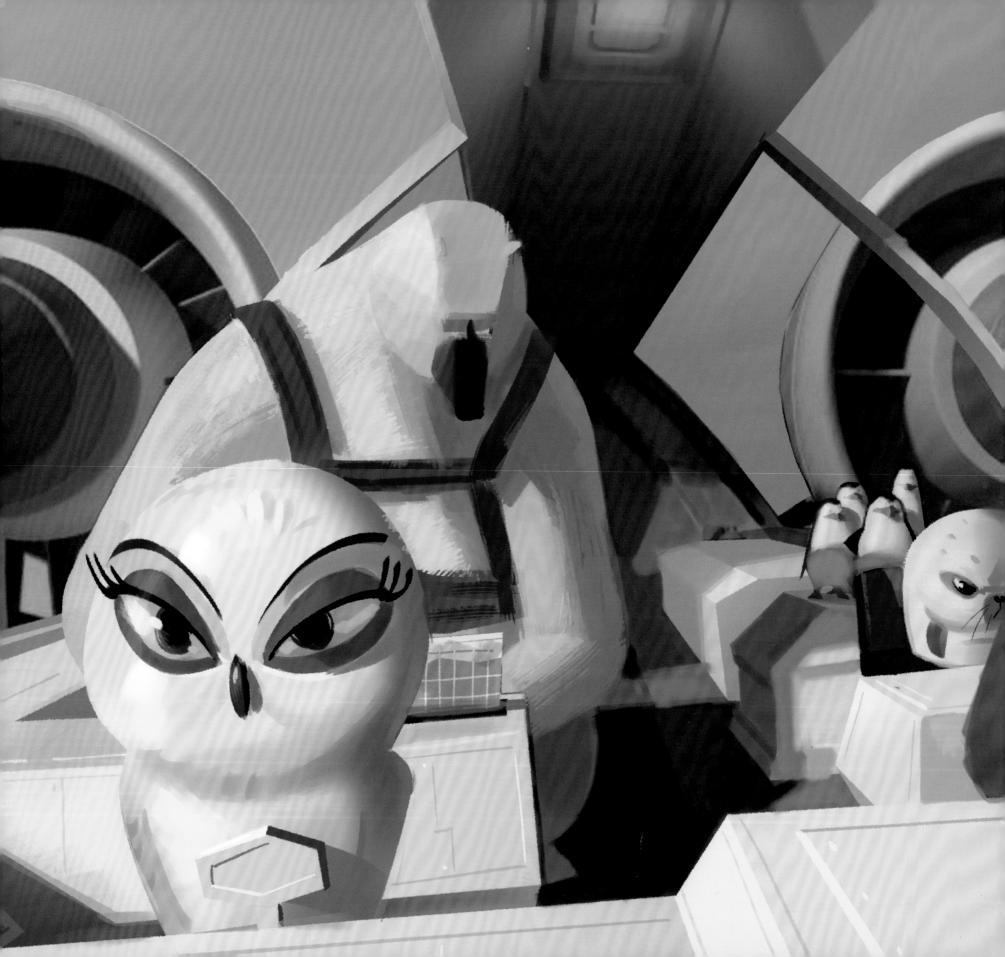

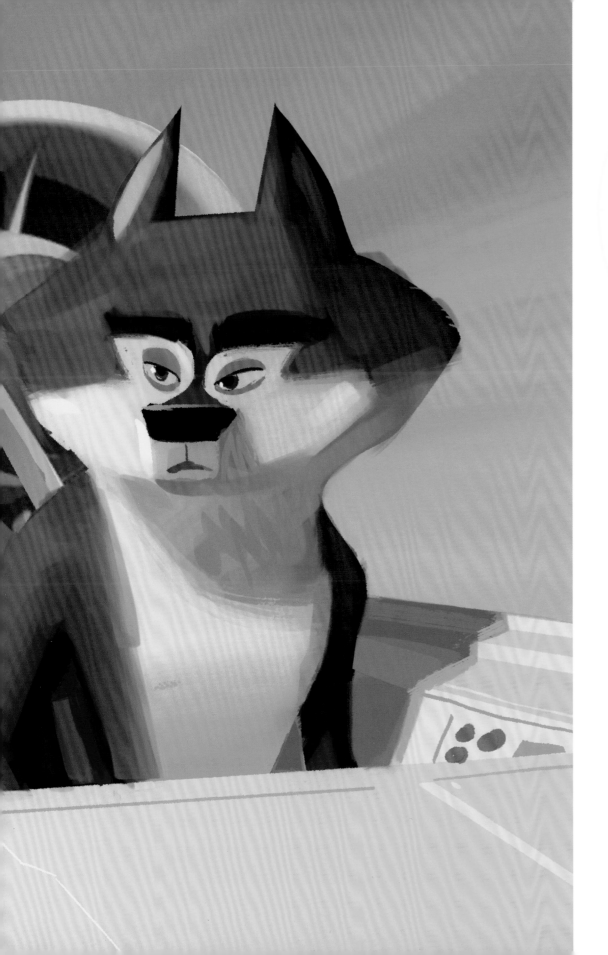

"We put the Penguins in a spy world where they run into real, professional superspies," Breay says. "They meet the better versions of themselves."

But a spy-versus-spy story with low-tech Penguins competing against the well-funded, high-tech North Wind agents took the filmmakers only so far. "We had a story where you felt sorry for the Penguins," Smith says. "But they were becoming other characters, ones you didn't know and love."

The Penguins needed to do something other than contend with rivals. "We needed a really strong villain," director Eric Darnell says. "A malicious cad who, as in Bond movies, wants to dominate the world."

Because penguins can swim, the team explored having the dueling spy teams contend with a beaver, leopard seals, starfish, and an army of marine animals. And then a unique sea creature rarely used in animated films captured their imagination: an octopus. Like spies, octopi are secretive and good at camouflage. For the animators, the technical and creative challenges inherent in performing a boneless creature were intriguing. "It's fun that they are essentially formless, kinda creepy, and move in bizarre ways," Darnell says.

LEFT >> STEVIE LEWIS & RUBEN PEREZ
TOP >> JOE MOSHIER

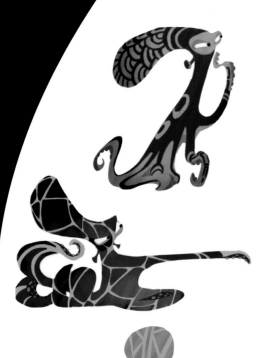

This octopus villain evolved into Dave, a character whose personality became fully realized when John Malkovich recorded his voice. When he was young, Dave felt rejected by the visitors at the Central Park Zoo, who recoiled when they saw him and flocked to see the cute penguins instead. Years later he has grown into an adult and disguises himself as Dr. Octavius Brine, a human who studies penguin genetics—all the while nursing his childhood resentment. Dave's ultimate goal is simple yet diabolical: Kidnap all the penguins in the world and turn them into monsters.

As the directors, writers, and story artists sent the competing North Wind and Penguin teams on missions to defeat Dave, the story evolved. The creative team began to downplay the spy story and focus in on a deeper, more emotional theme.

"The theme we picked was to not let other people's perceptions define who you are," Smith says. Just as people at the zoo misjudged Dave, so too does Agent Classified misjudge the Penguins, and the Penguins misjudge Private, the youngest and cutest member of their team.

"You want a villain to have similar or overlapping issues to our heroes," explains Damaschke. "The Pen-guins are underestimated because they're cute, so we thought of a villain who would want to take that cuteness away from them."

"We realized we couldn't have a big spy movie focus if we wanted to stay true to the Penguins," Darnell says, "but we still have the feeling of a spy movie."

Over-the-top chase sequences in exotic locations drive thrillers, always with a comedic twist. The Penguins start in Antarctica, flash back to New York, and travel to Kentucky. Then, they're off to Venice, the Gobi Desert, Shanghai, and the South Pacific before landing again in New York.

"We wanted to put them on the world stage in an international adventure that would challenge them," Damaschke says.

Shannon Jeffries, who had been the art director for all three Madagascar films, joined the crew as the production designer. "We wanted our film to reflect the Madagascar style," she says, "so we carried the visual language from *Madagascar 3* into this film: the wiggle in the line, the loss of detail as we go back in space, the transitional light and shadow color. With each Madagascar movie, we change and update the design, but the principle of 'straights against curves' is always there. The differences

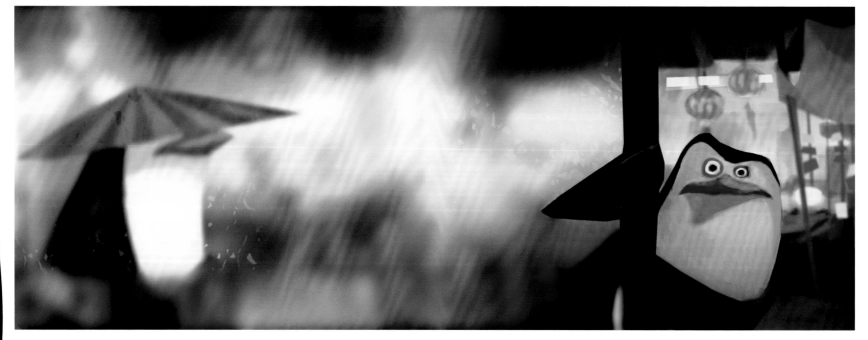

TOP & ABOVE ›› FLORIANE MARCHIX

LEFT >> FLORIANE MARCHIX
BELOW >> JAMAAL BRADLEY

are in the way we use color and detail. The thing that really changed in the Penguins is the palette."

In *Madagascar 3*, the color palette reflected the story points, and thus, Monaco, Rome, the Alps, London, and New York City each had a different palette. "To accommodate the fact that the Penguins' story was going to take them around the world, I decided to attach a color and line quality to the characters rather than to the story," Jeffries says. "The color palette and shape language within a location change depending on whether the Penguins, the North Wind, or Dave dominate. Also, in this film, I wanted to link color and confidence. As the Penguins' confidence builds throughout the film, so does the color."

Because the Penguins and North Wind characters are the inverse of each other, Jeffries gave them variations within a style. For example, the low-tech Penguins' ultramarine blue becomes computer-screen cyan in the high-tech, North Wind–dominated sequences. By contrast,

Dave has the rotten green and ocher colors of polluted water, and Jeffries filled his world with curves.

The film opens in Antarctica with quiet colors. The Penguins are young, not yet a team. And then Private hatches, the newly formed team drifts on an iceberg toward an orange sun, and the fun begins.

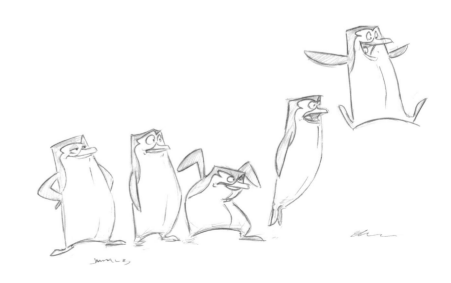

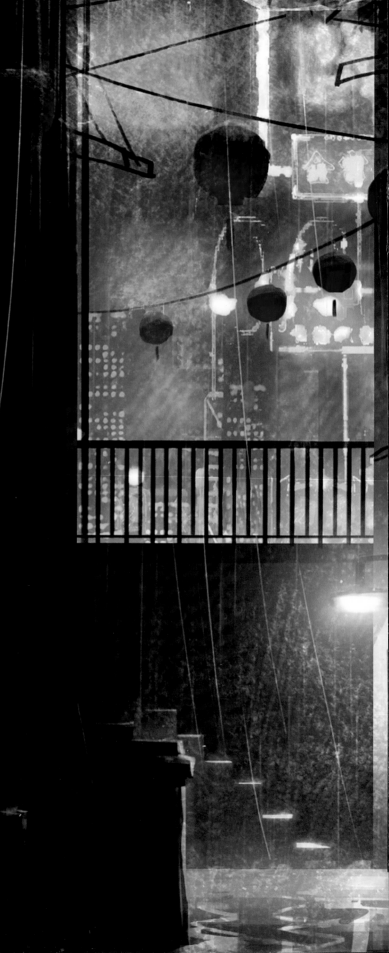

THE ELITEST OF THE ELITE

THE PENGUINS

THE PENGUINS

When you want to move characters as popular and familiar as the Penguins into feature-film starring roles, it might seem that their design is set, their personalities fixed, and nothing needs to change. But that was far from the case.

"The Penguins were fantastic in the previous films, but they had only one or two notes," says producer Lara Breay. "Now they have to take center stage."

The Penguins had to stay familiar, but they couldn't remain the same. DreamWorks Animation chief creative officer Bill Damaschke explains, "Essentially, they are the same characters they always were, but by moving the spotlight over to focus on them, we've found all their dimensions. We've filled out their characters and the brotherly relationship they have with each other."

"We didn't want the Penguins to be like the Three Stooges," says co-producer Tripp Hudson. "They're more sophisticated than that; they're resourceful spies with a sense of humor."

"In the previous films, they were only comedic relief," says director Simon J. Smith. "They had no subtlety, breadth of emotion, or expression. We had to update our lead characters." In addition, the original models and animation rigs were now more than ten years old and had only been developed for bit parts. "The Penguins needed to show a broader range of emotions, with broader facial expressions and body motion," says head of character animation Olivier Staphylas. "We couldn't have them do eighty minutes of just snappy actions. We had to make sure we could portray new feelings."

In the early stages of development, the DreamWorks artists considered distinguishing the Penguins film from the look and feel of the Madagascar films, drawing up concepts of what this would entail. And then, when the team decided there was no reason to veer from the Madagascar world, the Penguins went through a redesign that returned them to the charming style of simple shapes and straights against curves. "Little by little, we brought them back to something much closer to what they had been in the Madagascar movies, because that look supports the cartooniness and humor," says visual effects supervisor Philippe Gluckman.

Still, you can see small changes. Skipper has a slightly flatter head. Rico has a more notable tuft and a scar on his beak that he didn't have before. Kowalski is slightly taller and thinner. But Private is as cute and cuddly as ever.

PREVIOUS PAGES >> CHRIS BROCK
ABOVE >> STEVIE LEWIS

THE ELITEST OF THE ELITE

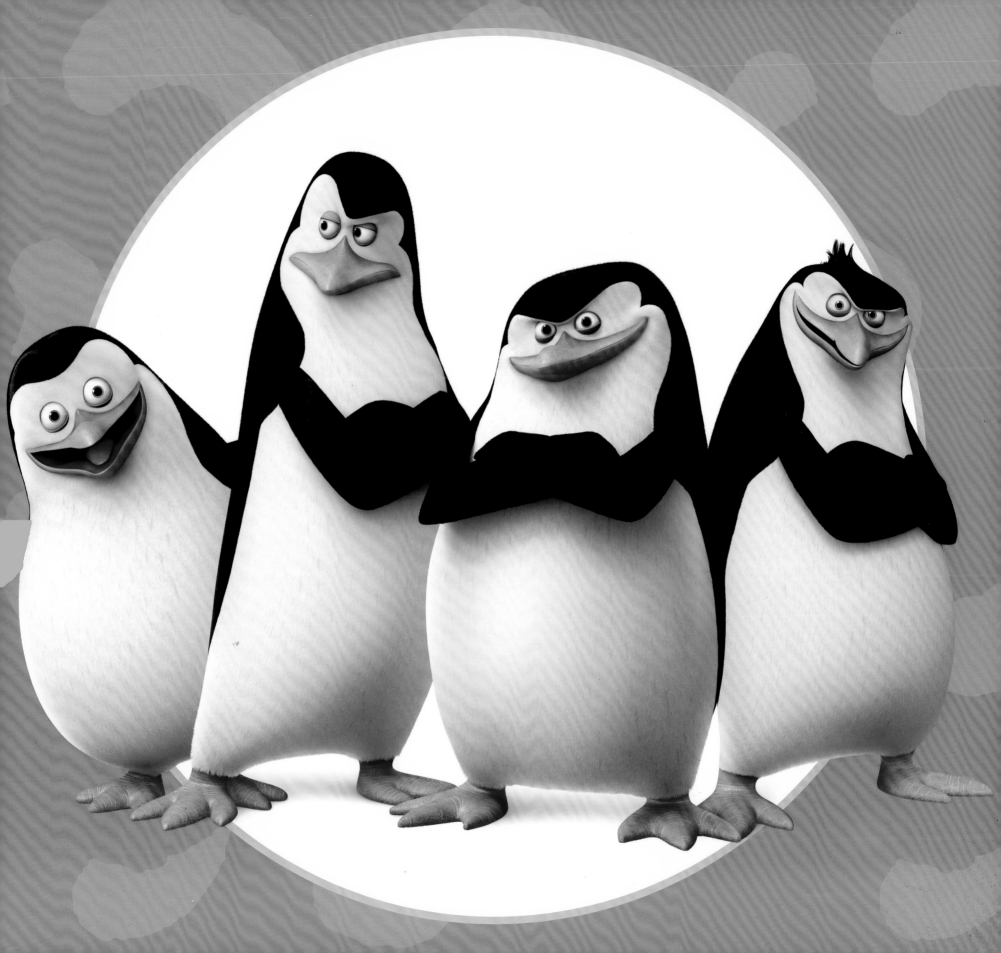

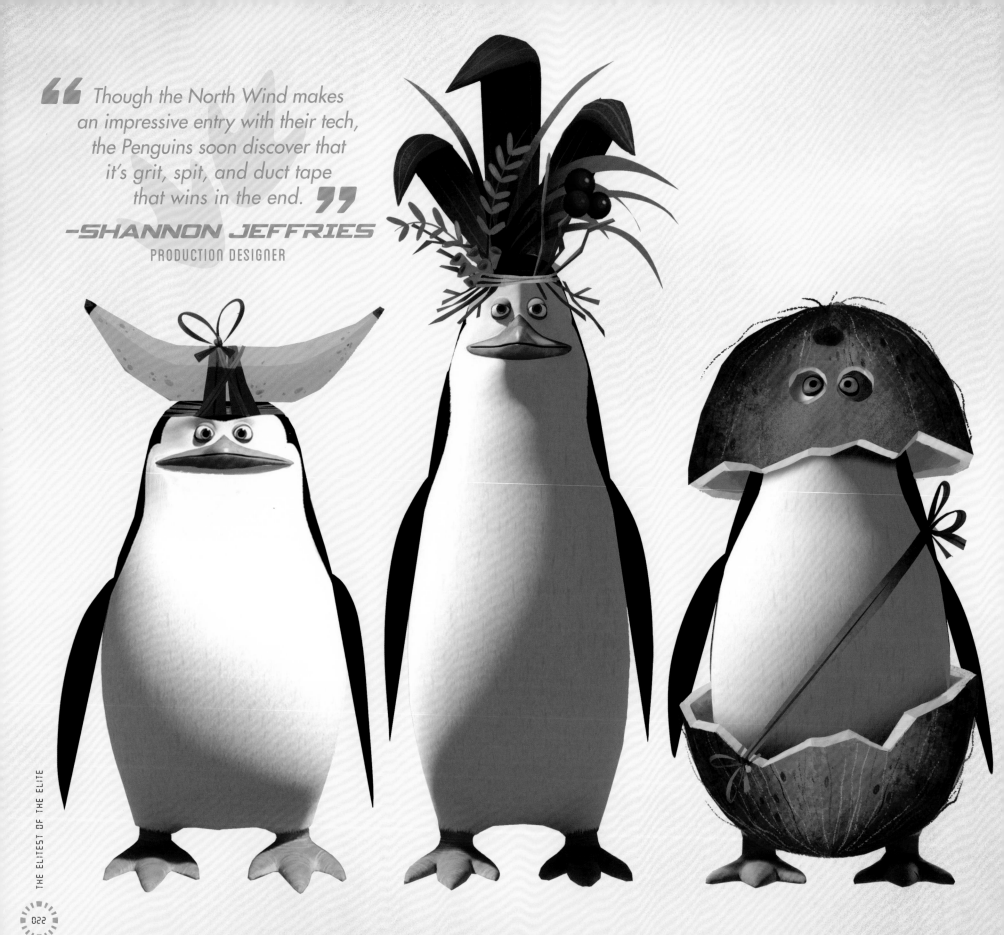

"Though the North Wind makes an impressive entry with their tech, the Penguins soon discover that it's grit, spit, and duct tape that wins in the end. **99**

—SHANNON JEFFRIES
PRODUCTION DESIGNER

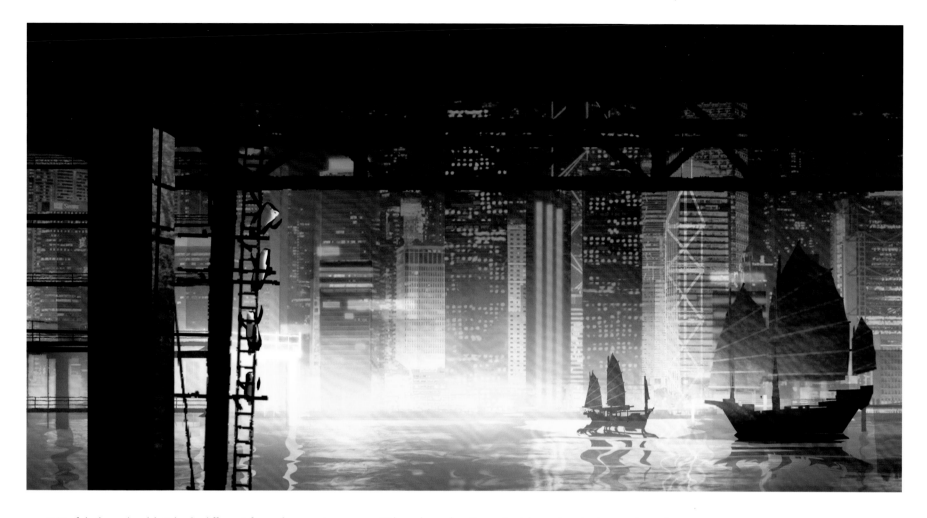

"We felt they shouldn't look different from the previous films, so we started the design process over," says production designer Shannon Jeffries. "We kept pulling parts of those beautiful redesigns out until they ended up being who they are." As always, Skipper—voiced by Madagascar director Tom McGrath—is the team leader. Rico is the muscle. Kowalski (Chris Miller), the brains. And Private (Christopher Knights) is the little guy. In *Penguins of Madagascar*, Skipper and Private have the largest character arcs.

"You can't sustain an entire feature film with background characters," says director Eric Darnell. "So we learn more about what makes them tick. For instance, Skipper fights against the stereotype that the Penguins are just cute and cuddly. But he makes the same misjudgment of one of his own team." Meanwhile, Private evolves from a mascot into a hero.

Other than the Penguins' homeland, Antarctica, the Penguins have no world of their own. However, they do have colors. "I wanted to start with beautiful colors in their home but a little crushed in the amounts of hue and value," says Jeffries. "When we're looking at a sequence that's Penguin-driven, we play up the warmth and orange and keep the blues within the range of blues we hit in Antarctica—a cobalt, ultramarine influence. And throughout the film, the Penguins' colors evolve as they become more confident." Their high point happens in Shanghai, which bursts with color.

The Penguins are also influenced by the palettes of other characters. When the Penguins are overwhelmed in the North Wind world, the ultramarine blues shift to cool cyan. Under Dave's influence, the Penguins' blues and oranges become tinged with greens and ochers.

OPPOSITE » STEVIE LEWIS
ABOVE » CHRIS BROCK
BELOW » ROBIN JOSEPH

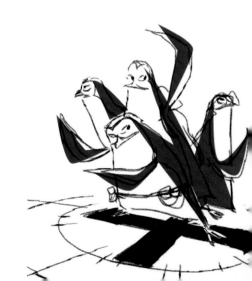

MUTANT PENGUINS

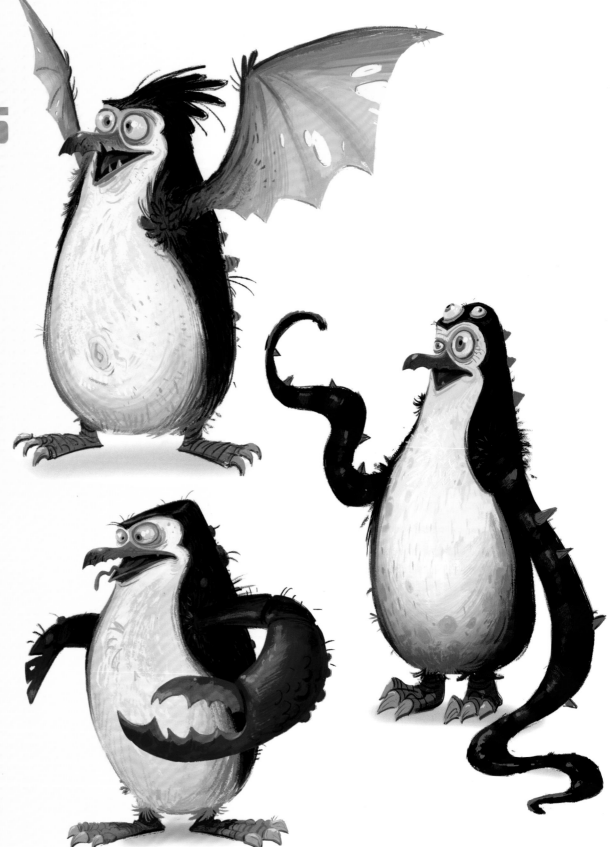

Dave's evil master plan to extract revenge on the cute penguins is to turn all the penguins in the world into ugly creatures by zapping them with a ray gun filled with something called the Medusa serum.

"The mutants evolved with the story," says co-producer Tripp Hudson. "Way back in the story process, Dr. Brine was going to kill all the penguins and flood the world. That didn't resonate with people, but we still needed to have Brine get his revenge. It went from him getting his revenge on all penguins, to only our four guys, to taking his revenge by making all the penguins less popular."

For the mutant penguins, the designers had to tone down the scariness. "We had to ride a fine line between scary and funny," says art director Ruben Perez. "We didn't want to scare a three-year-old."

The mutants also needed to illustrate a theme in the movie: Don't judge a book (or a penguin) by its cover.

"Designing the mutants has been a slippery slope," says Shannon Jeffries. "We didn't want to have a message in the movie that ugly is bad. We wanted the mutants to be appealing and to have people like them, because in the end, our heroes are mutated, and we want them to be funny and endearing. So, they are less about creepy and gross and more about having big simple features that change the silhouette. We didn't randomly put horns on a penguin that didn't make sense with the teeth we selected. We realized that within the elements we chose for each mutant, they still had to make sense from a design point of view. We mixed and matched things that are unexpected, but still kept them cute."

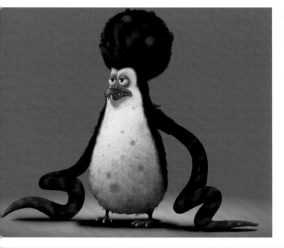
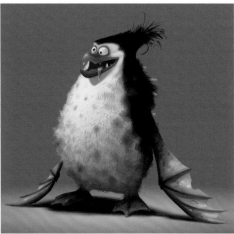
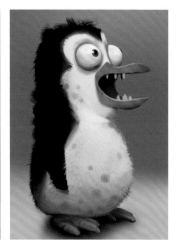
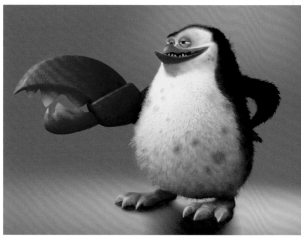

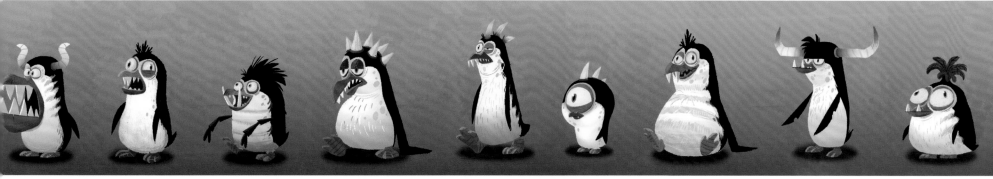

TOP >> RUBEN PEREZ
ABOVE & BELOW >> STEVIE LEWIS
LEFT & FAR LEFT >> PRISCILLA WONG

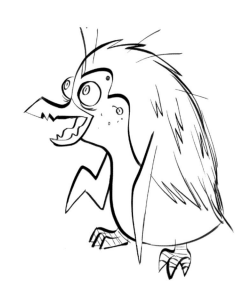

"We did hundreds of drawings of things added to normal penguins, such as horns and extra arms, but they looked like penguins in Halloween costumes," says Perez. "But it didn't look like they'd gone through a transformation unless we changed their beaks and gave them big teeth."

"For our heroes, we tried to leverage off their characters," says Jeffries. "Kowalski, the smart one, got a bigger brain. Rico is a little more haphazard in his design. Skipper has a big claw."

"We also dipped the mutants in a little green dye," says Perez. "Otherwise, when you saw a hundred mutants from a distance, they looked like regular penguins. The ray we shoot them with is in the villain's colors—green and ocher—so the mutants are influenced by that."

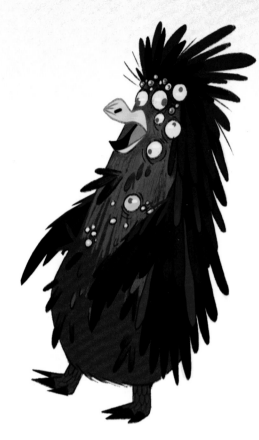

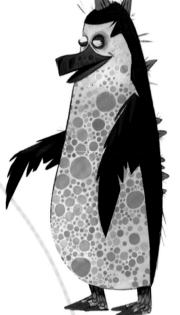

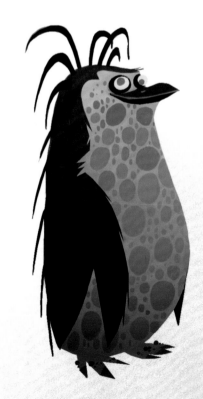

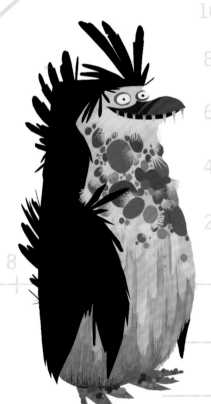

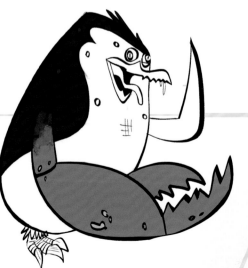

THE ELITEST OF THE ELITE

THESE PAGES >> STEVIE LEWIS, FLORIANE MARCHIX & TODD KUROSAWA

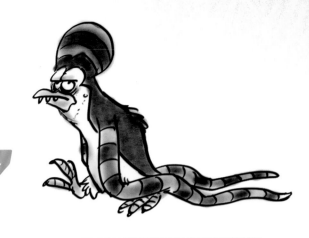

> **"** We ended up with hundreds of brilliant and crazy ideas for the mutant penguins—more than we could ever fit on screen. The ones that made us laugh the loudest were the ones that made it in. **"**
>
> **—LARA BREAY**
> PRODUCER

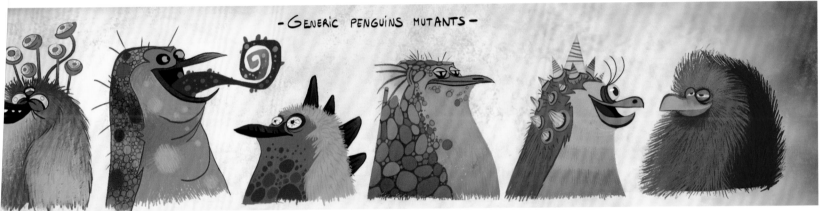

— GENERIC PENGUINS MUTANTS —

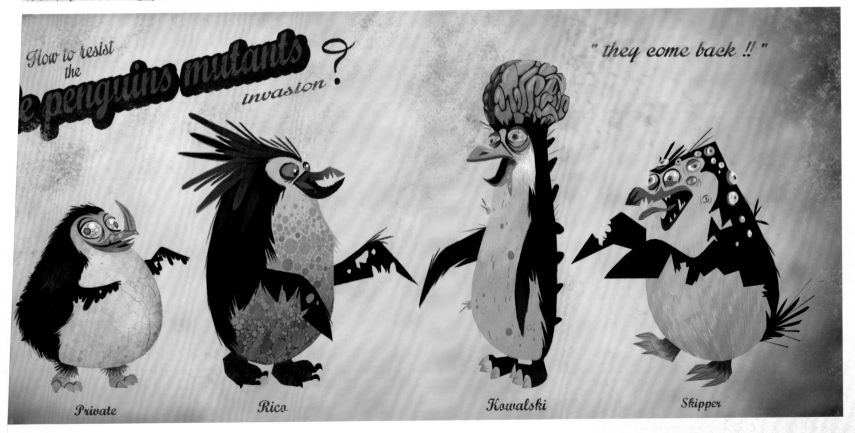

How to resist the **penguins mutants** invasion ?

" they come back !! "

Private Rico Kowalski Skipper

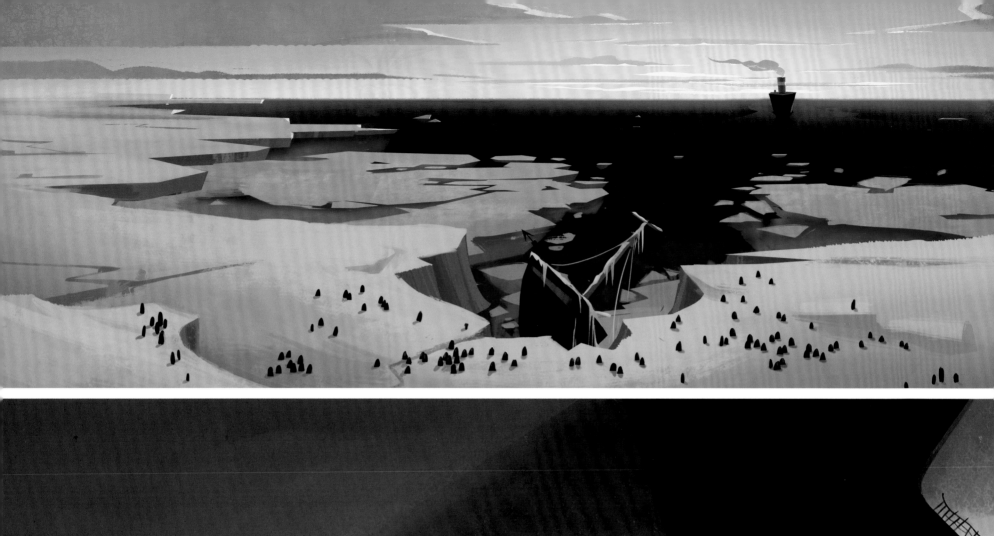

ANTARCTICA

The film begins with an origin story set in Antarctica, where our young Penguins are separated from the flock. The colors in Antarctica are muted whites and ultramarine blues, beautiful and desaturated. There, the Madagascar style is set, with details and textures that fade into the background and a hand-drawn quality to the lines.

"We explored the set for quite a while," says Ruben Perez. "Different ways of having the snow break, different drawings for the cliff. The shapes are so specific. Unless we give drawings like this to modeling, they'll create something that looks photographic. Our shapes are intentional,

even the way the snow cracks on the side of the iceberg. We don't have any parallel lines or ninety-degree angles. For Antarctica, I mostly designed shapes of snow."

Even after the modelers turned the drawings into three-dimensional sets, the art department continued to provide drawings and illustrations. For example, Perez worked with Conan Low, head of layout, as Low explored the environments from various camera positions.

"If Conan asked for an arch, I would draw an illustration for the modelers," Perez says. "Or, he might want a long camera move, so I would do a series of drawings to support it."

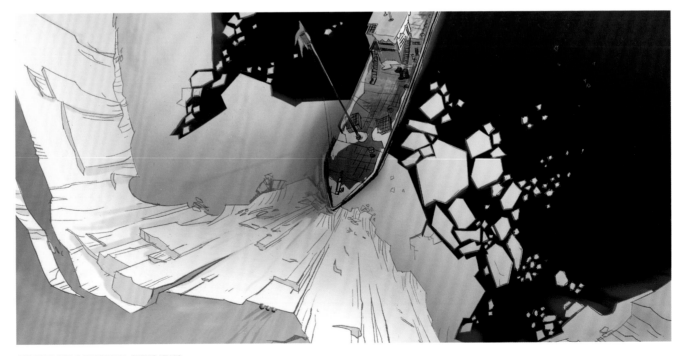

OPPOSITE TOP & BOTTOM >> STEVIE LEWIS
ABOVE >> RUBEN PEREZ

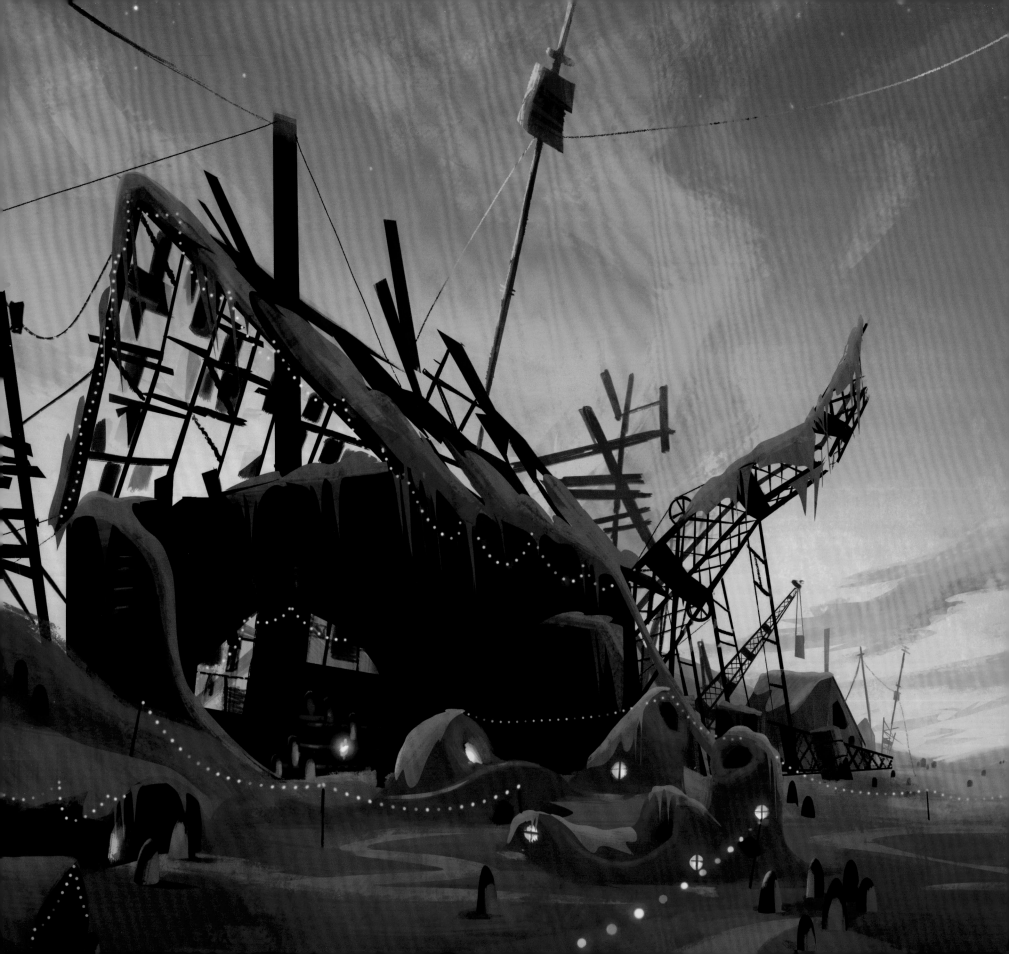

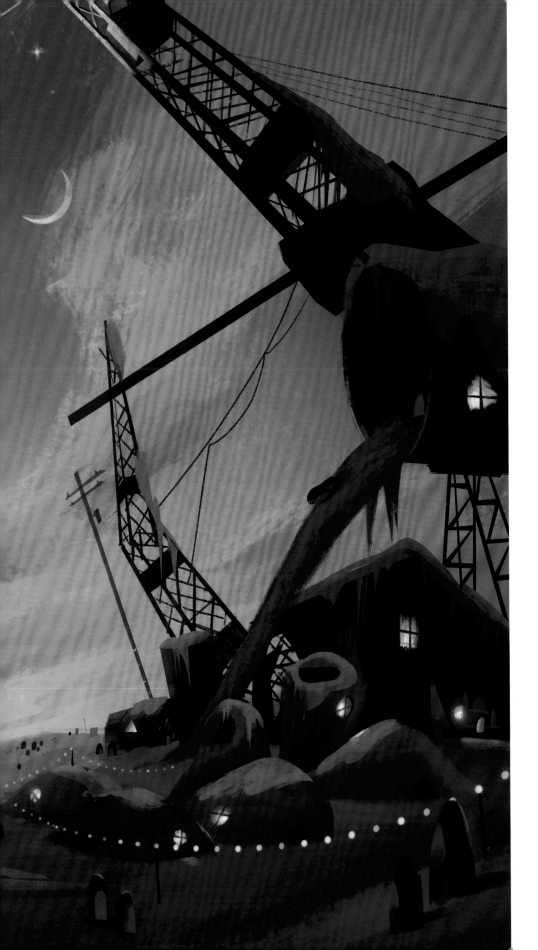

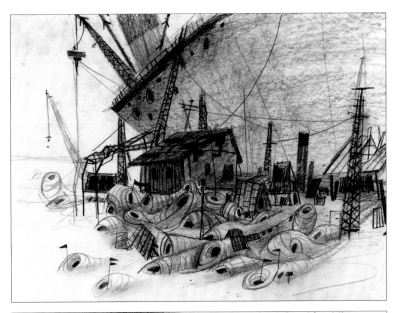

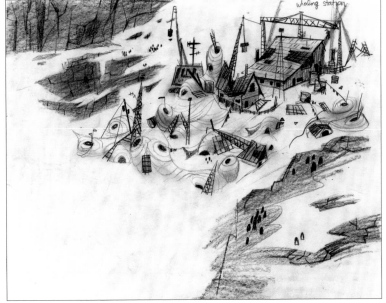

THESE PAGES >> STEVIE LEWIS

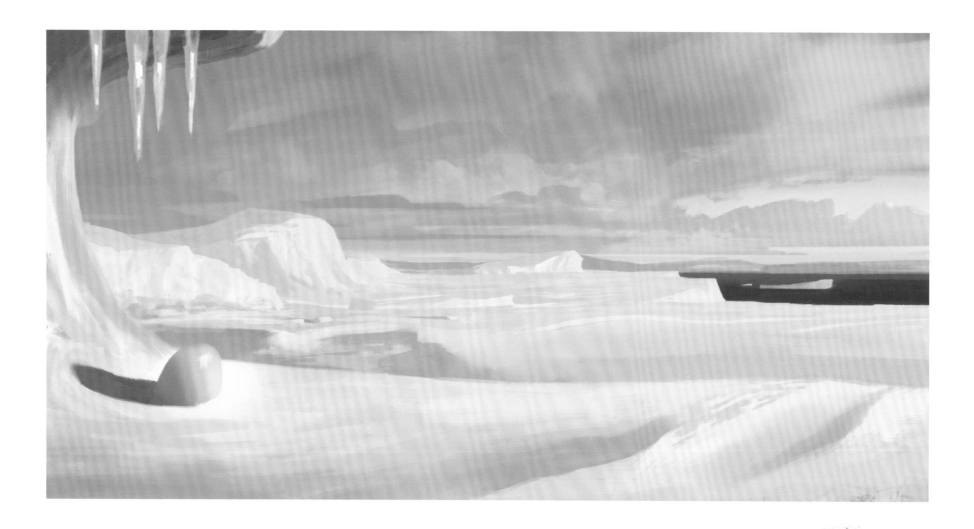

The art department also supplied color keys. "I'll paint illustrations of key moments as a base for the lighting department," Perez says. "For every sequence, there will be five to ten paintings."

Based on those color keys, head of lighting Jonathan Harman explored ways to make the Penguins stand out against the white snow.

"We needed to offset their white fur," he says. "Sometimes we give the snow a tinge of blue or a little transparency. It's very subtle. Luckily, the Penguins are egg-shaped. If we light them from above, the light at the bottom falls off and creates a little shadow. That and the color of the snow helped us separate them from the snow on the ground."

As this sequence plays out, Skipper, Rico, Kowalski, and a newly hatched Private become the unit that will take them through three Madagascar films and into their own feature.

"At the end of this first sequence, the Penguins discover they can work as a team," says Shannon Jeffries. "As they sail off on an iceberg into the sunrise, we get a little hit of orange, and we build upon that warmth during the rest of the film."

ABOVE & OPPOSITE ≫ CARLOS FELIPE LEÓN
RIGHT ≫ FLORIANE MARCHIX

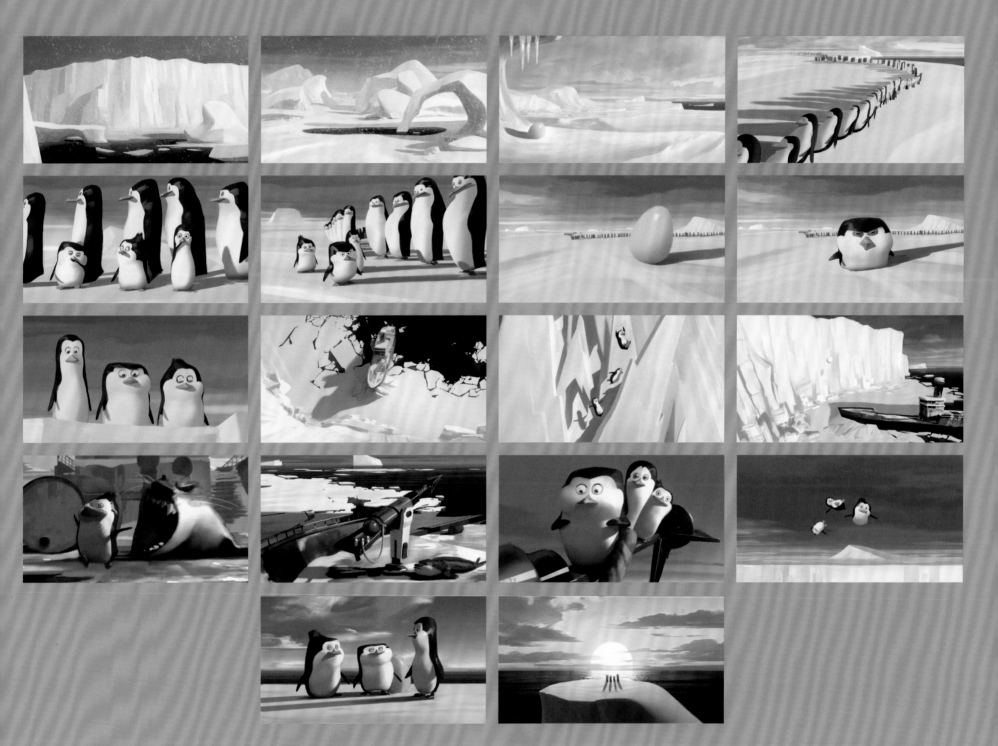

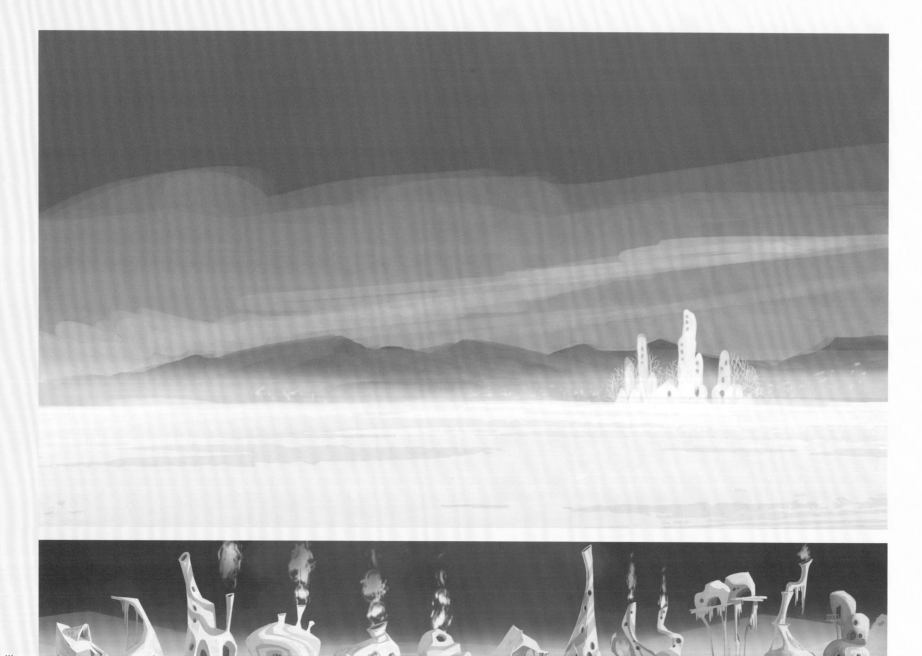

TOP & ABOVE >> FLORIANE MARCHIX

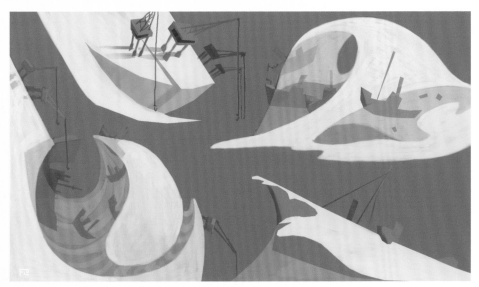

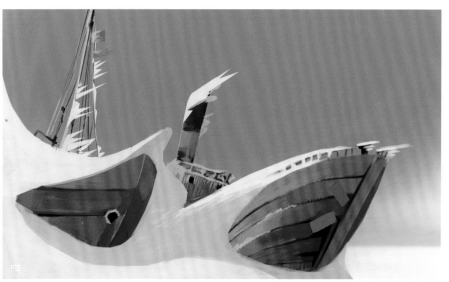

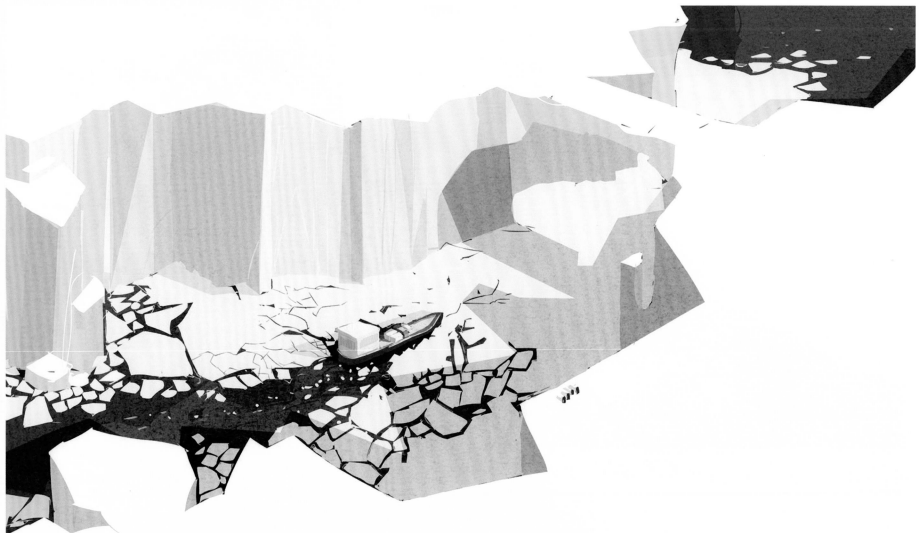

TOP LEFT & RIGHT >> FLORIANE MARCHIX
ABOVE >> PASCAL CAMPION

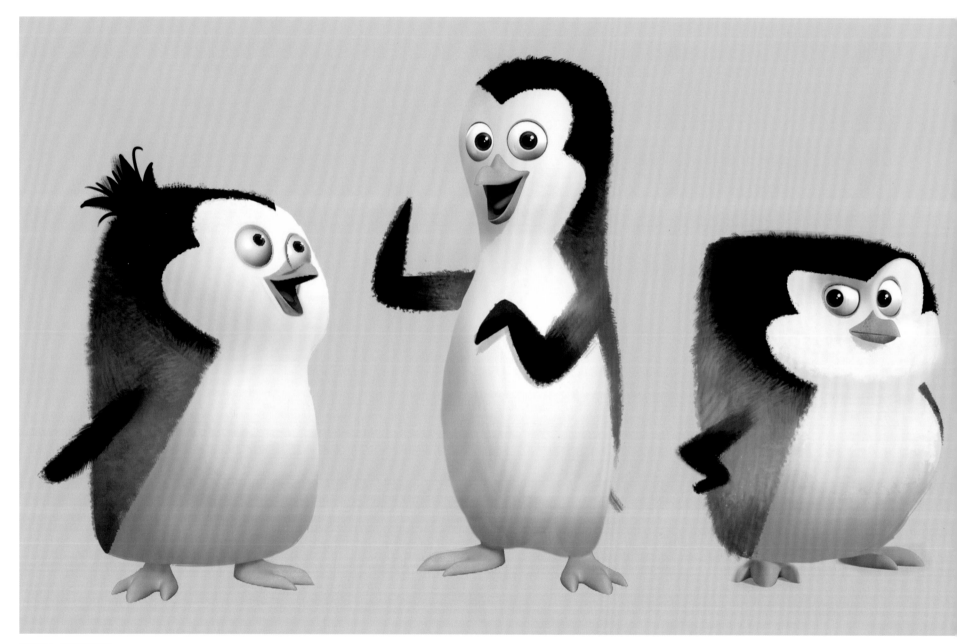

ABOVE >> STEVIE LEWIS

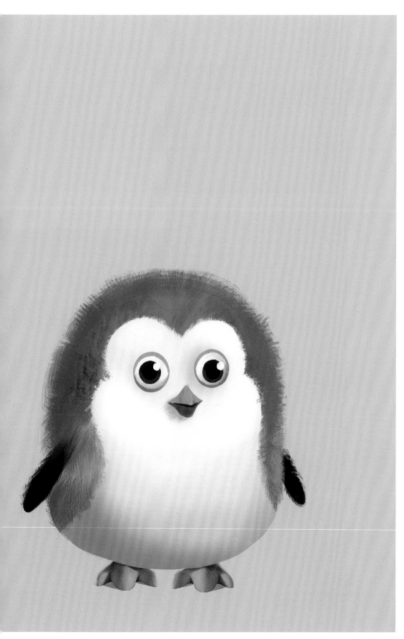

TOP & ABOVE >> PASCAL CAMPION

FORT KNOX

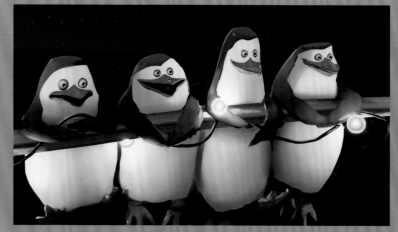

T he glow of the sun dissolves into the spark of a match as it lights a cannon fuse inside the Zoosters circus tent. Popping in and out of the next few frames are our Penguins, now fully grown. Kowalski and Rico stuff a rickety glider into the cannon and jump in. Skipper and Private dive in after, and the cannon blasts them through the top of the circus tent. As they glide across open country, Skipper reveals their plan to break into Fort Knox. And they do, with Penguin-style paramilitary action. Once inside, they bypass the rows and rows of gold bricks.

"Fort Knox is a one-off sequence," says Philippe Gluckman. "The gold room is entirely a matte painting."

Finally, the Penguin team reaches its goal: a vending machine with a surprise birthday present for Private—the last remaining packages of Cheezy Dibbles. But octopus arms shoot out of the dispenser tray, wrap around the Penguins, and pull them inside the machine. A helicopter lifts the machine and carries it off to parts unknown. The chase begins.

"Fort Knox is in the Penguins' colors when we break in. But the gold starts pushing the blues toward green, the villain's color, as he steps in," says Shannon Jeffries.

ABOVE ➤ GORO FUJITA, SHANNON JEFFRIES & STEVIE LEWIS
LEFT ➤ CHIN KO

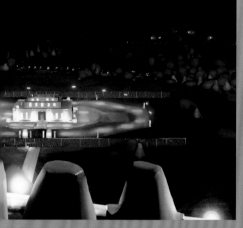
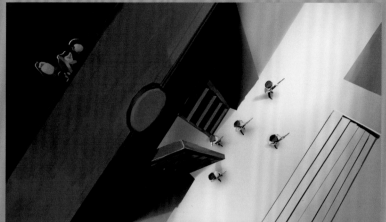
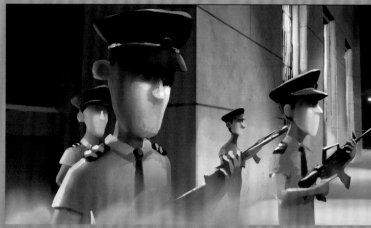

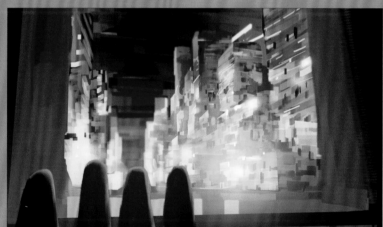
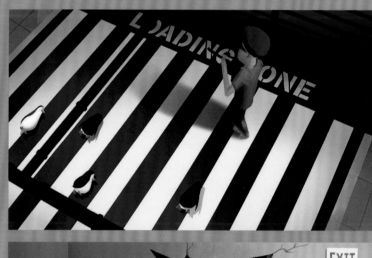

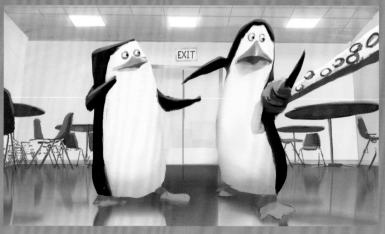

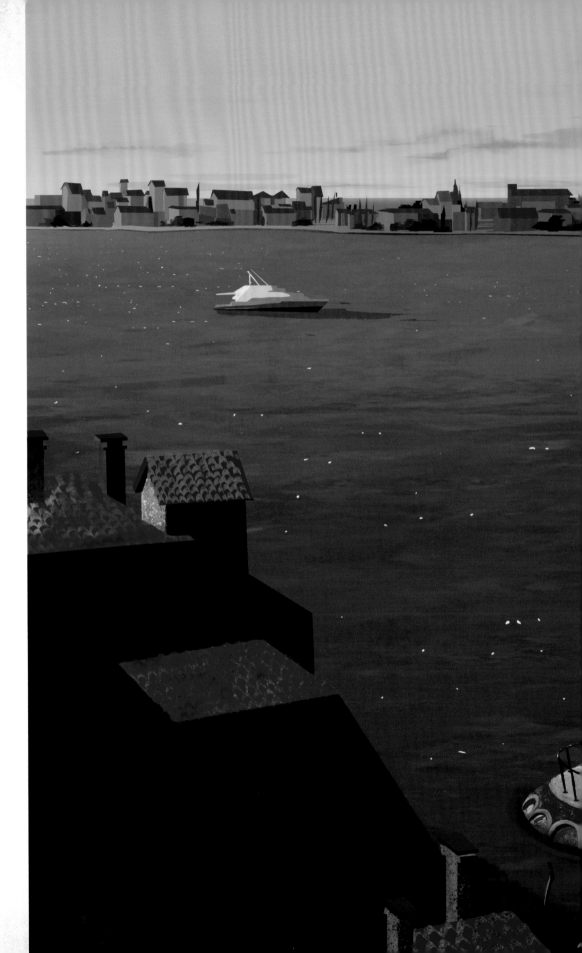

VENICE

Venice is an important location in the film: It's where our heroes first meet their rivals, the North Wind. After a harrowing chase by Dave's henchmen through the canals of Venice, Agent Classified and his team swoop in to save the Penguins—much to Skipper's dismay.

As the sequence begins, the Penguins escape from Dave's submarine into a Venice lagoon and jump into a gondola. Dave's octopus henchmen quickly spot the Penguins, swim through the canal, attack a gondolier in a second gondola—and the chase is on.

"When we picked Venice as a location, the story was darker than it is now," co-producer Tripp Hudson says. "We had a chase set in underground tunnels that were part of a sewage system network. When the story changed, this still seemed like a fun location, so we set the chase through the canals."

"It's a very dynamic, diverse sequence," says head of lighting Jonathan Harman. "Things whiz by fast. There's a plaza with people, the Penguins use the gondola oars as stilts, they jump onto a scooter, and the scooter jumps through the air." At the end of the scene, the North Wind's VTOL jet lands, and the North Wind agents rescue the Penguins.

BELOW ≫ FLORIANE MARCHIX
RIGHT ≫ AVNER GELLER

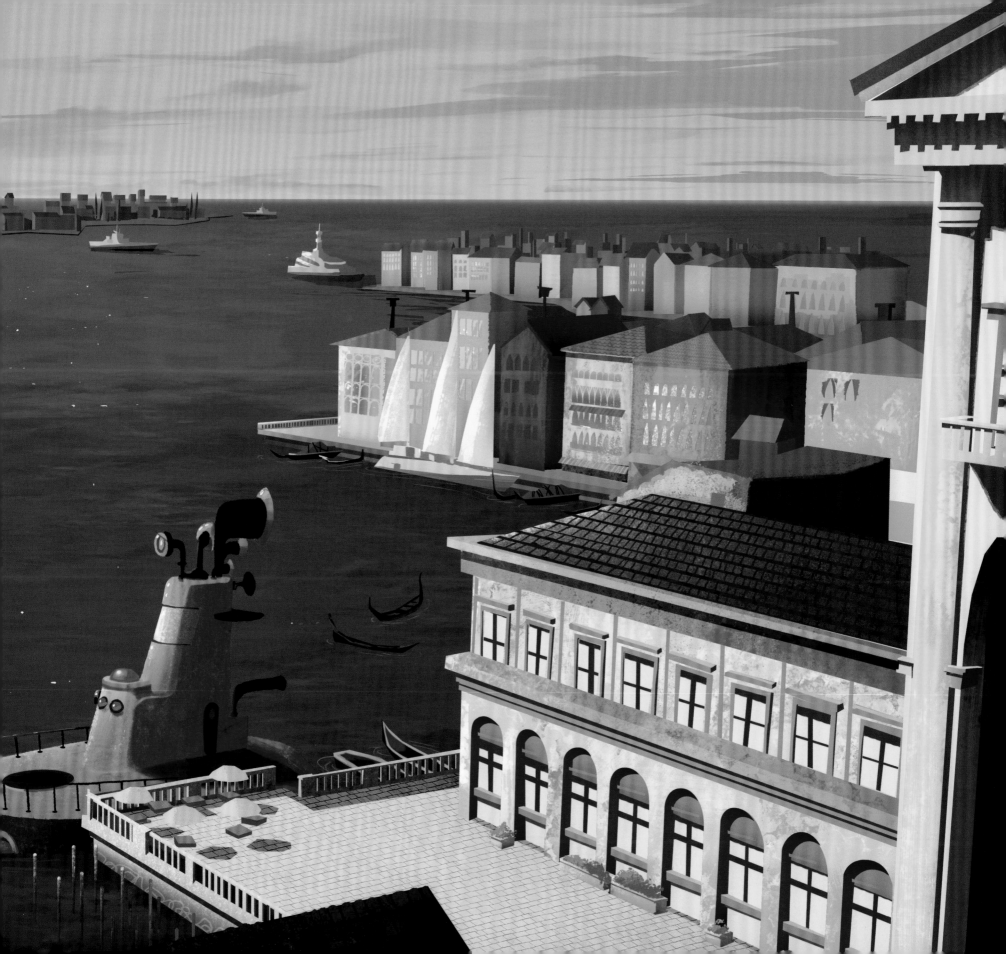

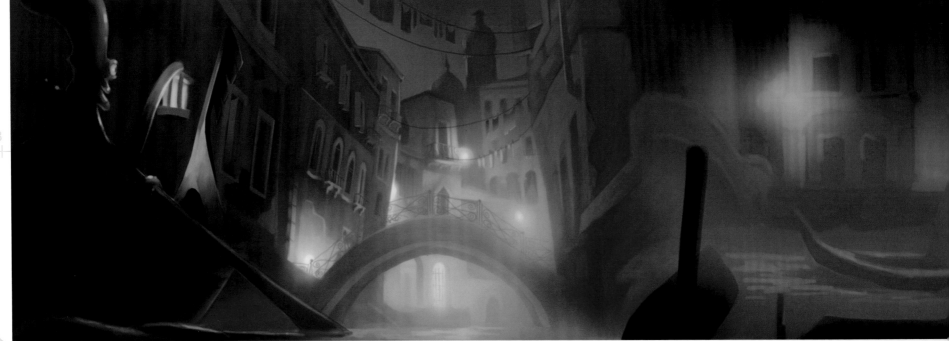

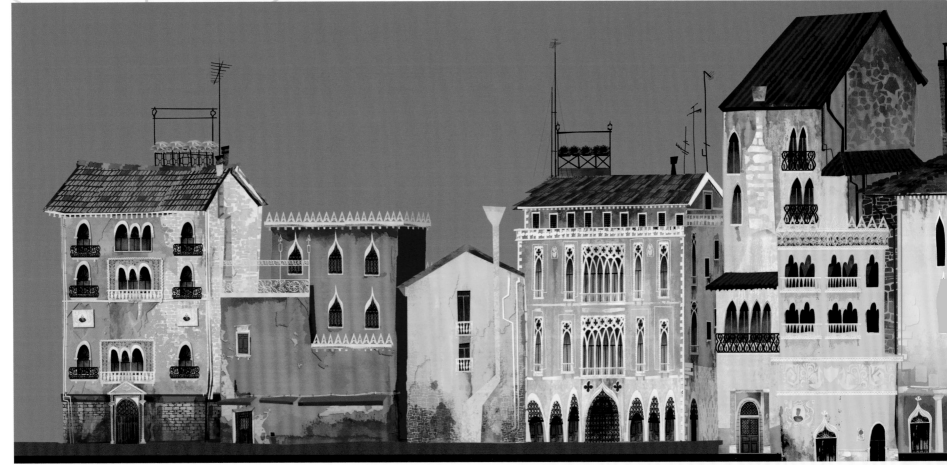

TOP » FLORIANE MARCHIX
ABOVE » LINDSEY OLIVARES

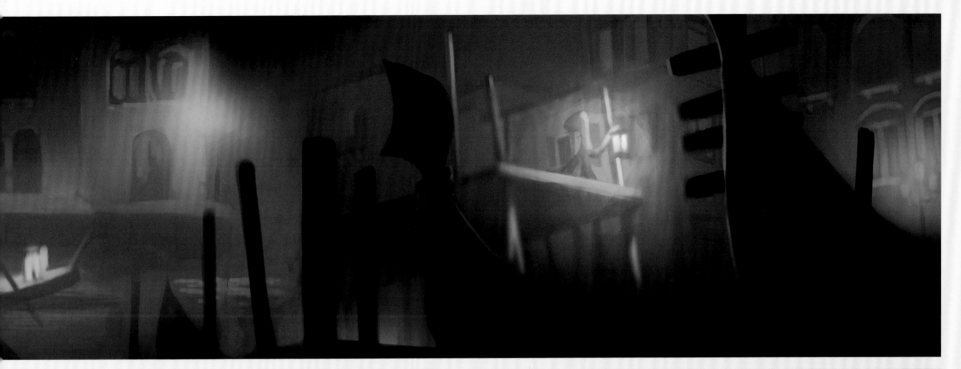

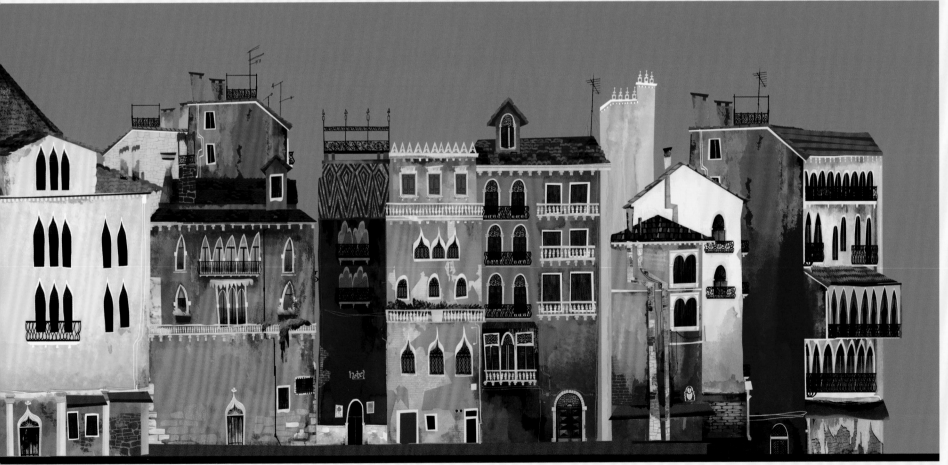

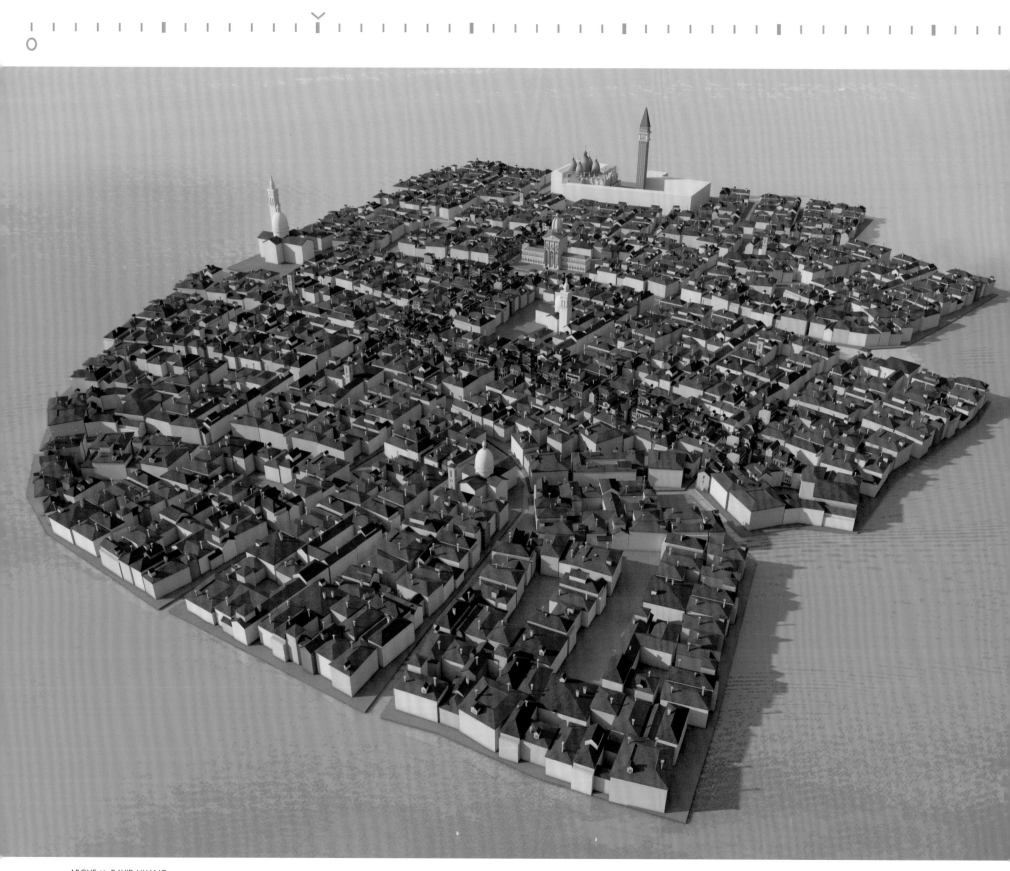

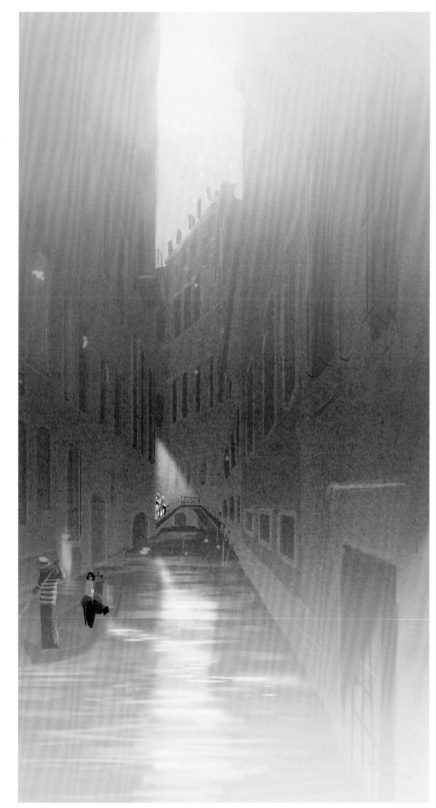

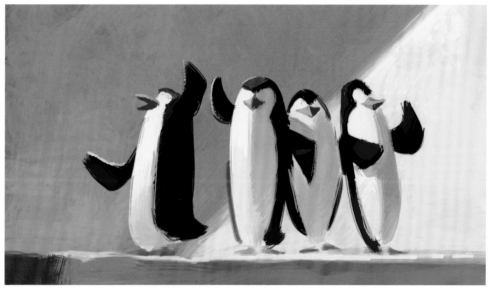

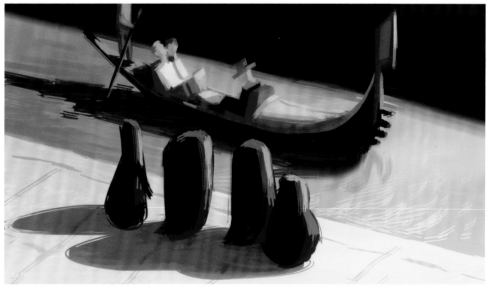

LEFT >> PASCAL CAMPION
TOP & ABOVE >> RUBEN PEREZ

THE MAKING OF SEQUENCE 500: VENICE CHASE

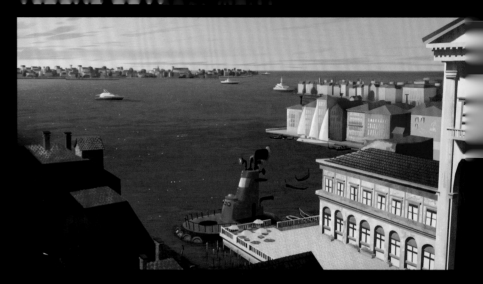

As with all good spy thrillers, the film's chase sequence is set in a glamorous location. The difference is that DreamWorks' production artists had to create all the characters and locations, down to the very last drop of water in a Venice canal and the feather on a gondolier's cap.

PRE-PRODUCTION

Script and Storyboard

Ordinarily, the script and storyboards determine the blueprint for the scene. However, this particular sequence came together in a rather unique way. The filmmakers started out with just a handful of storyboards and the basic arc of the scene: The Penguins would be chased by Dave's henchmen, cornered, and saved by the North Wind. Two comedic rules gave the sequence shape: Skipper would be blindfolded throughout but still lead his team with confidence and gusto, and through it all the Penguins would never leave the gondola, but it would gradually be destroyed beneath them. With this in mind, the story, art, layout, and animation departments worked together to develop the sequence in an interactive atmosphere. "The final results are spectacular and a tribute to what's so special about the animation process," says producer Lara Breay.

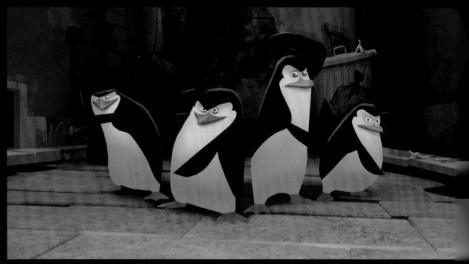

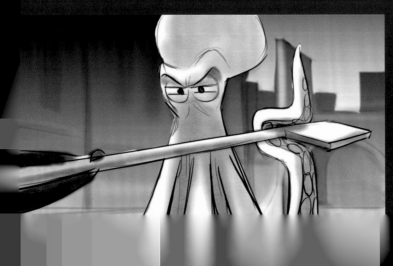

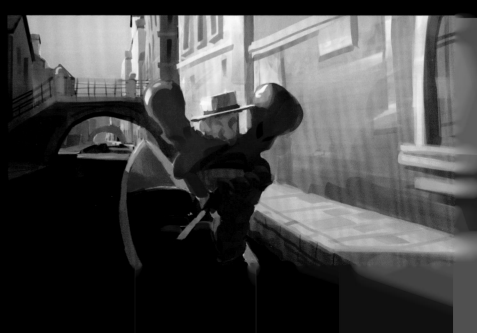

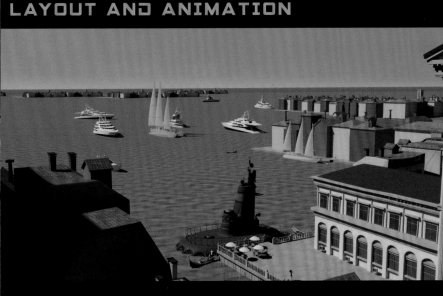
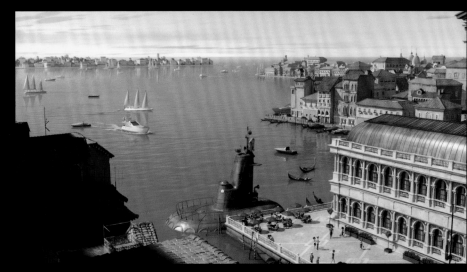

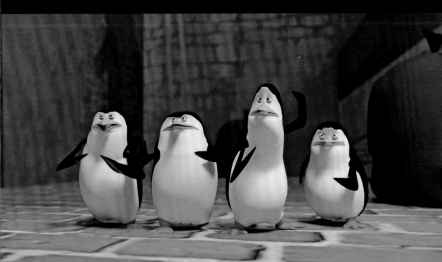
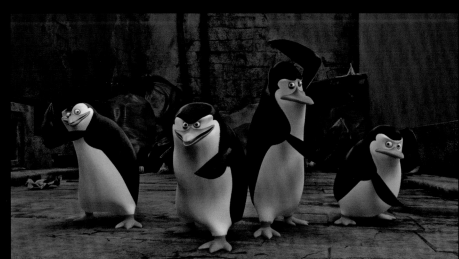

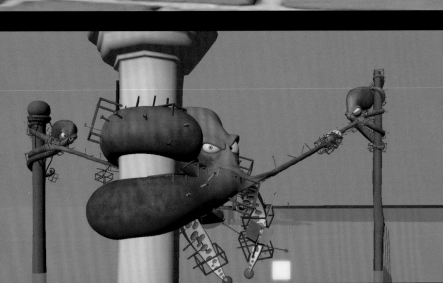
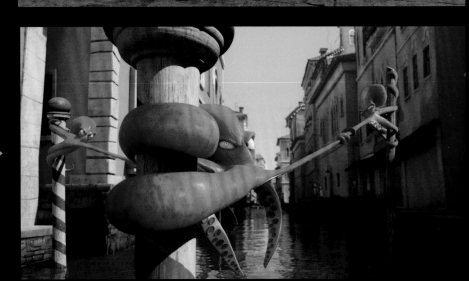

VISUAL DEVELOPMENT AND MODELING

Concept Art, Color Keys, Lighting Keys, Set Design, and Models

Working from storyboards, the art department created set designs, lighting keys, and color keys. The artwork describes the design, visual structure, and emotional intent of the entire film through shape, color, and lighting, and more particularly, for individual sequences and shots.

The visual structure of the Venice sequence builds on the style developed through the three Madagascar films, with loss of detail in the distance, a "whack" factor in the lines, and, of course, the ubiquitous "straights against curves" principle. In addition, because the Penguins dominate the Venice sequence, the color palette is largely in their aquamarine blue and warm orange colors. "But since they are being chased by the villain's henchmen, we leaned the water toward green," says production designer Shannon Jeffries.

Set designers used a modular approach to build the famous Italian city. "We could combine floors like building blocks to efficiently cover a lot of ground," says visual effects supervisor Philippe Gluckman.

BELOW ≫ MINYU CHANG
RIGHT ≫ RUBEN PEREZ

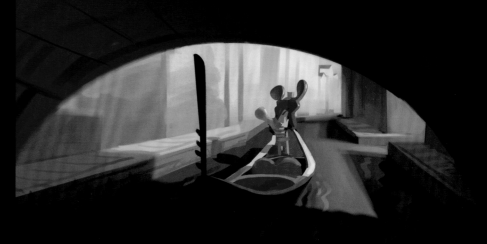

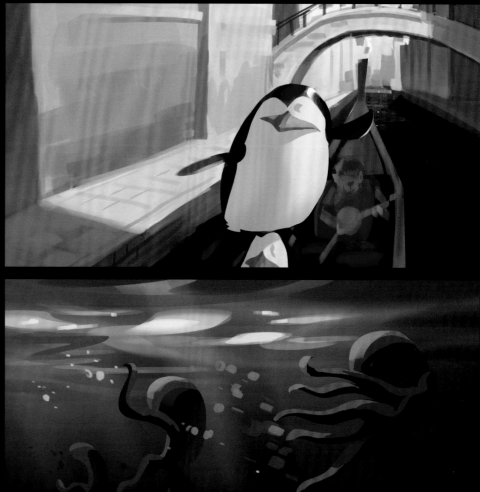

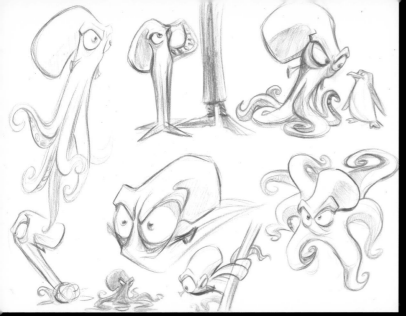

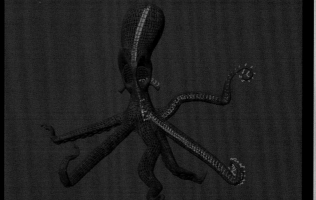

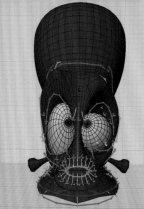

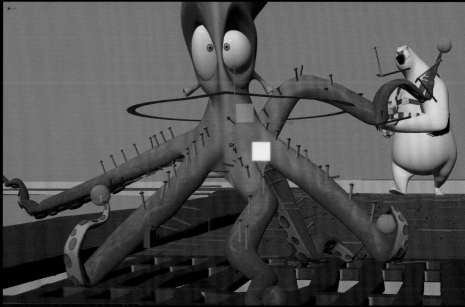

CHARACTER DEVELOPMENT
Design, Rigging, Animation, and Character Effects

The Penguins, Dave's octopus henchmen, and the North Wind characters all take part in the Venice chase sequence. Modelers referenced character designs to sculpt three-dimensional shapes fitted with a skeleton inside. Character riggers added controls that animators used to move the skeleton's joints and create facial expressions. The outside shell—that is, the skin—slides over the skeleton as if real muscles inside cause it to stretch and contract.

"We had a brand new software called 'Premo' for this film," says head of character animation Olivier Staphylas. "The Penguins had new designs, so we redid their skeletons and all the animation controls. We wanted to capture their essence so everyone could connect, and then take them beyond. We gave them more emotions. We stuffed their bellies with food. And when they ate too much, they passed gas."

Character effects artists added secondary movements, such as the Penguins' full belly jiggles, the Cheezy Dibble dribbles, and the farts. In shots with Dave in his human disguise, they moved his wig hair and his lab coat in artistic yet believable ways.

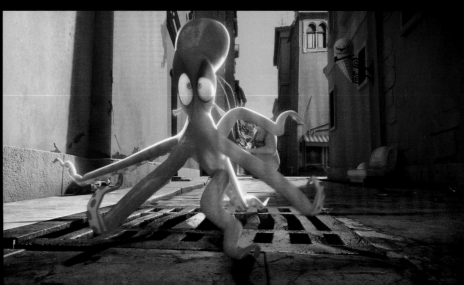

TOP LEFT >> RAVI KAMBLE
TOP CENTER >> NATHANIEL DIRKSEN
TOP RIGHT >> EVAN BOUCHER
RIGHT CENTER >> NIDEEP VARGHESE
RIGHT BOTTOM >> RAJARAJAN RAMAKRISHNAN

LAYOUT
Previs and Final Layout

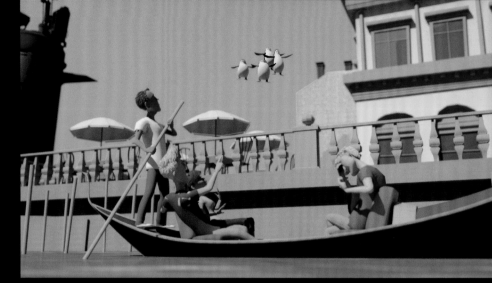

"In previs, we translate storyboards into three dimensions with full motion and temporary audio," says Conan Low, head of layout. "Before, the directors had a comic book. This is their first chance to see characters move through space."

Until recently, this exploration happened largely on a computer screen. With *Penguins of Madagascar,* layout expanded into a room Low calls the "camera-capture room."

"The goal of previs is to give people a sense of character blocking, shot timing, and assets," Low says. "Also, lighting artists want to know things like how high the buildings will be and if the characters should be in shadow."

In the camera-capture room, layout artists and others can see a rendered version of Venice canals and buildings on a wall-sized screen. Scattered about the room are props that people can pick up and use to control the camera view, the Penguins, the octopus henchmen, and the gondolas. It's like a sophisticated video game.

"We design the sets to a certain level and give the art keys to Conan," says art director Ruben Perez. "Then, it's a back-and-forth process. Conan might say, 'This building needs to be three stories high because of the action.' Then we redesign that part of the set."

Alternatively, the directors might want to see a different action. "Once we could see Venice, the directors decided to have the Penguins come out of the submarine tower rather than the sea," Low says.

When a director wants to know how fast to send the Penguins through the canal, the layout team has him hold a device that acts as a camera. A rolling chair controls an onscreen gondola. As the team pushes the chair at different speeds through the room, the director can walk or run alongside and "film" the scene as if he were in Venice watching the gondola slide through the canals.

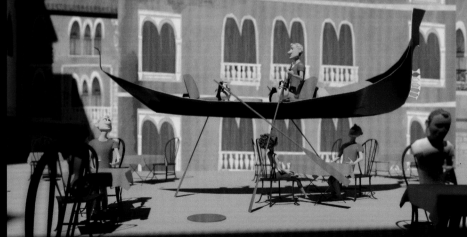

"Rather than just shooting storyboards, this filmmaking process is akin to live action, where you shoot coverage and then decide what the shots are," Low says. "And everyone can contribute: story artists, art directors, production designers, editorial, of course the directors. All the creative leads, anyone we think can have input into making the film—modeling, lighting, matte painting, effects—can come in, and together we figure out how to shoot the film. We can play with sequences. We have unlimited creative freedom."

Once the directors approve the previs, final layout artists divide the sequences into shots that the crew sends to all the production artists who create the film.

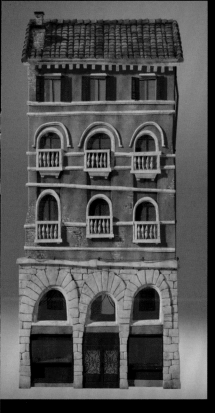
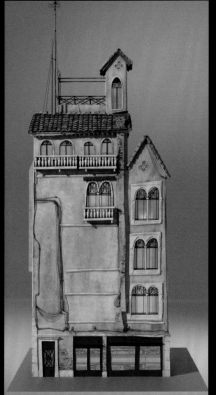
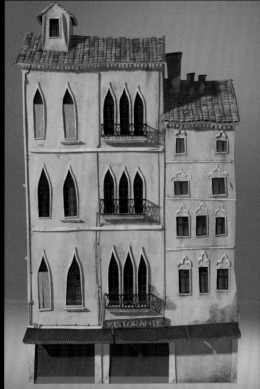
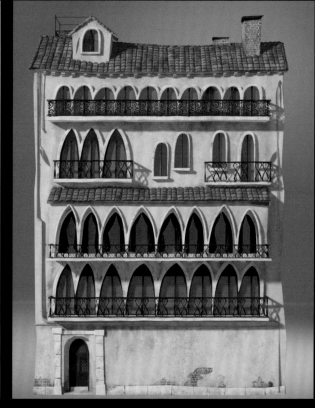

ABOVE >> NEHA GUPTA, PREMA PARAB & DHARATI RAMEKAR

TEXTURE PAINTING, SURFACING, AND LIGHTING

Once models are built, whether for Venetian palaces and gondolas, or soft-skinned and furry characters, surface and texture artists add details that bring them alive. For characters, they might paint surface details pixel by pixel. For hard surfaces, they often create textures from photographs.

Because light in a scene bounces on these surfaces, picks up color from the surface as it bounces, and sends that color on to another spot, lighting artists collaborate with surface artists to refine the look and feel of the characters and the scene. In addition, lighting artists typically reference real world photography.

"We work with the surfacing and art departments to decide which details to keep," says head of lighting Jonathan Harman. "The octopus we photographed for reference was pretty gross-looking. So we threw away a lot of the surface texture and detail."

By selecting and positioning lights and therefore shadows in a scene, the lighting artists create mood, direct the viewer's eye to story points,

heighten emotion, enhance colors, and amplify textures. Or perhaps hide a devious villain in a shadow.

"For Venice, we looked at photographic reference to see how light reflects off water, how much refraction you see in murky green Venice water, how much of a wall you'd see underwater, and so forth," Harman says. "We worked with layout to figure out the best way to cut the Venice sequence together for light and shadow."

Art director Ruben Perez helped lighting artists conquer a unique problem. "We had designed a set, but when we designed the lighting, we had to reconfigure it," he says. "If you have the light come from opposite directions in shot after shot, it feels like the characters travel backwards. So we designed the streets to be mostly parallel and always positioned the sun on the left side. Because we go from close-up to wide shots, it doesn't feel like a tunnel."

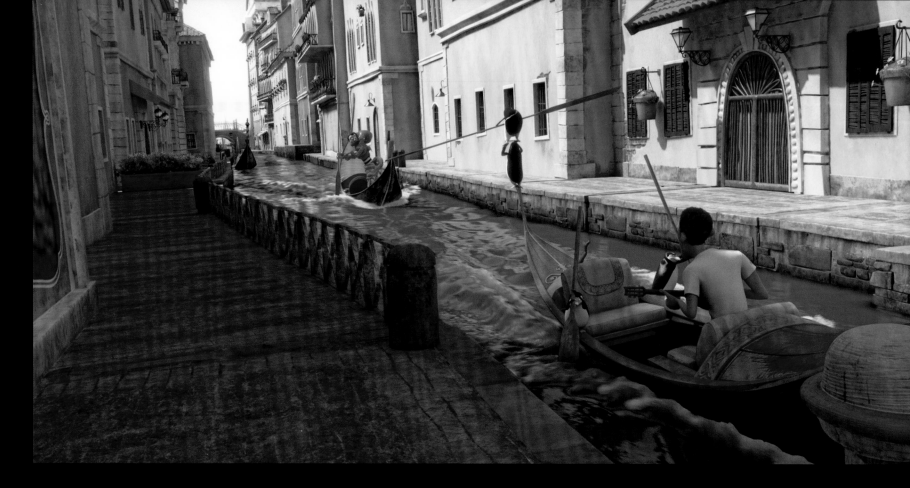

MATTE PAINTING, ENVIRONMENTAL EFFECTS, AND COMPOSITING
Background Paintings, Set Extensions, Simulation, and Composites

Artists in the matte painting, effects, and compositing departments provide much of the visual complexity typically seen in 3-D animated films. They add backgrounds that extend into infinity, bits of dust, insects, clouds, and water vapor in the air, natural phenomena such as water and fire, and movement in cloth and hair where you would expect it to be.

For Venice, matte painters created "set extensions," much as they would for a live-action film shot on a stage. "Previs blocked the shot and then Ruben [Perez, art director], Shannon [Jeffries, production designer] and I moved things around in layout for the best possible solution," says Pete Billington, matte painting supervisor. "We matched and added to the foreground set that had the surfaced and lit 3-D models of the submarine and the plaza. We painted the sky, Murano Island in the distance, and another island. The boats in the foreground are in water created by the effects department. We blended our painting into that, with reflections and distortions on our waves."

Originally, one of the main effects in the film would have been water. "Initially, the story called for many sequences involving water, so that was something we developed early," says visual effects supervisor Philippe Gluckman. "Eventually, there was less of that, but Venice is still a major sequence with water." The effects department also simulated the cloth in various awnings and umbrellas the Penguins bounce on and squirted octopus ink into one of the Penguins' eyes.

When the animation is final, the characters and all the backgrounds and effects are rendered, and the matte paintings painted, compositors layer everyone's work together into a final shot, tweaking and adding touches as they go. They create one image from the left-eye view and one from the right to create the final stereo film.

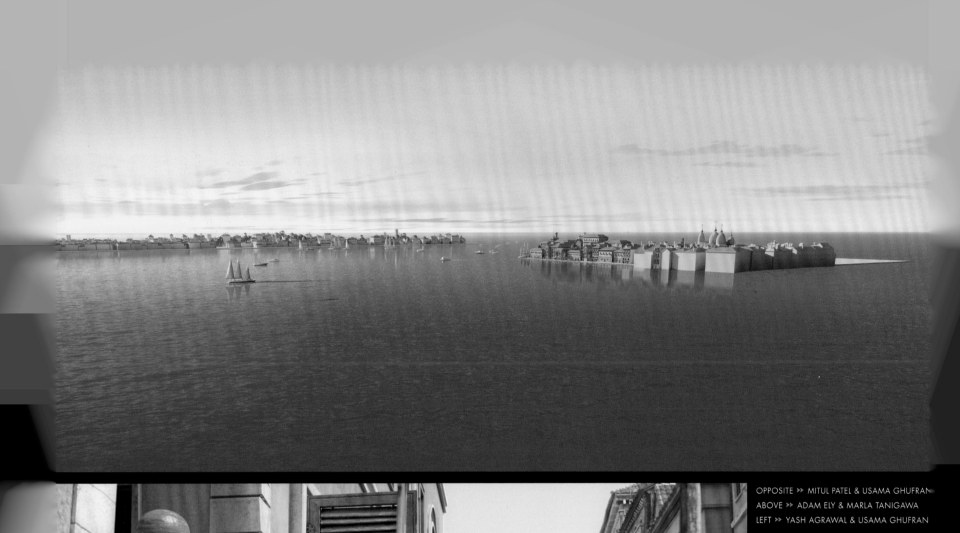

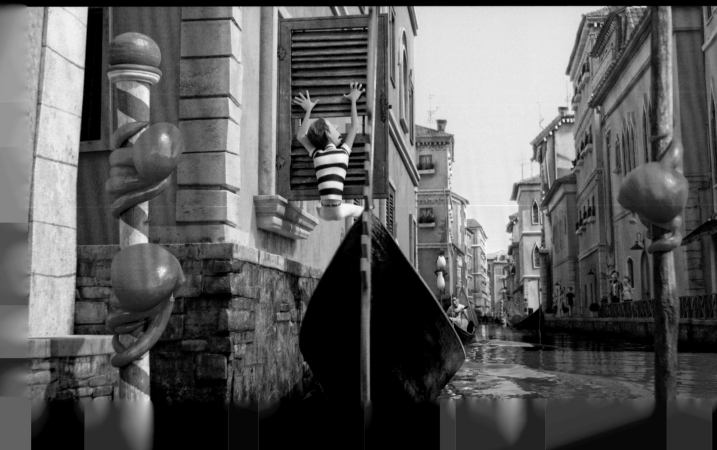

OPPOSITE >> MITUL PATEL & USAMA GHUFRAN
ABOVE >> ADAM ELY & MARLA TANIGAWA
LEFT >> YASH AGRAWAL & USAMA GHUFRAN

FREE FALL

We're in the high-tech North Wind head-quarters when an alert sounds. Dave has kidnapped penguins from the London Zoo. Skipper and his team are poised for action until . . . the North Wind agents shoot them with tranquilizer darts and ship them in a cargo plane to . . . Madagascar. And the colors shift from the cool cyans of the North Wind to the warm aquamarine blue and oranges of sequences controlled by the Penguins.

Art director Ruben Perez drew paintings that provided the basic designs. "We start in a box with all the lights off," Perez says, "but we see the Penguins' eyeballs. One of the Penguins cuts a hole, and we see that they're inside an airplane."

Skipper slams the cargo door release button with his flipper and *whoosh!* The Penguins and several boxes fly out. For the next four minutes, they're in free fall.

"This sequence started with four shots from the story-board artists," says Conan Low, head of layout. "But once the directors saw it, they wanted to make it more fun and create a big stereo moment."

The Penguins smash into the windshield of a jet, slide off, and crash through the roof of a passenger plane. They then ride a beverage cart through an emergency exit, grab a falling box, and fall with the box to the desert below while inflating a bounce house inside.

RIGHT >> RUBEN PEREZ

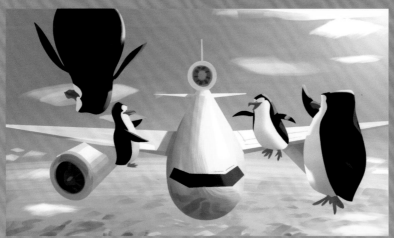

> ❝ *Designing what sand dunes look like from 10,000 feet in the Madagascar world is challenging because you're trying to distill it down to line and form, and the Madagascar films are so specific. We spent a lot of time finessing the sand dunes.* ❞
>
> **–PETE BILLINGTON**
> MATTE PAINTING SUPERVISOR

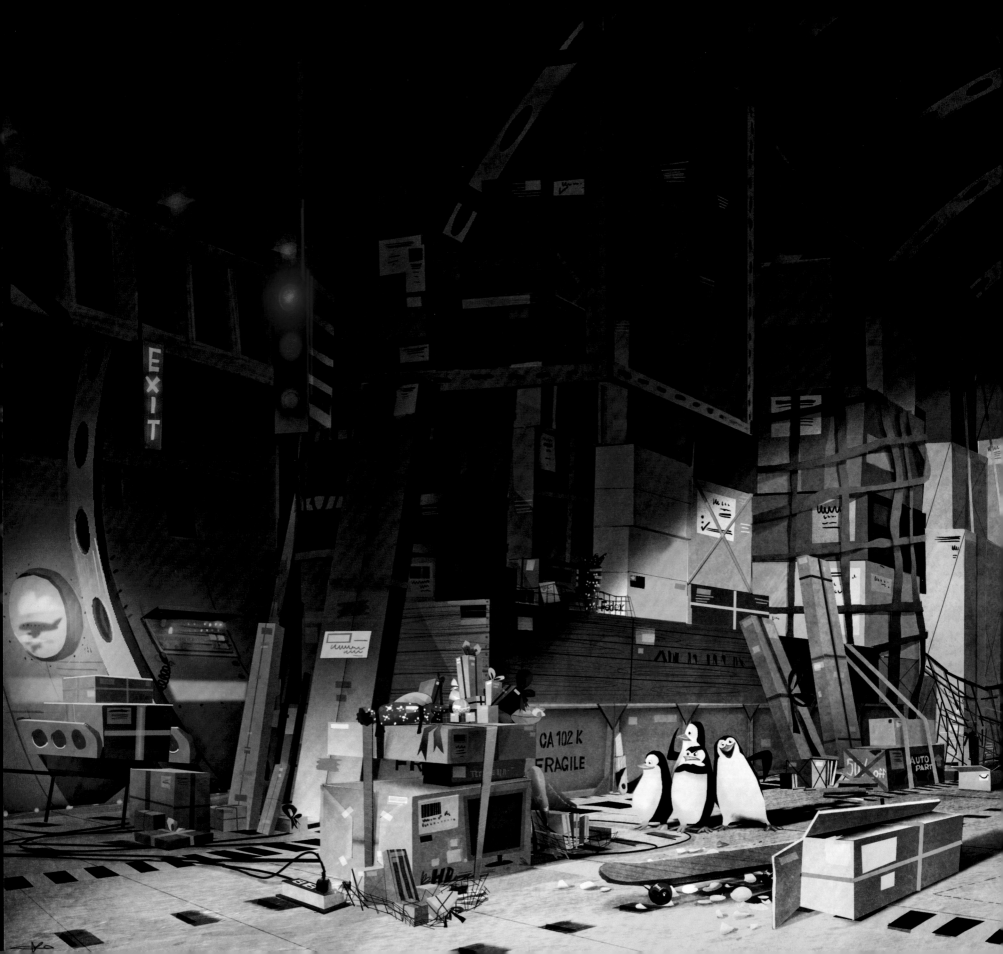

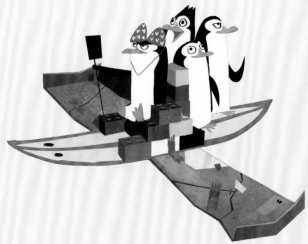

"We had to figure out how to have the camera stay with them on their great adventure all the way to the ground in what appears to be a continuous shot," Low says. "Like Alfred Hitchcock did in *Rope*, we hide cuts by having a box fly by or by wiping a frame with a door. We cut between shots, but it appears as if you're watching one camera move."

Paintings from Perez provided art keys for matte painters who created the world around the Penguins as they fall.

"They're tumbling in space, so we have to paint a spherical world with varying levels of fidelity and detail in the desert, sky, and clouds as they get closer to the ground," says matte painting supervisor Pete Billington. "One of the big rules in Madagascar is straight lines against curves, so you won't see straights or zigzags. You'll see a straight line, then a curve."

Perez also created the set design for the land surrounding the Penguins in their bounce house. "The ground was very difficult," he says. "We used windblown streaks to make the space feel bigger, and we had to draw the rhythm and consistency of the lines for the modelers. Every little rock had to have a drawing."

LEFT ≫ CHIN KO
TOP & RIGHT ≫ STEVIE LEWIS

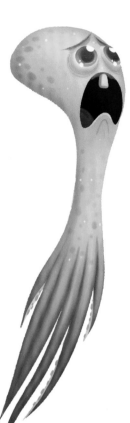

SHANGHAI

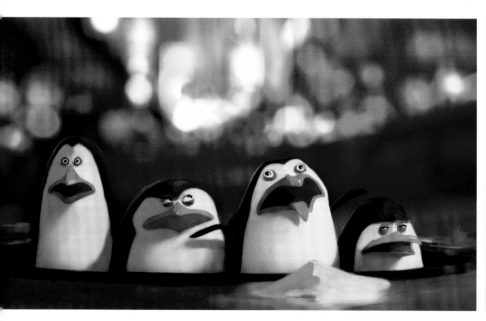

The sequence begins with the Penguins popping out of a manhole. They think they're in Dublin. But they're in Asia, as the colorful nighttime signs and the street life make obvious to the viewer.

"Shanghai is the height of drama. The Penguins have the upper hand and they're on a high, so there's color everywhere, on the streets, in the signage," says production designer Shannon Jeffries. That colorful complexity was an interesting challenge for the production team.

"The Penguins start doing an Irish dance," says visual effects supervisor Philippe Gluckman. "The problem is that the animation is great with intricate foot movement and distinctive arm positions, but the sequence is at night, so it's hard to see them. One thing that's true for all the Madagascar movies is that the black part of the Penguins is hard to make read. If you make it shiny, it looks like aluminum. If there's no shine, you don't see anything."

TOP LEFT & MIDDLE >> STEVIE LEWIS
ABOVE LEFT & RIGHT >> CARLOS FELIPE LEÓN

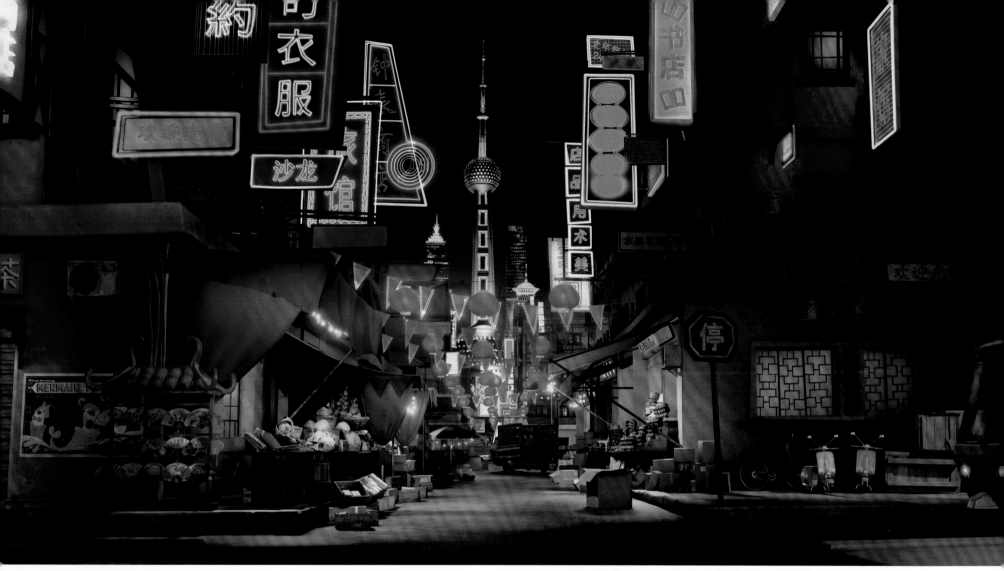

TOP >> RAJARAJAN RAMAKRISHNAN
ABOVE LEFT & RIGHT >> CARLOS FELIPE LEÓN

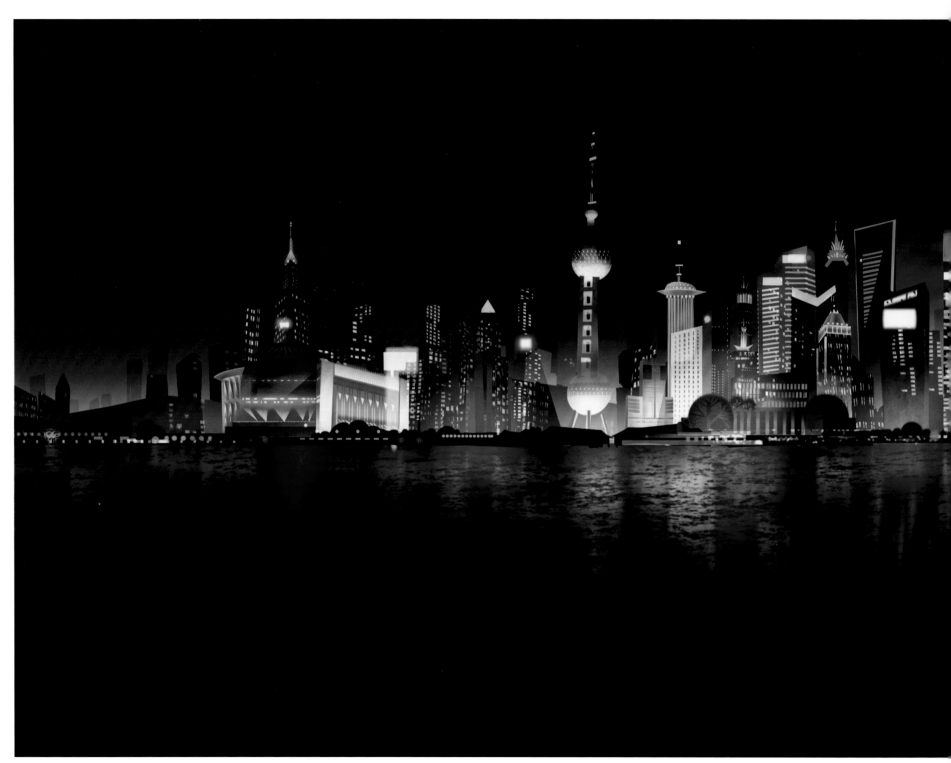

ABOVE >> KEN PAK

> *Beyond the first row of characters and the action in the center, it's a matte painting, a classic set extension. Ruben [Perez, art director] provided the art keys that showed how dark to make the sky. We bridged the foreground to our skyline in the back and painted the sky.*
>
> **—PETE BILLINGTON**
> MATTE PAINTING SUPERVISOR

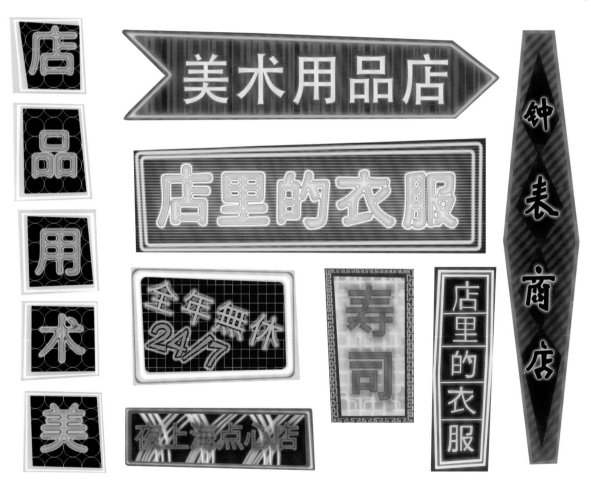

ABOVE >> AVNER GELLER

> ❝ *The Penguins go to a fish stall and pick up a little squid. The ice there was a challenge. We wanted it to look like shaved ice, not ice cubes.* ❞
> **—PHILIPPE GLUCKMAN**
> VISUAL EFFECTS SUPERVISOR

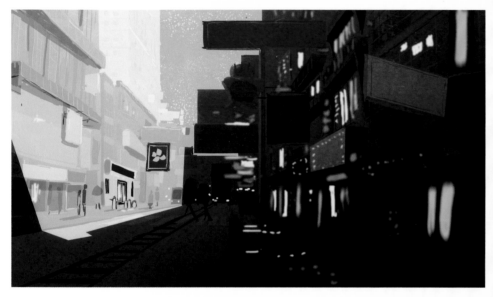

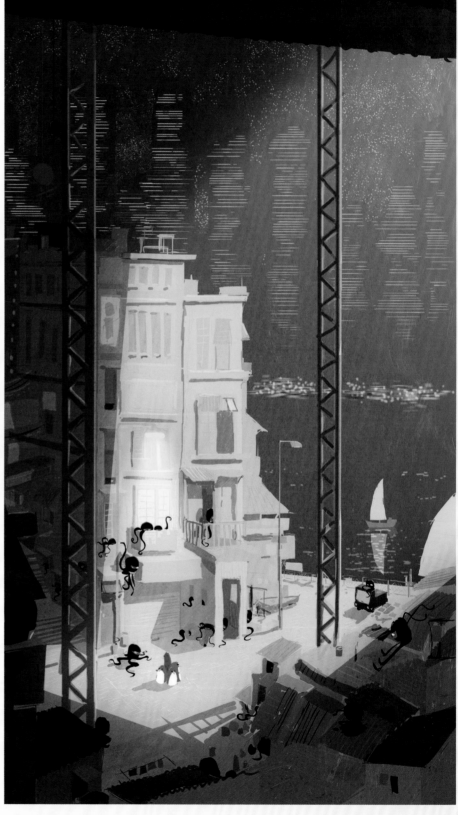

ABOVE & RIGHT ≫ PASCAL CAMPION
OPPOSITE ≫ ROBIN JOSEPH

Lighting artists helped solve the problem. "We try to define the black with rim lights or by catching the sheen in their fur," says head of lighting Jonathan Harman. "The trick is to separate the character from the background in a nice way without looking forced. Shanghai is crazy colorful, and there's a lot going on. There are crowds of characters walking in the background with our Penguins talking in front and shops with lots of items on shelves. We wanted to feature the characters and direct the eye of the viewer to their story but also have the viewers experience the complexity of the entire environment."

"Shannon wanted this sequence to be very colorful, so we shamelessly brought in colored lights," Gluckman says. "Some are justified by the scene, some are not. But they bring in that cheerful note and provide extra readability."

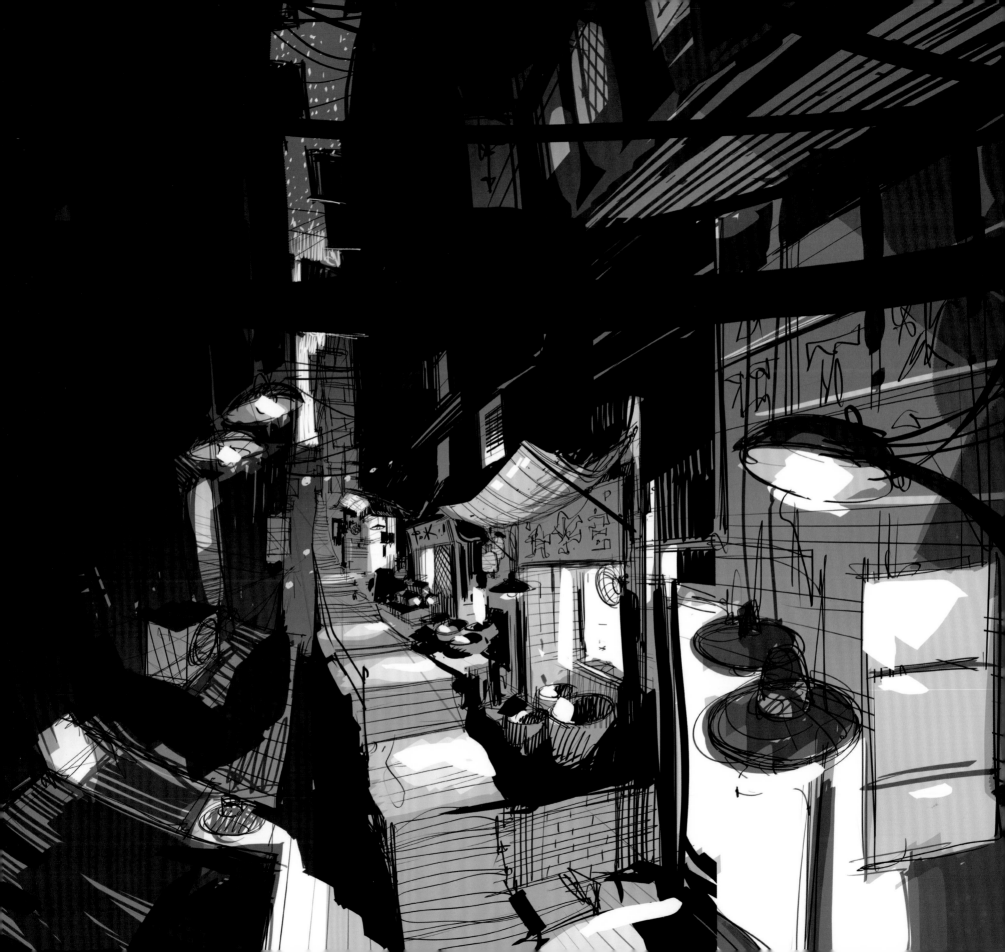

SNOW GLOBES

Dave uses snow globes to show locations where he will or has captured penguins.

"They are important in the movie," says Philippe Gluckman. "They come back several times, and they are hard to do."

Jonathan Harman explains, "The snow globes all have refractions, which is essentially when light gets bent. Glass has one refraction. When you have glass plus liquids, the light bends more. To have that work for one snow globe on a table is difficult, and we had twelve. You look through one through another through another, so the refractions add up."

To help reduce visual confusion, the artists changed the backgrounds behind the snow globes to eliminate distracting shapes.

"We tweaked the shots quite a bit," Gluckman says. "We wanted the viewer to feel the refractions, but we didn't want a house of mirrors. When we thought we were done, we looked at the snow globes in stereo, and the shot was horrendous. Jonathan [Harman] did some trick to make it work in stereo. All I can tell you is that it was a challenge."

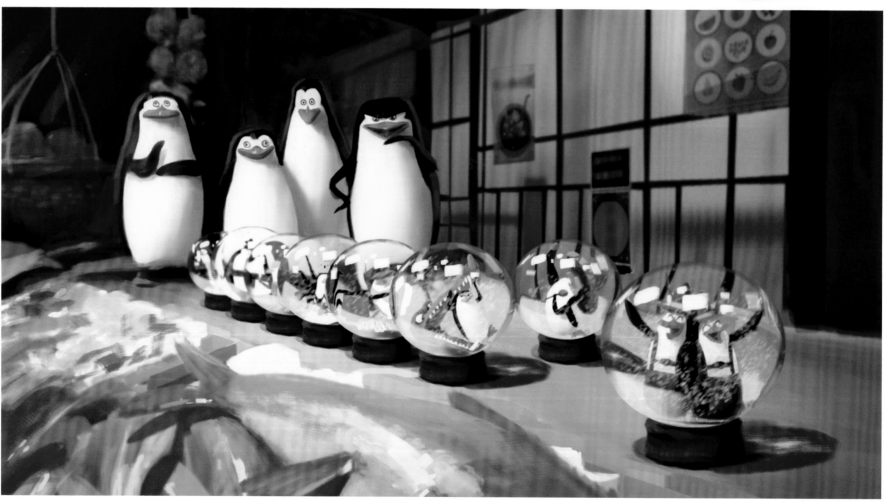

TOP RIGHT ›› STEVIE LEWIS

ABOVE ›› CARLOS FELIPE LEÓN

OPPOSITE ›› CARLOS FELIPE LEÓN & STEVIE LEWIS

GUADALAJARA

OAXACA

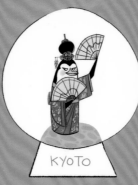

KYOTO

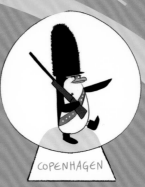

COPENHAGEN

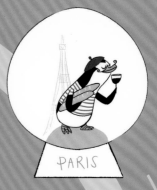

PARIS

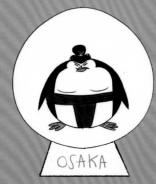

BALDY HUGHES

DUSSELDORF

BULAWAYO

BANGALORE

ZAGAZIG

OSAKA

CAIRO

ATHENS

ROME

MADRID

CARRICKMACROSS

LIMA

PERTH

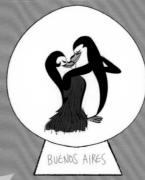

BUENOS AIRES

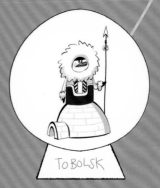

TOBOLSK

AQUARIUM

The aquarium is home to Shanghai's world famous Mermaid Penguins Show, and Dave wants to capture those oddly costumed performing penguins. But our Penguins save them and capture Dave—or do they? With the clever use of a decoy, Dave tricks the Penguins and the North Wind agents. He kidnaps the mermaid penguins. And Private!

"There are certain things about the James Bond movies that Simon likes," says Shannon Jeffries. "One thing is that there is always a competition, a game with high stakes. So, that's something we wanted to bring into this movie. For a while, there was going to be a Ping-Pong game. Now, in the aquarium in Shanghai, there will be a moment of competition, a chase."

At the end of the scene, the Penguins capture the North Wind's jet and take off after Dave's submarine.

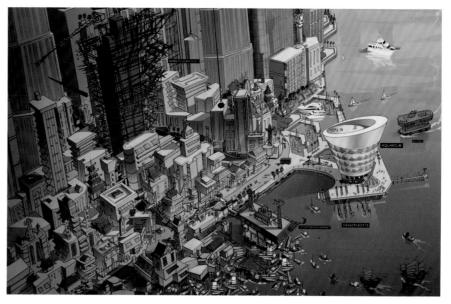

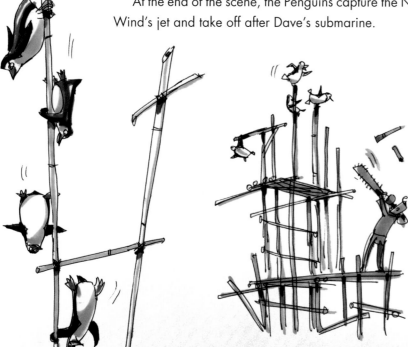

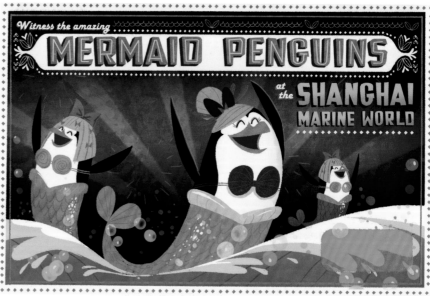

LEFT & TOP » JAMES WOOD WILSON OPPOSITE TOP » NIC HENDERSON
ABOVE » STEVIE LEWIS OPPOSITE BOTTOM » WIN ARAYAPHONG

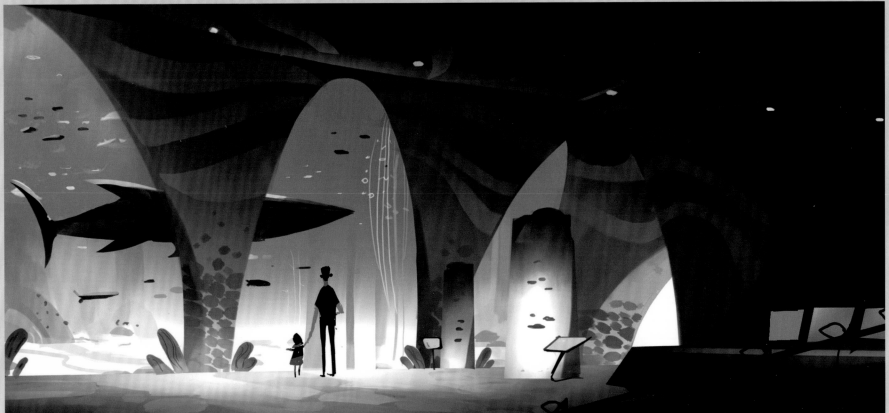

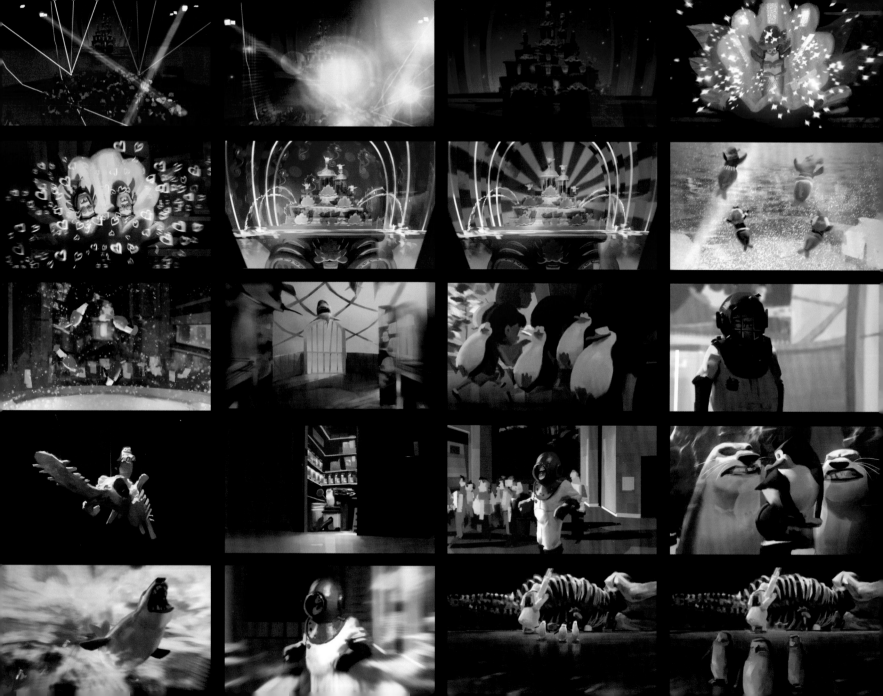

> *The aquarium scene was an opportunity to see the Penguins at their best as a capable crack team. Of course, they weren't expecting Dr. Brine to be one step ahead of them.*
>
> **—ERIC DARNELL**
> DIRECTOR

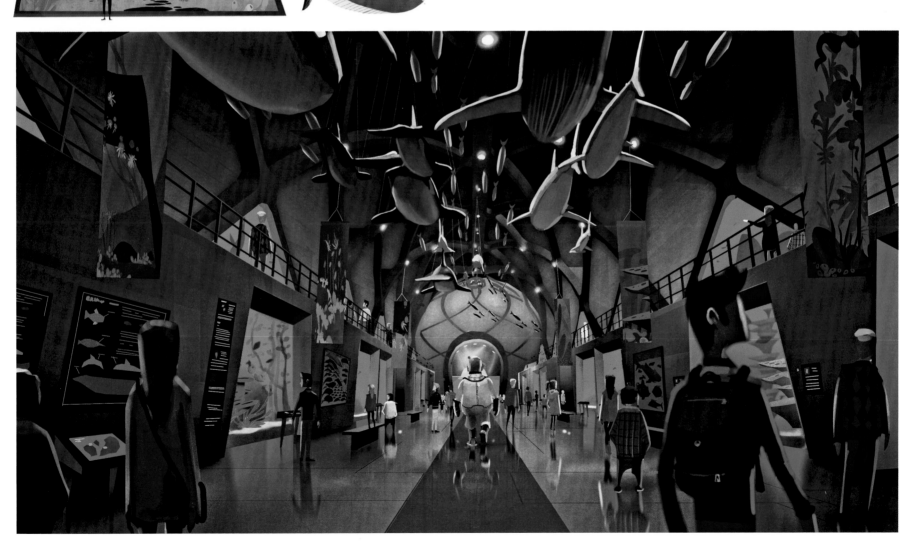

OPPOSITE ≫ CARLOS FELIPE LEÓN & FREDERIC STEWART

ABOVE ≫ GORO FUJITA

TOP (FISH) ≫ STEVIE LEWIS

TOP (AQUARIUMS) ≫ FLORIANE MARCHIX

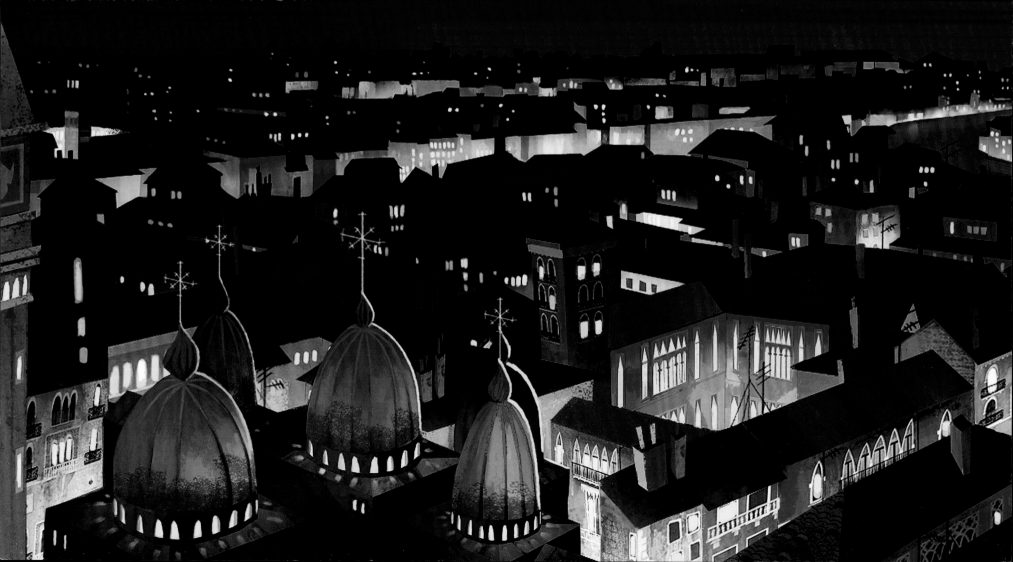

SPY MASTERS

NORTH WIND

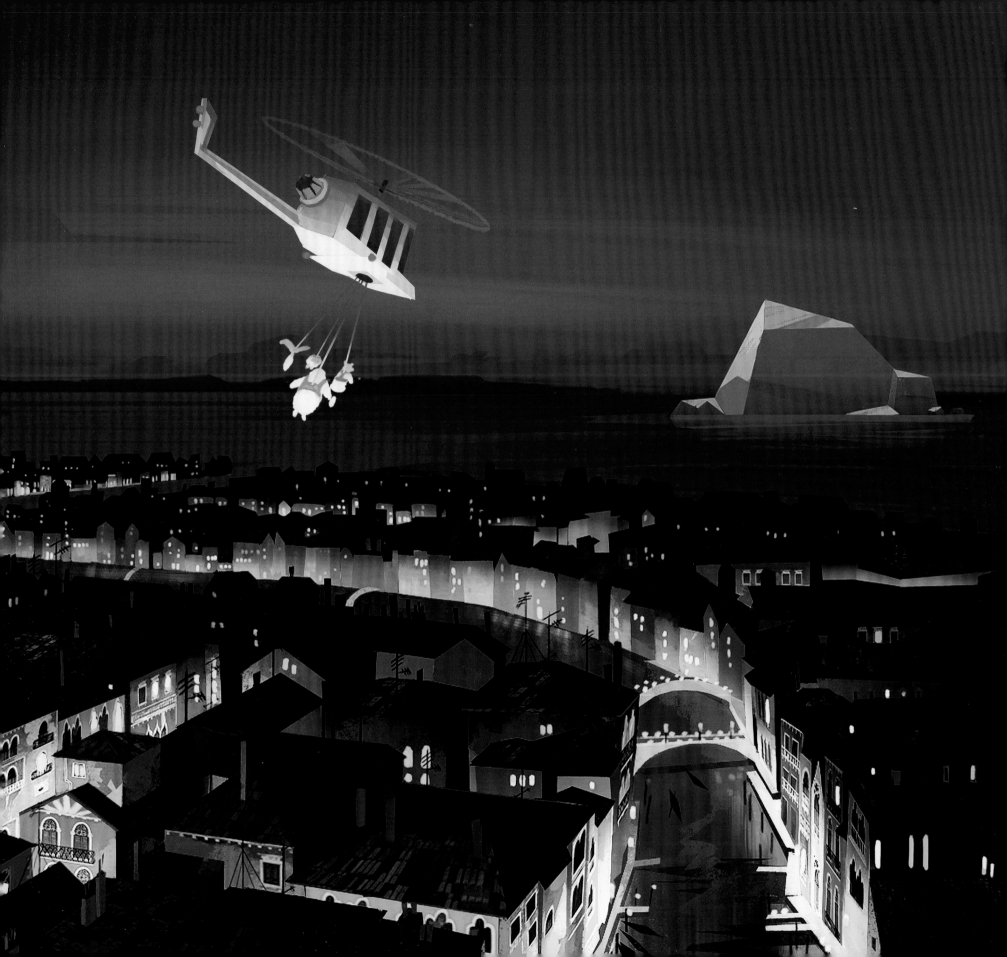

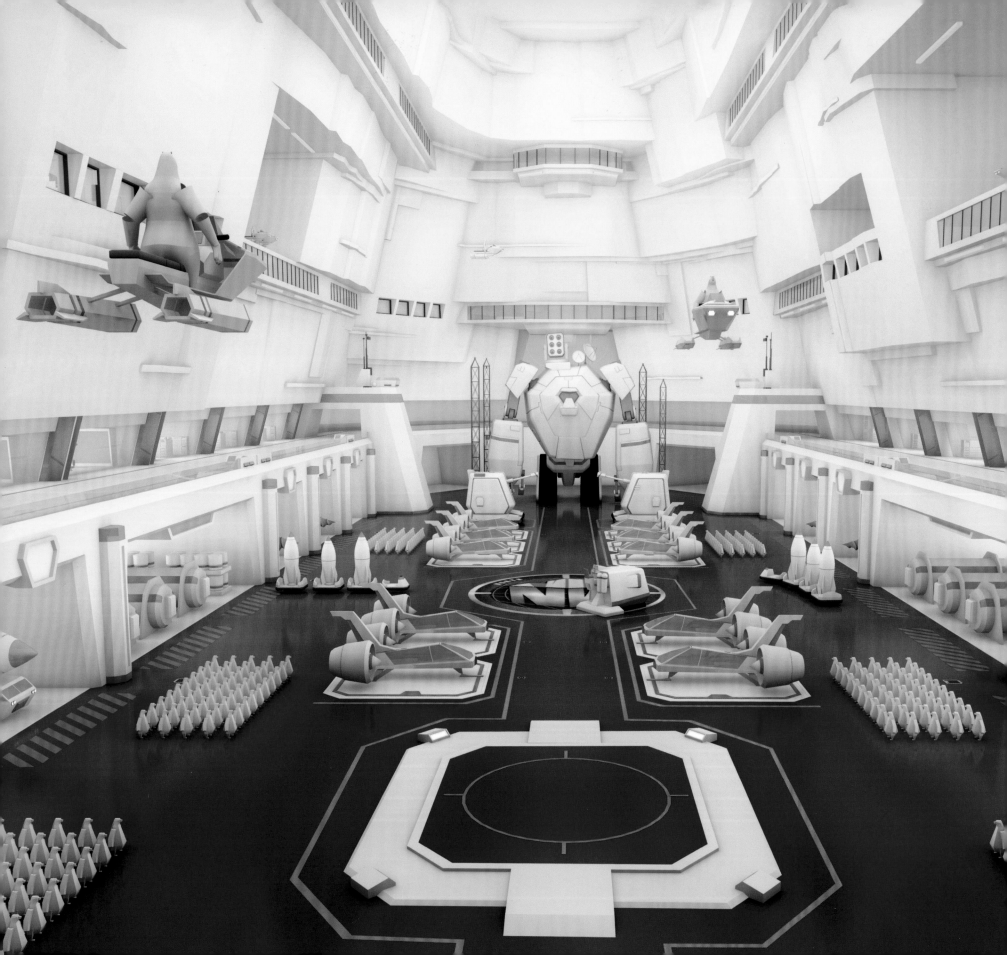

NORTH WIND

In stark contrast to the bumbling—yet surprisingly effective—Penguins, the North Wind agents are cool, sophisticated professionals who zip in and rescue our heroes from the octopi chasing them through the streets and canals of Venice.

"The North Wind started out as an animal-led spy agency that the human world knew nothing about," says producer Lara Breay. "They evolved slightly from that team of animals who protect the world and other animals from humans into an organization that protects helpless animals, whatever their plight."

The confident superspies have never failed a mission. "They are cool, calm, and collected planners," says director Simon J. Smith. "They have statistics, data, and gadgets."

The North Wind agents are the complete opposite of the Penguins. "While the Penguins have to figure everything out on their own, the North Wind is an elite spy force with technology, training, and education," says director Eric Darnell. "They have financial backing and incredible support. From their point of view, the Penguins are deluded if they think they can do better."

These arrogant, holier-than-thou characters are good counterweights to the Penguins, who tend to fly by the seat of their pants. Darnell adds, "Everyone likes to see the scrappy underdogs show up the highfaluting superior."

The art department mastered the spy-versus-spy similarities and the low-tech versus high-tech differences through color palettes and visual language. In the North

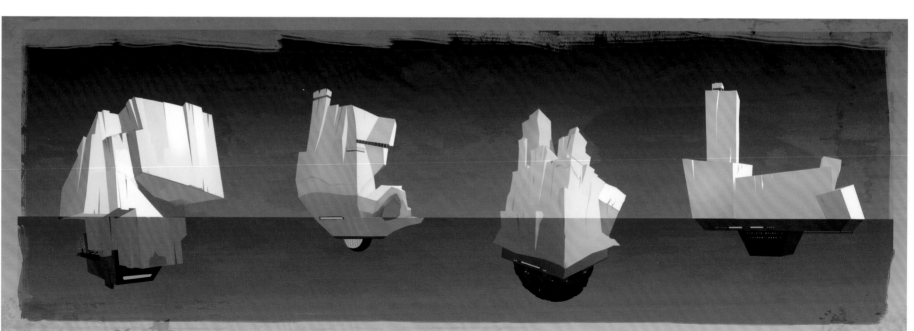

> *We toyed with having the Penguins join the North Wind as agents before we realized the great thing about the Penguins is that they already are an elite unit, the best of the best. They don't need to be part of anyone else's gang to be cool.*
>
> **—SIMON J. SMITH**
> DIRECTOR

Wind's world, the Penguins' blue becomes cyan, and the Penguins' open vistas come under tight control.

"The North Wind has the same palette as the Penguins, but it's an artificial palette," says production designer Shannon Jeffries. "The computer screen drives their palette, and, of course, the North Wind's world is confined. We see tight little hits of orange color artificially placed in the environment."

We meet the North Wind agents as they fly the stunned—but still cheeky—Penguins to their headquarters in a vertical take-off and landing (VTOL) aircraft, a sleek, modern jet unlike anything the Penguins have access to.

All four of the agents are Nordic animals, a choice that perfectly complements their super-cool attitudes. At the controls are Eva, a snowy owl; Corporal, a polar bear; and Short Fuse, a baby seal. They are led by an arctic wolf, who, not long after they meet, the Penguins dub "Agent

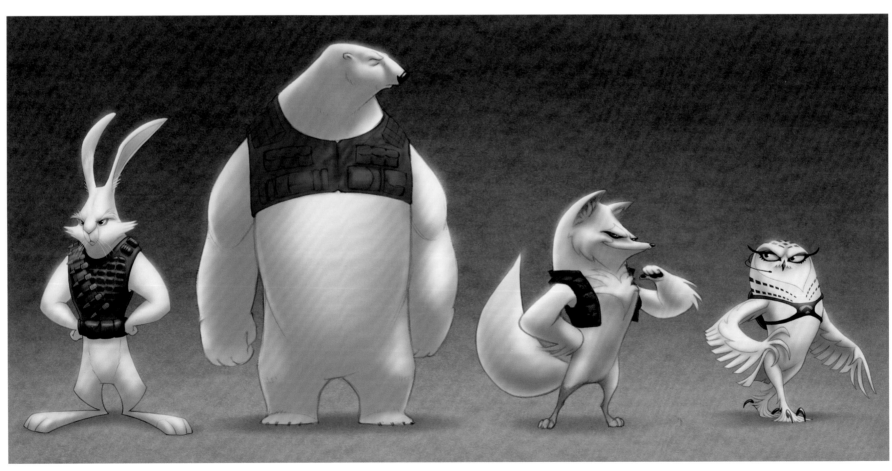

TOP » JOE MOSHIER
ABOVE » CHRIS AYERS

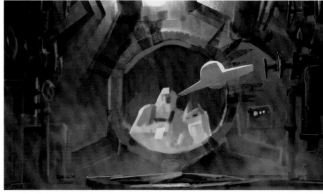
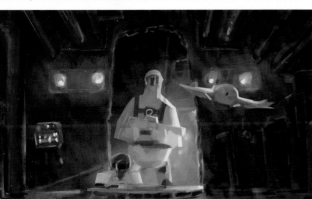
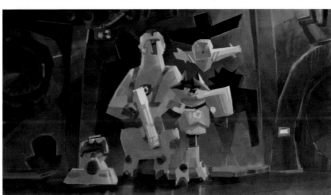
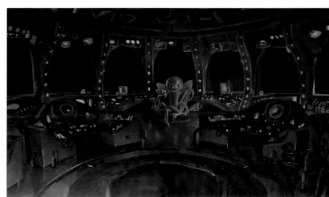

Classified." In the hilariously memorable scene, the wolf introduces the North Wind team as an "elite undercover interspecies task force dedicated to helping animals who can't help themselves—like penguins."

"And you are?" Skipper asks between mouthfuls of Cheezy Dibbles.

"My name is classified," answers the wolf starchily.

"Well, Agent Classified, we happen to be an elite unit, too," Skipper says.

Originally, the North Wind team was the star of a spy-versus-spy story. Once the movie shifted into the world of the Madagascar films and the story was edited to focus more on Dave, the North Wind team changed as well.

"Once we knew the movie was going to be a part of the Madagascar world, we had to revisit our designs," says Jeffries. "We only had to alter Short Fuse and Eva a little, but Corporal and Agent Classified didn't fit at all anymore."

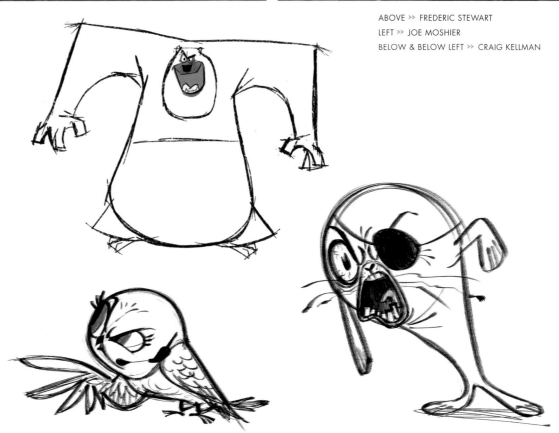

ABOVE ›› FREDERIC STEWART
LEFT ›› JOE MOSHIER
BELOW & BELOW LEFT ›› CRAIG KELLMAN

CLASSIFIED

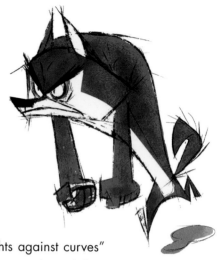

Once a fox and even for a short time a beagle, the stoic arctic wolf spy was conceived in his early incarnations by character designer Craig Kellman.

"Classified was originally a stuffier, more uptight character than he is now," Shannon Jeffries recalls. "He changed by degrees. But Simon [Smith, director] always wanted a compact character with lots of attitude who is very confident."

When the North Wind characters joined the world of Madagascar, Classified's design had to evolve to fit the established "straights against curves" aesthetic of those films. "It isn't always straight and then curve," Jeffries says. "We mix it up. Classified has a strong curve, a straight, curve, straight, straight, curve. It's a clean retro style for character design."

Although Agent Classified can walk on all fours, the character stands upright for the most part. "It helps to have him above the Penguins," says head of character animation Olivier Staphylas. "In his mind, they are very small—both literally and figuratively."

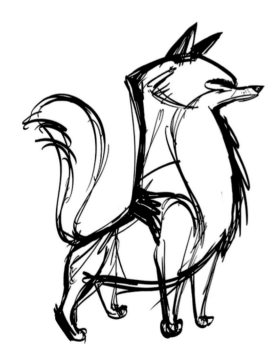

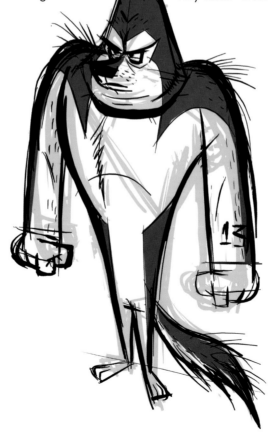

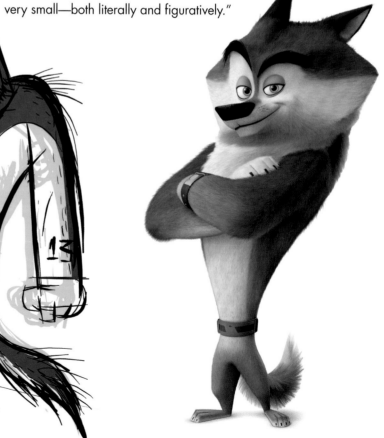

TOP & CENTER » JOE MOSHIER
ABOVE » CRAIG KELLMAN
OPPOSITE » CRAIG KELLMAN & STEVIE LEWIS

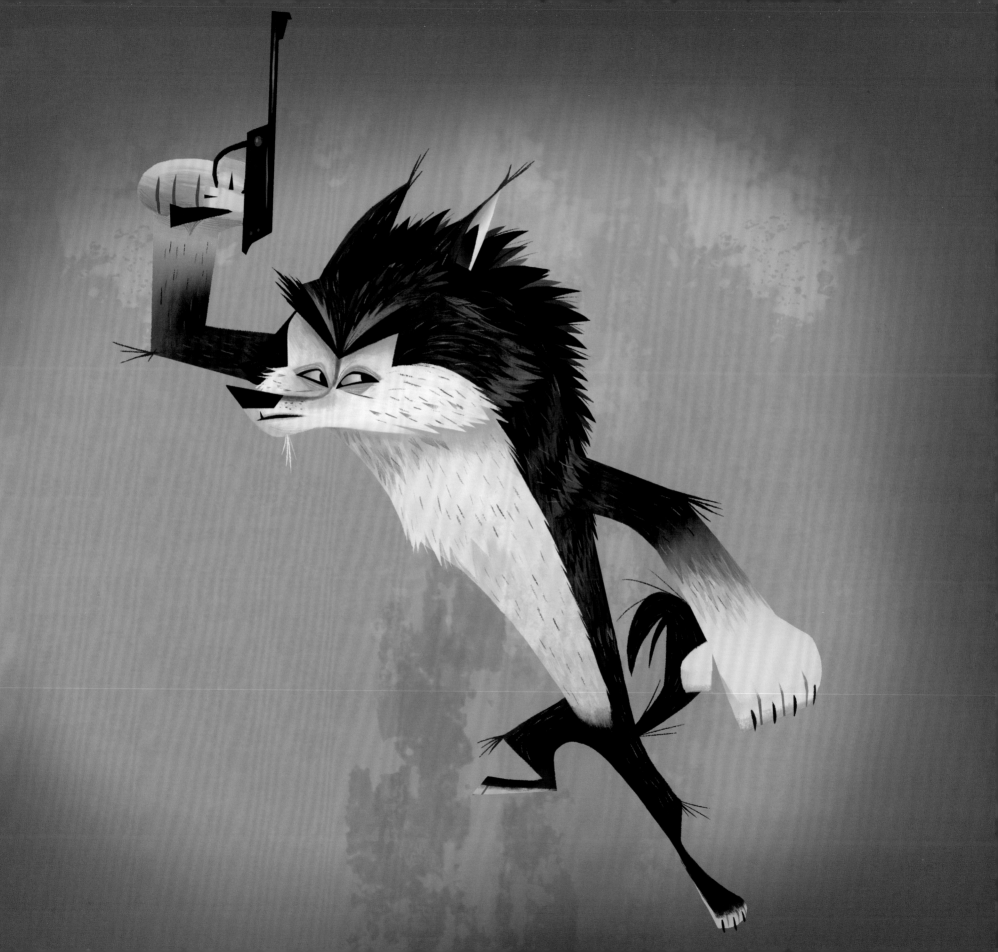

> 66 *Classified is a character who's always in control, so it was important that his fur was impeccably well-groomed.* 99
> **—SHANNON JEFFRIES**
> PRODUCTION DESIGNER

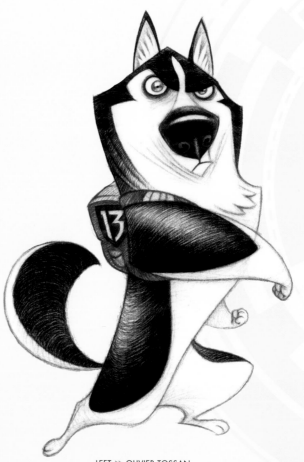

LEFT >> OLIVIER TOSSAN
TOP >> JOE MOSHIER
ABOVE >> CHRIS AYERS

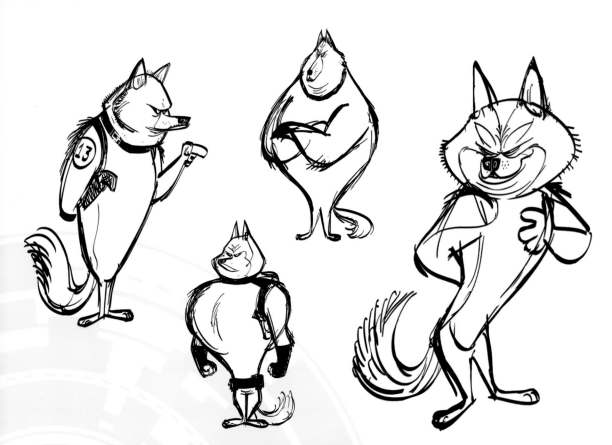

Classified's arrogance provided unique challenges for the animation team. "We have a very proud and cocky character," Staphylas says. "He's a jerk to the Penguins and a jerk from the audience's point of view. But we had to find a way to make him relatable."

Surprisingly, the animation team looked at the protagonist of the Madagascar films, Alex the lion, for reference. "Classified's body is similar to Alex's," Staphylas says, "but we toned down Alex's broad range to make Classified match Benedict Cumberbatch's voice better and to make him more contained. He moves only when it matters."

LEFT & RIGHT >> CRAIG KELLMAN
BELOW LEFT >> AVNER GELLER
BELOW RIGHT >> STEVIE LEWIS

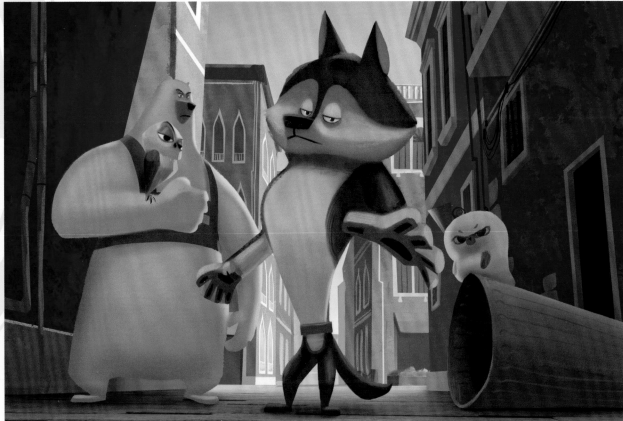

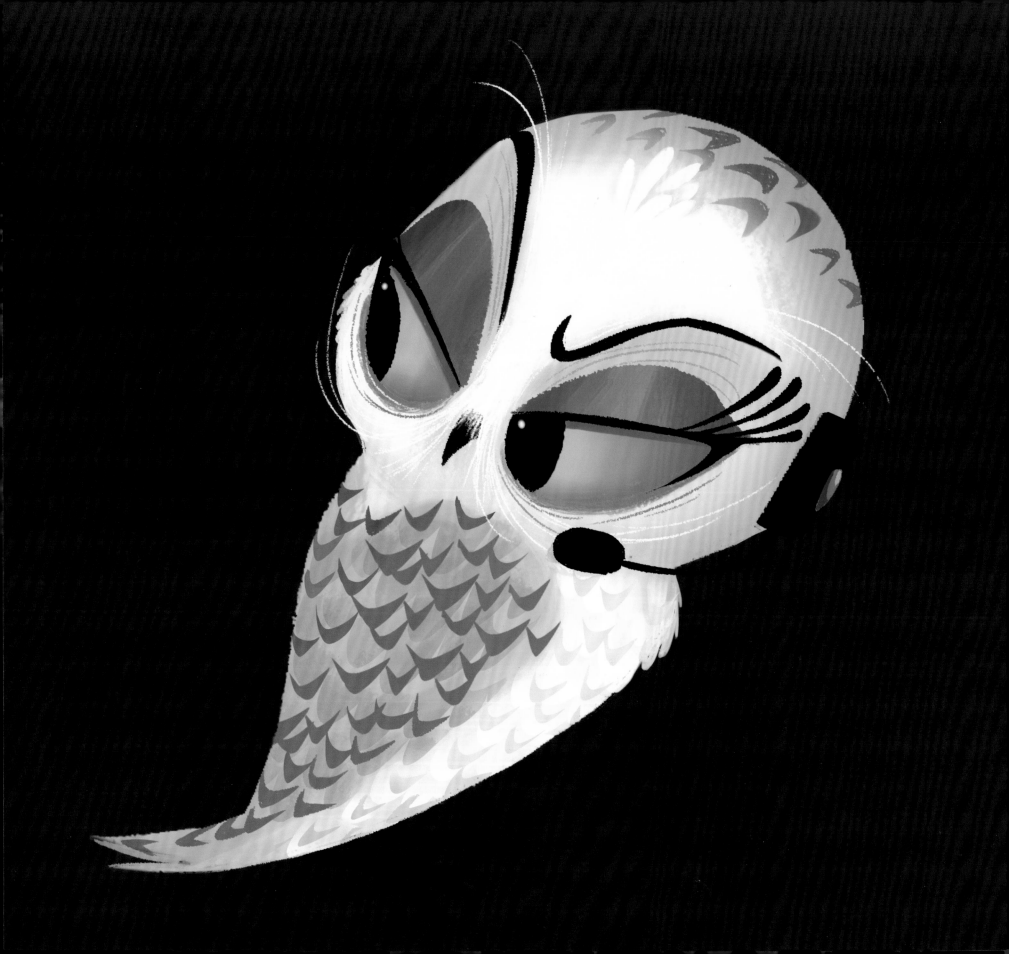

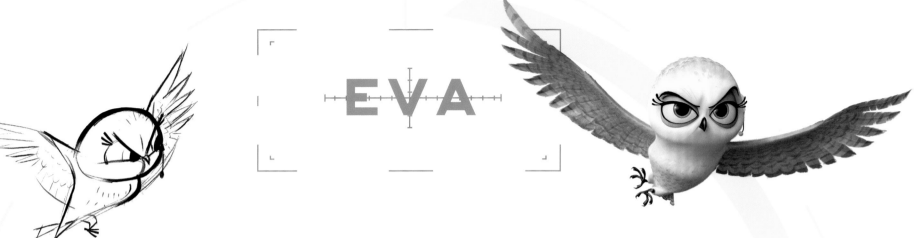

EVA

An elegant, white snowy owl, Eva is cold, beautiful, and visually stunning. "She's very reserved," says Olivier Staphylas. "We tried to make sure her performance was all about her eyes, which are huge. And she has that distant demeanor, as if she's too good for you." Like Classified, Eva needed to exude a certain haughtiness. Staphylas explains, "The feeling you get when you look at Eva and Classified should be that you don't belong in their social circle. We tried to project a superior body language from them."

Like the other North Wind characters, Eva was a challenge to light, due to the white color of her feathers. "We always have to put a tone on white-colored characters," says Shannon Jeffries. "Classified is a little cooler, Corporal a little warmer, Short Fuse a bit brown, and Eva slightly redder in her white."

Eva is a serious character who is all business—that is, until Kowalski falls in love with her and is not at all subtle about his affections. Then, the aloof owl turns slightly pink.

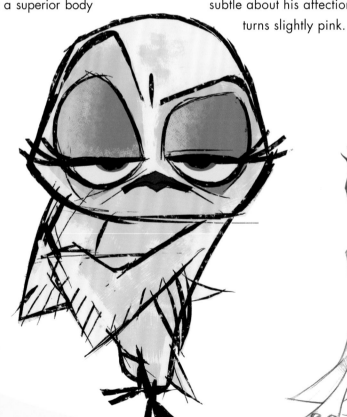

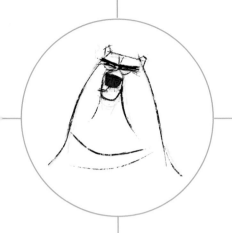

CORPORAL

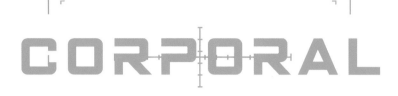

The polar bear is the muscle of the North Wind team. At the same time, he's the one with a soft side. Upon meeting the Penguins, he gathers the cute characters in his arms and tries to cuddle them, to their dismay. "The joke is that although he has the power of a muscle guy, he has the mind of a kid," says Olivier Staphylas.

"Corporal's design probably came the closest to an S-curve," says Shannon Jeffries. "But we still have straights and curves rather than a continuous shape."

Corporal's heft meant that animators needed to balance weight and snappiness. "We looked to Vitaly and Alex from *Madagascar 3* for inspiration on how to animate big characters in a snappy universe," says Staphylas. "But we toned down some of the snappy animation to ground him and make him seem seven feet tall."

TOP LEFT & RIGHT >> JOE MOSHIER

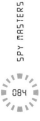

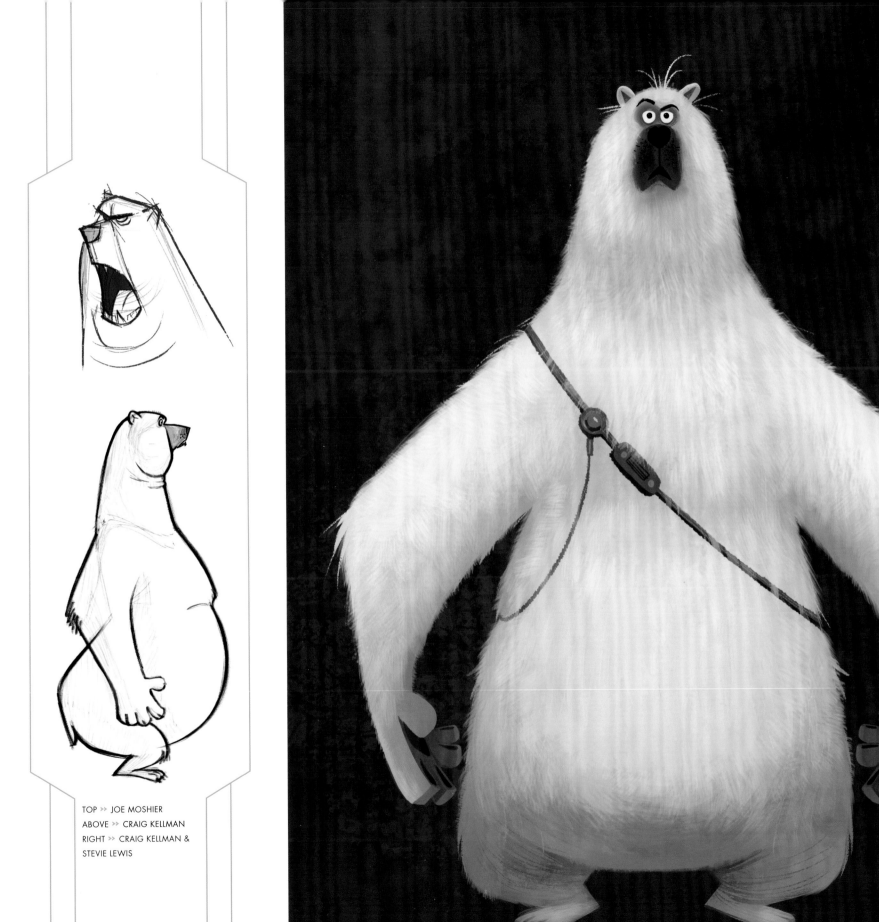

TOP >> JOE MOSHIER
ABOVE >> CRAIG KELLMAN
RIGHT >> CRAIG KELLMAN &
STEVIE LEWIS

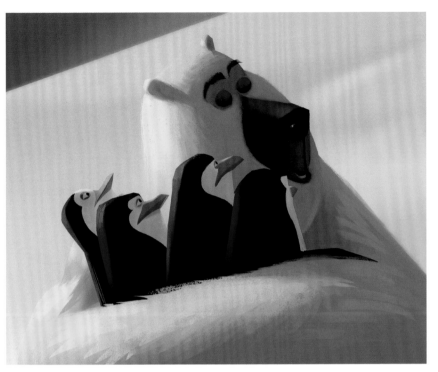

> **"** *He's soft and bear-like, and when we move him, his huge belly takes a bit of time to settle.* **"**
>
> **—OLIVIER STAPHYLAS**
> HEAD OF CHARACTER ANIMATION

OPPOSITE >> OLIVIER TOSSAN TOP RIGHT >> AVNER GELLER

TOP LEFT >> STEVIE LEWIS ABOVE >> GRISELDA SASTRAWINATA

SHORT FUSE

Although Short Fuse appears to be the cutest, fluffiest character ever, he is actually an explosion expert with a foul mouth and bad temper.

"Short Fuse is a scrappy little guy and a sycophant when it comes to his relationship with Classified," Eric Darnell says. "He's a fun character."

"He's a forty-year-old baby seal," adds Shannon Jeffries. "He's contrary. We nailed his design right away."

But once he made it to the animation stage, Short Fuse's design changed slightly. "Because he's a seal, he's supposed to lie on his belly," says Olivier Staphylas. "But that put him too low in frame, so we have him on his tail. With his waist and chest upright, you can see his face. That brought him into our world."

Much of Short Fuse's adorable appearance is achieved through surfacing and lighting techniques. Head of lighting Jonathan Harman explains: "Each North Wind character had its own lighting rig, and Short Fuse has a slightly different treatment in surface and lighting that puts softer shadows inside his fur. It makes him feel more plush than Corporal and Agent Classified."

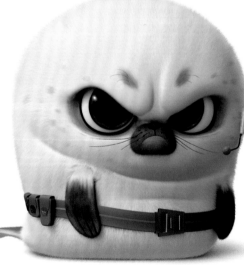

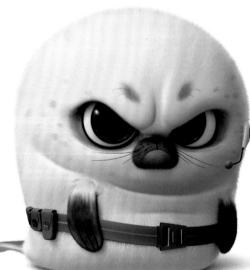

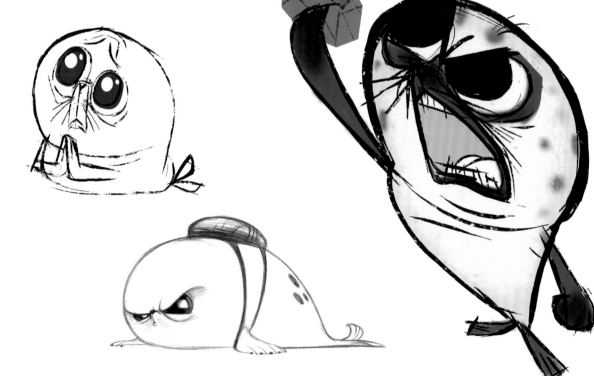

TOP LEFT >> AVNER GELLER
TOP RIGHT >> CRAIG KELLMAN
CENTER & FAR RIGHT >> JOE MOSHIER
RIGHT >> CHRIS AYERS
OPPOSITE >> CRAIG KELLMAN & STEVIE LEWIS

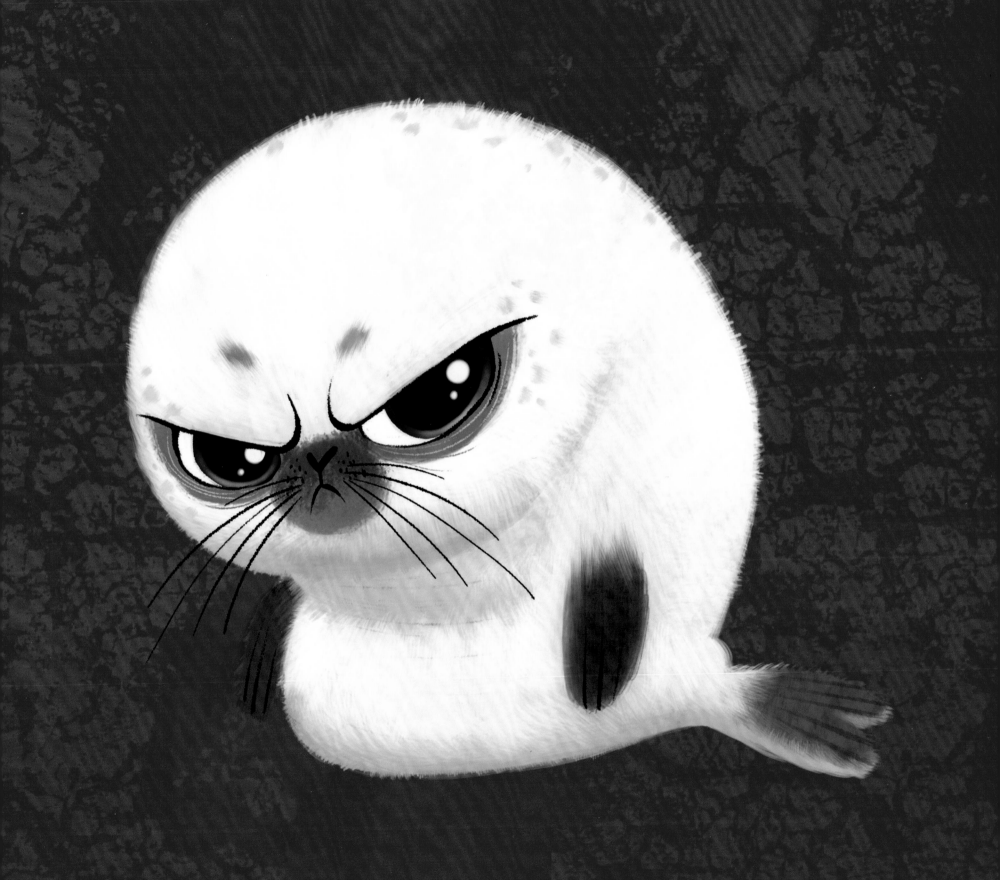

"We tried millions of stories," says Simon J. Smith. "In one, leopard seals were the main villains. In another, we had a brilliant sequence where the villain octopus pulls a red herring out of a canister in Venice. Then, a henchman octopus rips himself open, and we see he's actually a beaver. We had starfish. We had the Penguins' mother as the head of the North Wind."

The North Wind team in particular was in flux. In an early iteration of the story, the spy agency's stern director was a puffin. At a later stage, the puffin was replaced by a walrus, who was to make a brief appearance to chastise the North Wind team for failing to defeat Dave quickly.

"Simon really loved the walrus," says Shannon Jeffries. "In fact, it was an early character design drawing with two walruses that inspired the North Wind headquarters."

Joining the North Wind characters that ended up on the cutting room floor are spy pigeons that were stationed at street corners and a scene with the North Wind agents involving a Columbian chinchilla revolution.

"These stories always take a long journey," says Eric Darnell. "You don't come up with a story at the beginning that's all cut and dried."

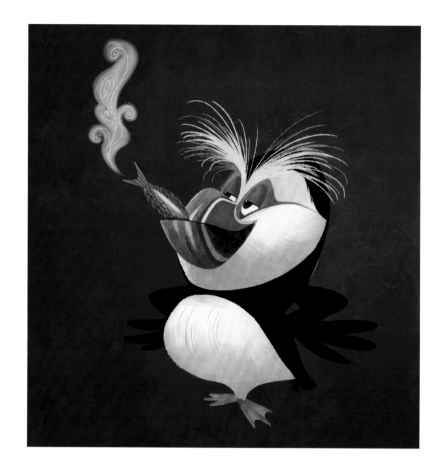

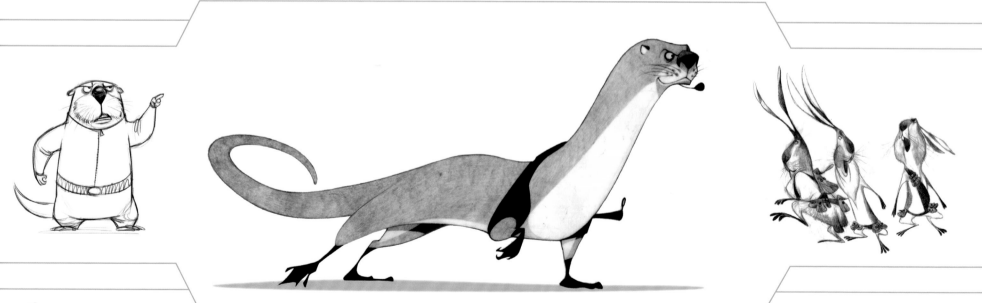

TOP RIGHT >> STEVIE LEWIS
ABOVE LEFT >> CHRIS AYERS
ABOVE CENTER >> OLIVIER TOSSAN
ABOVE RIGHT >> ROBIN JOSEPH

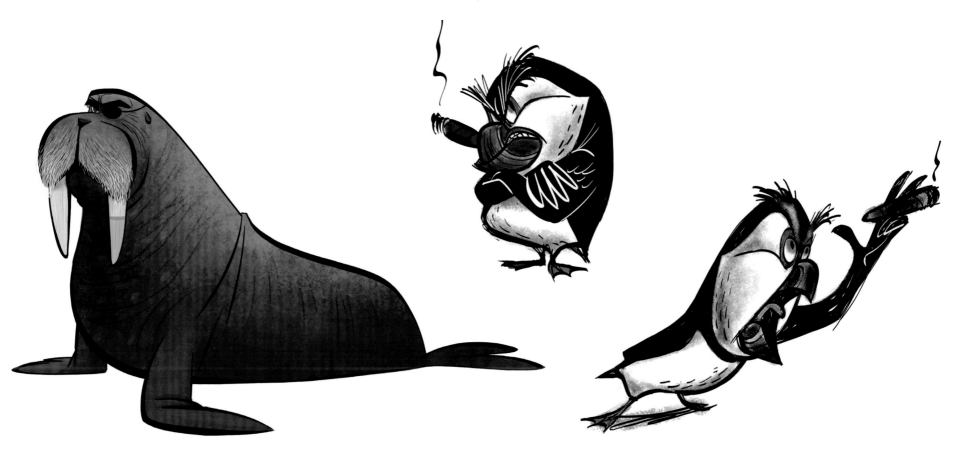

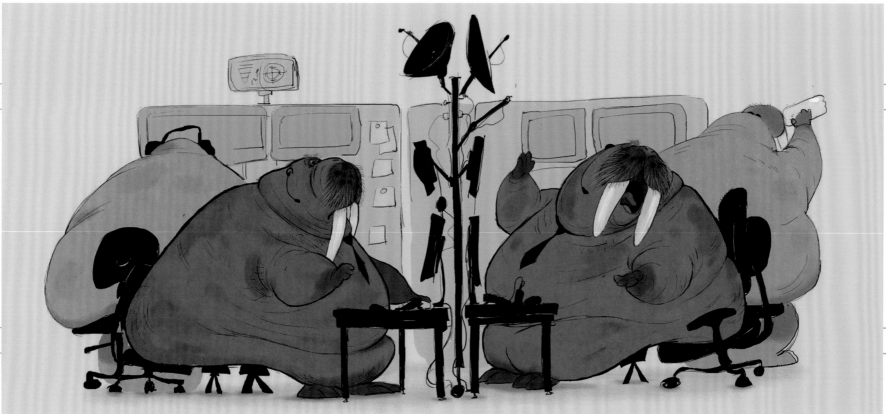

TOP LEFT >> STEVIE LEWIS
TOP CENTER & RIGHT >> CRAIG KELLMAN
ABOVE >> JEREMIE MOREAU

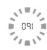

TOP LEFT >> CHRIS AYERS
LEFT >> CHIN KO
ABOVE >> GRISELDA SASTRAWINATA
RIGHT >> GORO FUJITA
OPPOSITE >> WIN ARAYAPHONG

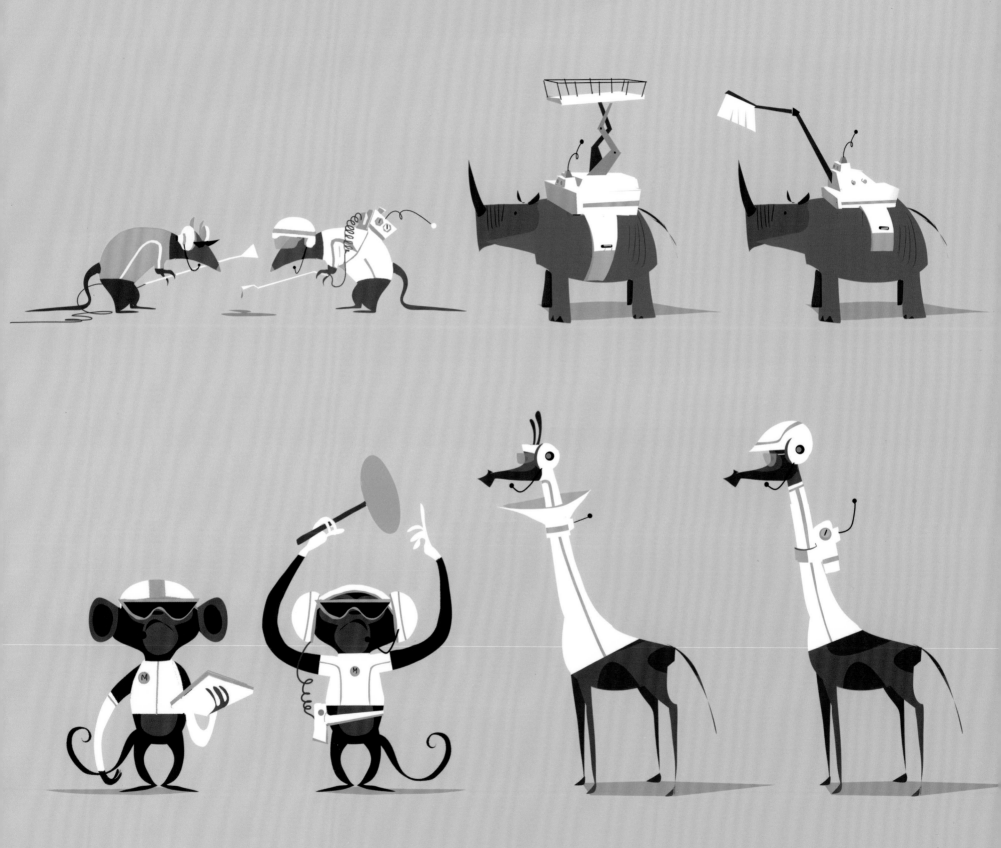

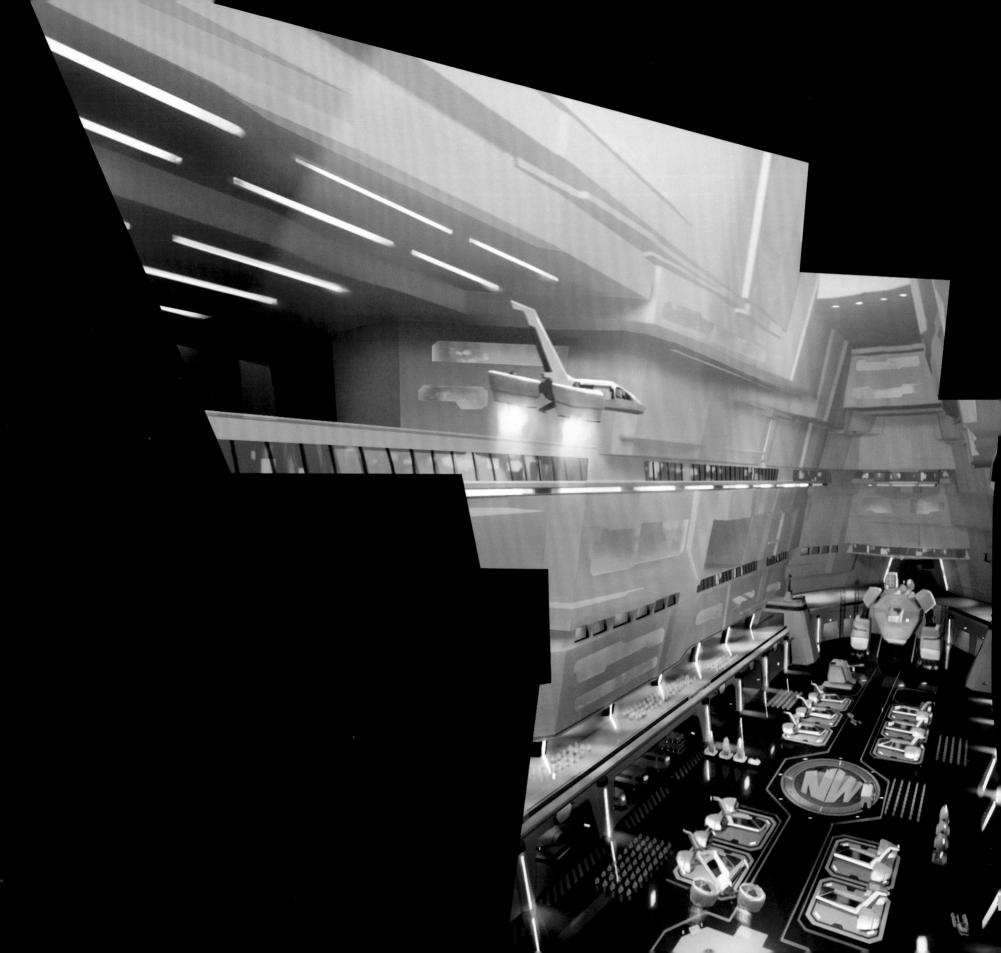

NORTH WIND HQ

In keeping with the attitudes of the North Wind characters, their headquarters are cool and sleek—and housed in an iceberg. "We went with a modern, clean, deliberate design style," says art director Ruben Perez. "In the North Wind world, the white parts of the Penguins' bodies become a very cool white, almost a cool gray."

Agent Classified sets the dramatic tone by aiming the VTOL jet they're flying directly at the impressive iceberg inside which the headquarters are located.

"We think they will crash into the iceberg, but suddenly the door opens, a hit of cyan breaks out of the hole, and we're in the North Wind world," says Shannon Jeffries. "For this world, we introduce more angles and more dramatic height to things. And it's a more organized world."

The jet flies through the cyan opening onto the iceberg's landing pad and stops inside a massive high-tech fortress housing several VTOLs and filled with agents scurrying about. The entire environment is a matte painting created by artists working with high-fidelity art keys created in the art department.

"It's a vast interior made of snow and ice," says matte painting supervisor Pete Billington. "As the jet comes in, you see an enormous factory floor with all these ships, sky bridges, offices with moving screens, silhouettes of troops walking along, and windows in the iceberg. It's the most ambitious project the matte painting department has ever worked on. We created it with five paintings that we projected onto models created in the art department and blended together."

OPPOSITE >> CARLOS FELIPE LEÓN
ABOVE >> RUBEN PEREZ

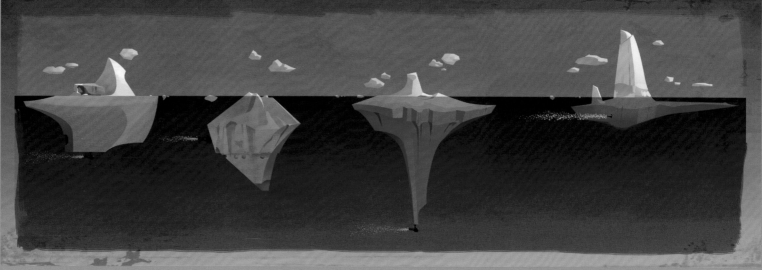

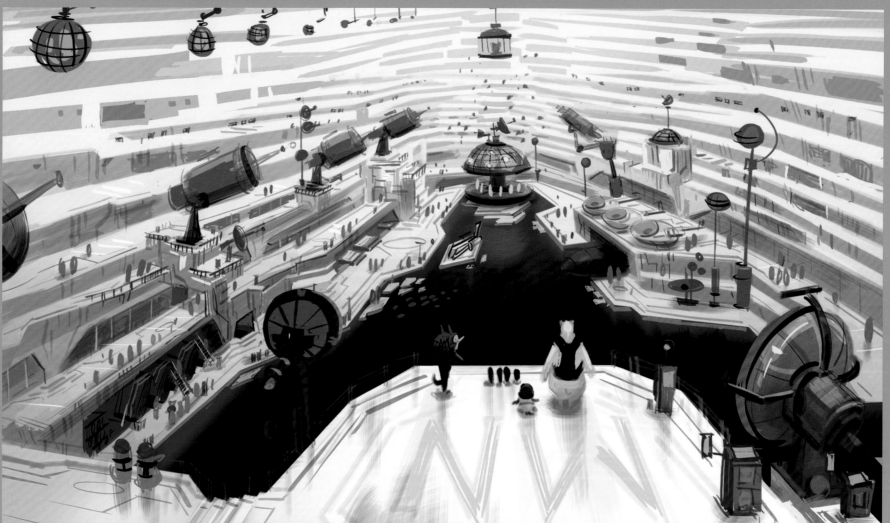

TOP ≫ GORO FUJITA

ABOVE ≫ RUBEN PEREZ

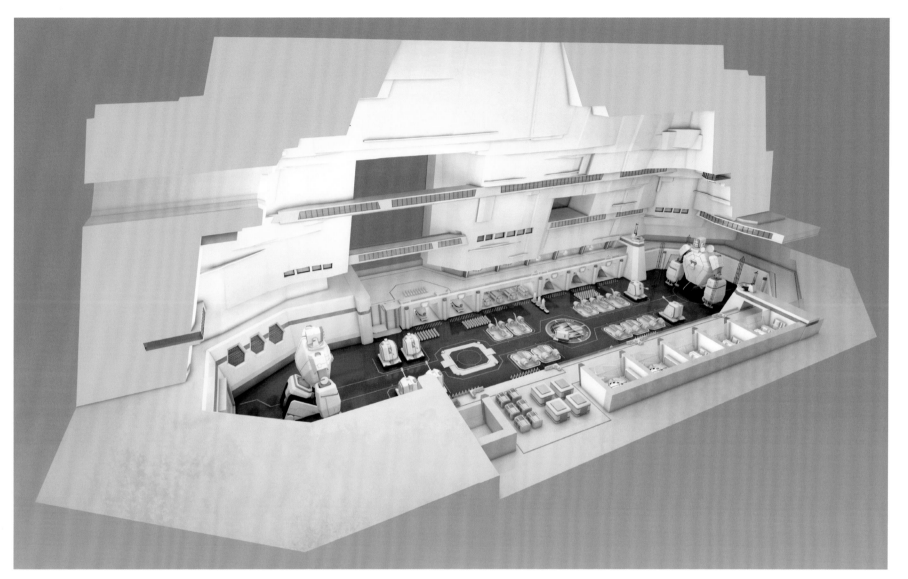

TOP >> DAVID HUANG
ABOVE >> RUBEN PEREZ

The next scene puts the Penguins and the North Wind team in an evidence room, the only space the Penguins will visit inside the elite team's secret headquarters. "Instead of sticky notes on their evidence wall, the North Wind headquarters uses high-tech displays," Jeffries says. "They are all about technology."

But the evidence room's clean white walls posed a design problem: "We have white characters in a white environment," Jeffries points out. "So, how do you make them pop?"

The solution lay in adjusting the environment to make them stand out. "Most of the characters are pretty small, so we darkened the ground to make them stand out," Jeffries says. "Also, we made sure that wherever we placed the color—those orange hits—they would be placed so the characters could pop. At the same time, although we have different subtle tones on each of the white North Wind characters, when they're all in one lighting scenario, it can look like each character is lit with a different temperature of light. So, we brought them closer to the hue of the light."

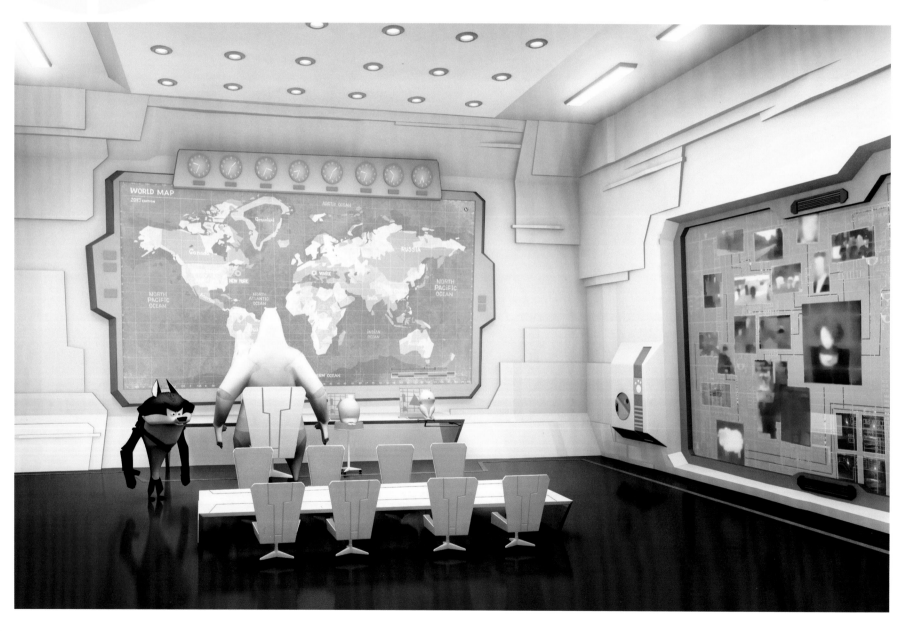

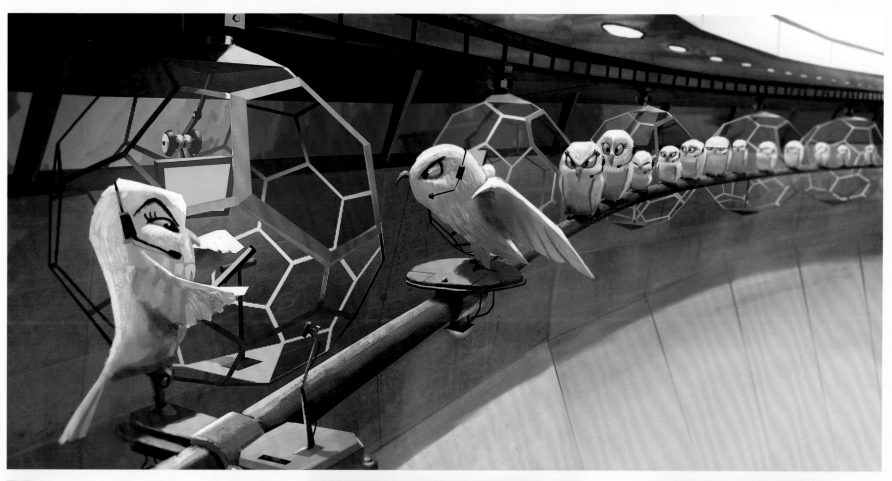

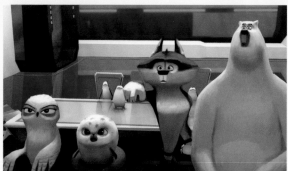

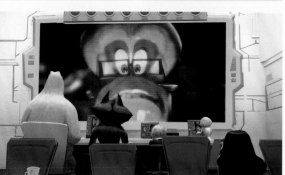

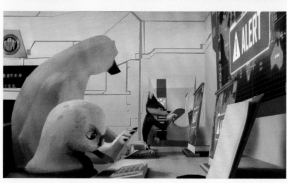

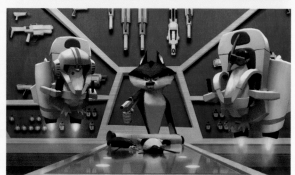

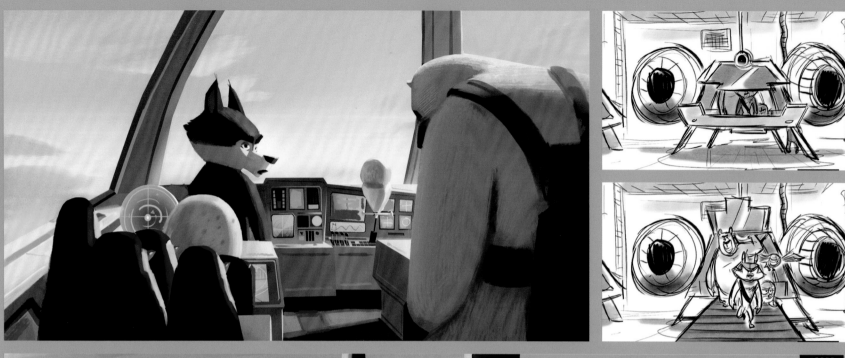

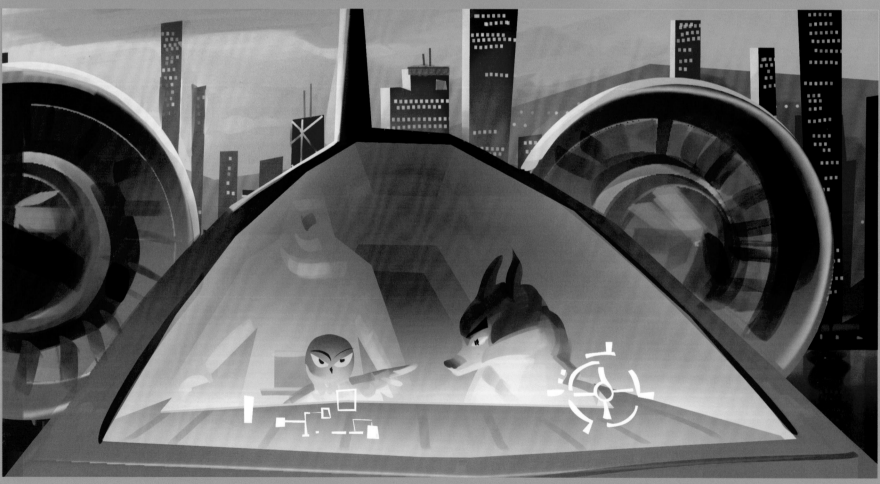

VTOL JET

The Penguins' first encounter with the North Wind world is from inside the stark white VTOL (vertical take-off and landing) aircraft, a high-tech jet that carries them from Venice to the iceberg-based headquarters.

For the view out the jet's large windows, matte painters created and animated Madagascar-style clouds to produce the feeling of motion. Pete Billington says, "It's not difficult—even in matte painting—to make a volumetric cloud move. But to make a volumetric cloud move in the Madagascar style is quite challenging."

The VTOL plays a starring role later on in the film as well. In an action-packed sequence, the Penguins manage to wrest control of the jet from the North Wind, leaving Classified and his team to try to recapture the VTOL.

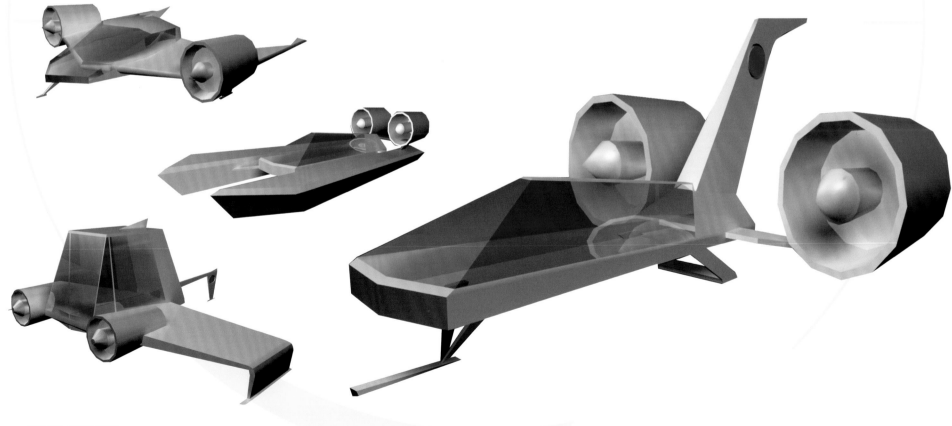

ABOVE >> RUBEN PEREZ

SCREENS & LOGOS

The North Wind jet and headquarters are filled with computer screens designed by the art department. "We had to make little movies for everything you see on a monitor," says Ruben Perez.

Even though North Wind represents a futuristic, high-tech world, the art department stayed true to the retro design language of the Madagascar films. "The straights against curves are always present," says Shannon Jeffries. "That hasn't changed. But here it's more about the way we use color, the amount of detail, and a little wiggle in the lines."

A lot of care was taken in designing the details of the film, including the graphics that appear throughout the movie. "We designed the logos and badges that the North Wind characters wear and that are on the VTOL. We went through a lot of very cool logos," says Jeffries.

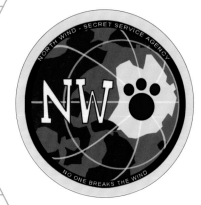
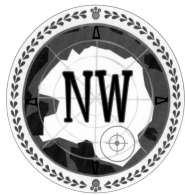

TOP >> AVNER GELLER
ABOVE LEFT & CENTER >> GORO FUJITA
ABOVE RIGHT >> SHANNON JEFFRIES
OPPOSITE >> STEVIE LEWIS

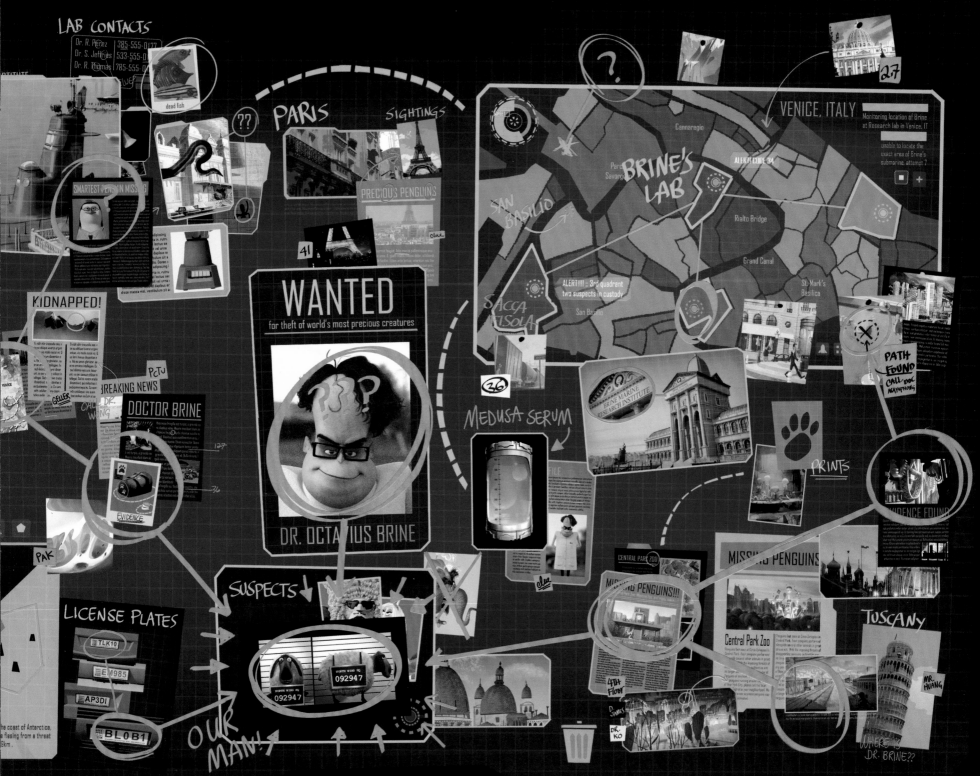

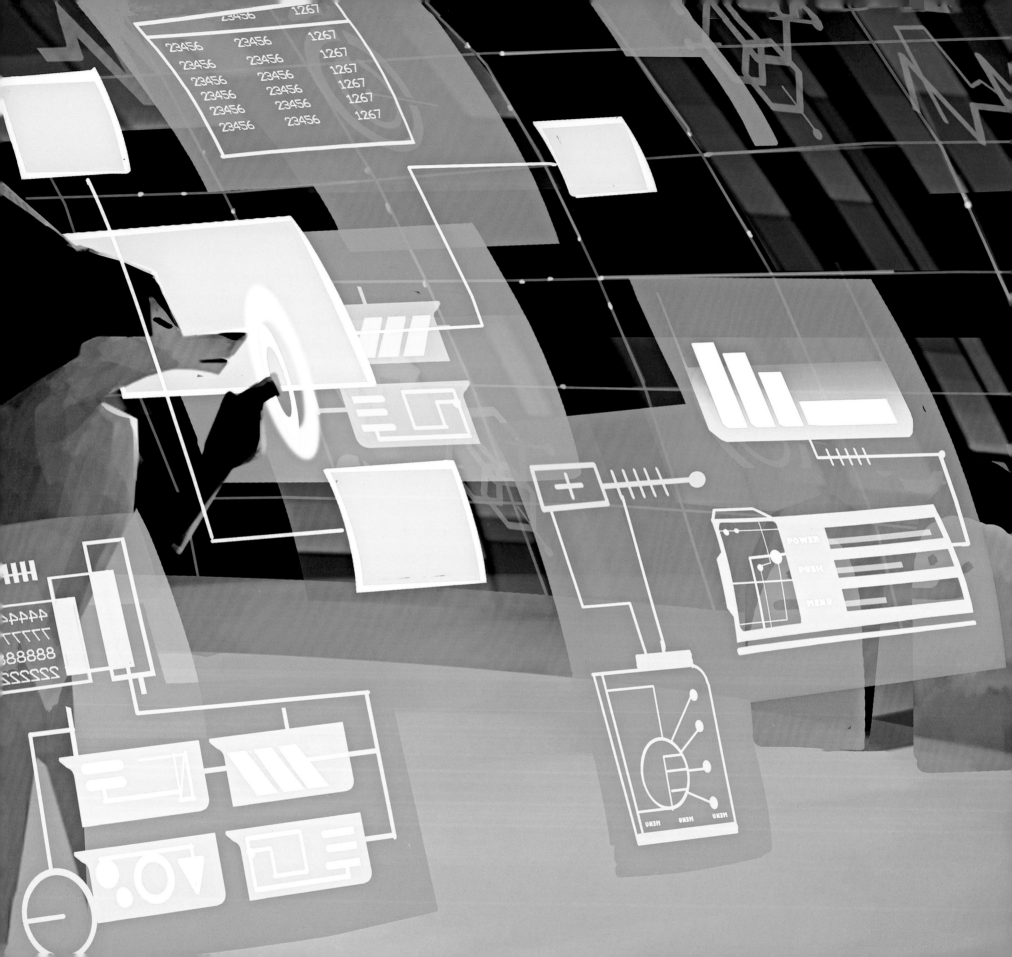

PLAN OFF

It's showdown time. Dave has kidnapped little Private and taken him to a secret atoll in the Pacific Ocean guarded by thirty-one octopus henchmen. The Penguins are floating on a small piece of debris towed by the North Wind characters, who lounge in an inflatable boat, partaking in a fancy dinner. While the parched Penguins have no fresh water, the North Wind team is enjoying champagne. Their differences have never been so apparent.

Both teams of spies have ideas for rescuing Private, so when they land on the beach, Eva proposes a "plan off," with the Penguins sharing their rescue plan and the North Wind offering theirs. Moments later, Skipper has drawn out his humble plan in the sand, to Agent Classified's amusement.

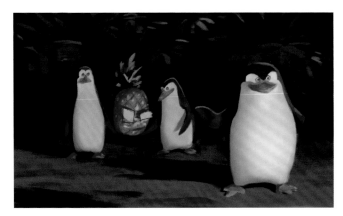

LEFT >> WIN ARAYAPHONG
ABOVE >> CARLOS FELIPE LEÓN

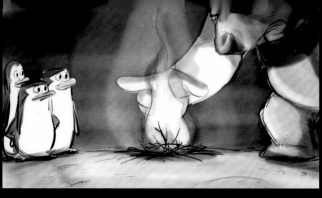 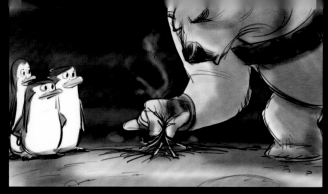 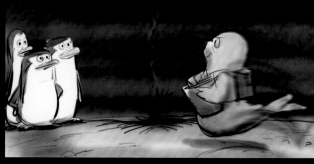

 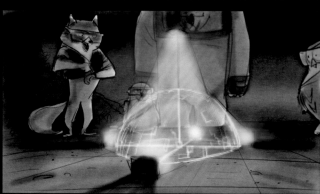

"Corporal, dim the lights," Classified commands. "Short Fuse, the glasses." He drops a cube on the ground, and the cube transforms into a holographic 3-D dome that surrounds all the characters with maps and data.

The holograms are wireframes—line drawings—that float in the air and show computer screens with data streams as well as video feeds of Dave's submarine and the North Wind's jet. Like a general demonstrating a battle plan, Agent Classified stands at the center of the dome and manipulates the glowing holographic objects to show his plan in action as the Penguins watch.

"We put light on the wires, as if they were really there, to give the objects some shape," says head of lighting Jonathan Harman. "So, the objects became light sources. They threw light on the characters, the ground, the environment, and onto each other."

This sequence is head of character animation Olivier Staphylas's favorite. "It's a turning point in the movie, both powerful and sad," he says. "Skipper is so sure of himself, as usual. But then Classified demolishes Skipper's plan by coming up with something bigger, greater, and better thought out. Skipper feels defeated. And then Classified, the jerk, adds another level of pain by criticizing Skipper for being the reason Private was kidnapped in the first place."

Supporting these story points are color shifts throughout the sequence. "This is an example of a scene in which we brought the Penguin world and the North Wind world together," says Shannon Jeffries. "It starts with the Penguins having the upper hand, so there's firelight influencing warm colors, and the moonlight is in the ultramarine blues. And then when the North Wind steps in to pull out their technology and show how they're going to do it, everything shifts to the cyan world."

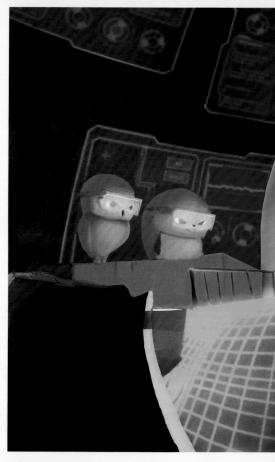

TOP >> NELSON YOKOTA

ABOVE & OPPOSITE BOTTOM >> GORO FUJITA

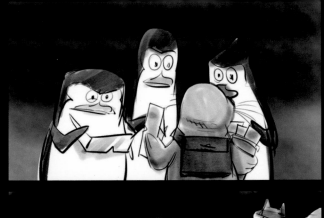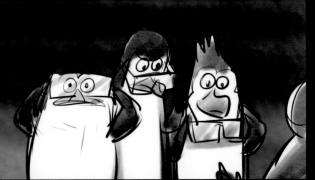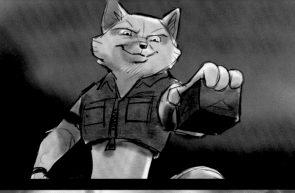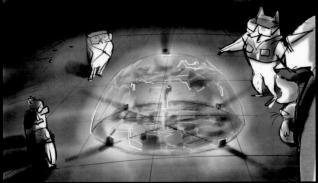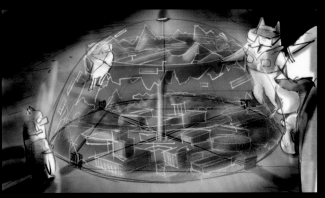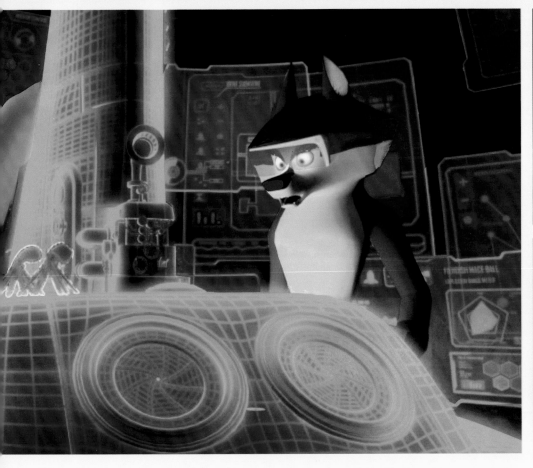

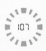

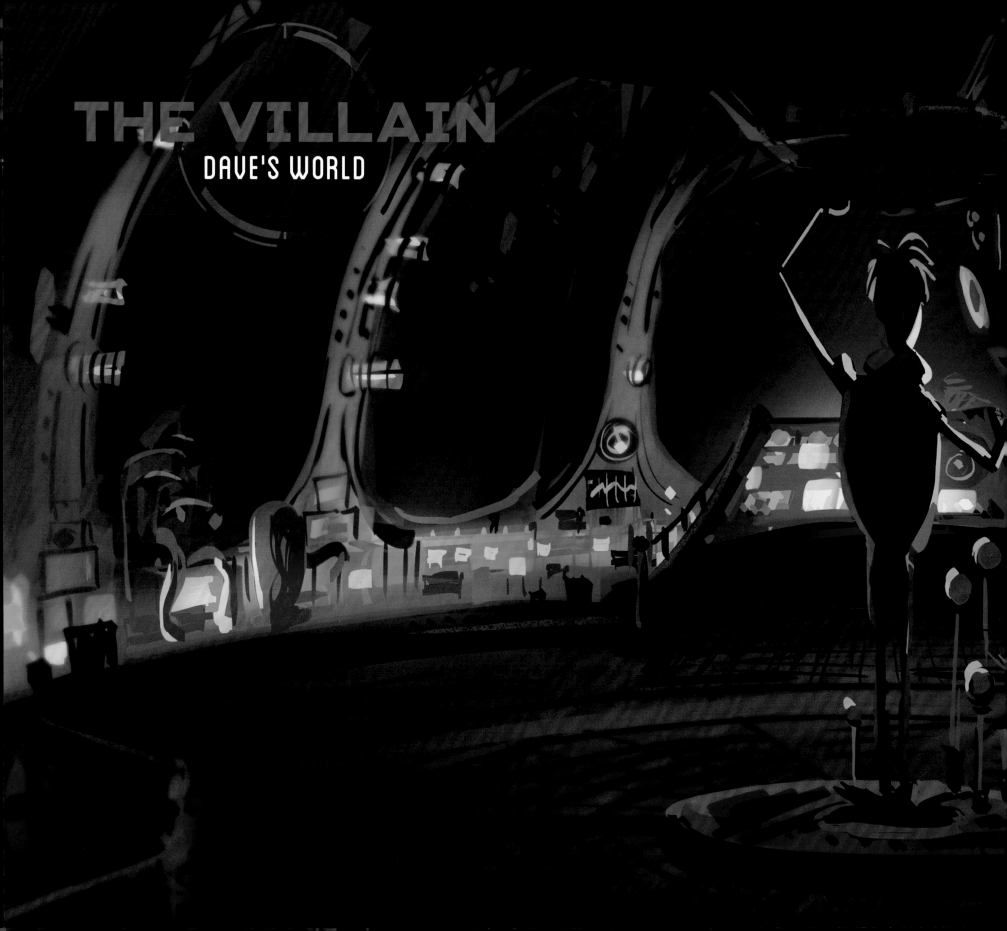

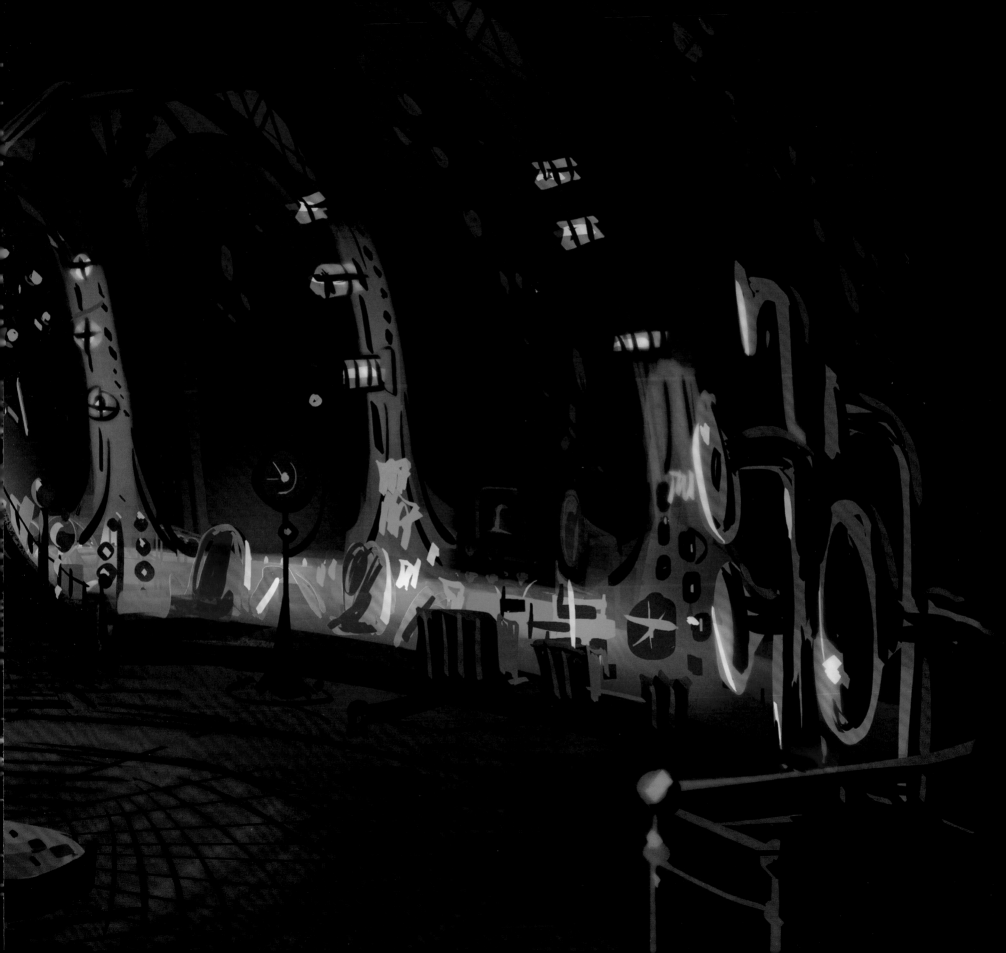

DAVE'S WORLD

The Madagascar films immersed audiences in sweaty tropical jungles on Madagascar, arid deserts in Africa, cool mountains in Switzerland, and crowded urban environments in New York City, Monaco, Rome, and London. Penguins, however, come from a land of snow and water.

"Penguins can swim, but we hadn't had an aquatic adventure yet," says producer Lara Breay. "So we started playing with a villain that was somehow aquatic in nature."

At first, the creative team considered a Doctor Doolittle character who could commandeer an army of marine animals, including octopi. Director Simon J. Smith imagined a team of octopus ninjas that would throw real starfish.

"Every time the starfish would hit something, it would go 'Ow!'" he says. Soon, the notion of an octopus as the villain took hold. "We fell in love with the physicality of the octopus," Breay says.

And what better villain for a spy movie? "The octopus is such a bizarre animal," says director Eric Darnell. "They are masters of disguise and really intelligent, and people think they are creepy. The octopus is a villain we really haven't seen in a film before."

PREVIOUS PAGES ≫ RUBEN PEREZ & JAMES WOOD WILSON
TOP RIGHT ≫ GRISELDA SASTRAWINATA
RIGHT ≫ CHRIS AYERS
FAR RIGHT ≫ FLORIANE MARCHIX

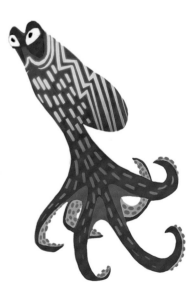

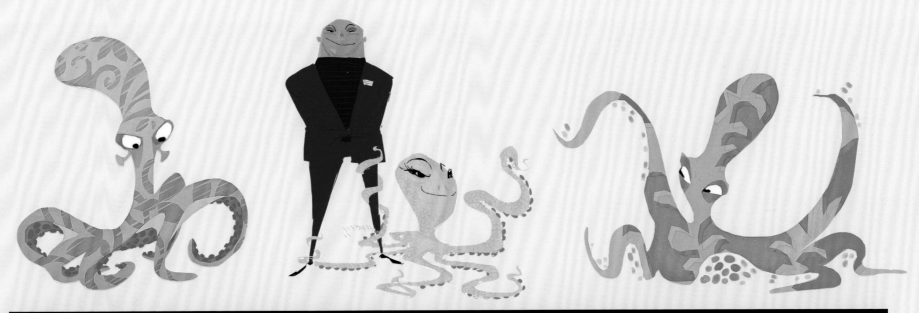

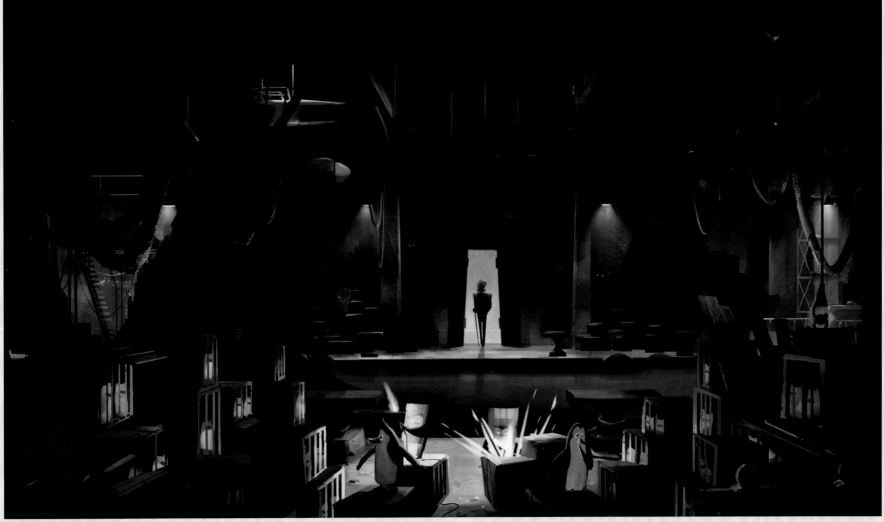

TOP LEFT & RIGHT » FLORIANE MARCHIX
TOP MIDDLE » PASCAL CAMPION
ABOVE » WIN ARAYAPHONG

TOP » FLORIANE MARCHIX
BOTTOM ROW » CARLOS FELIPE LEÓN

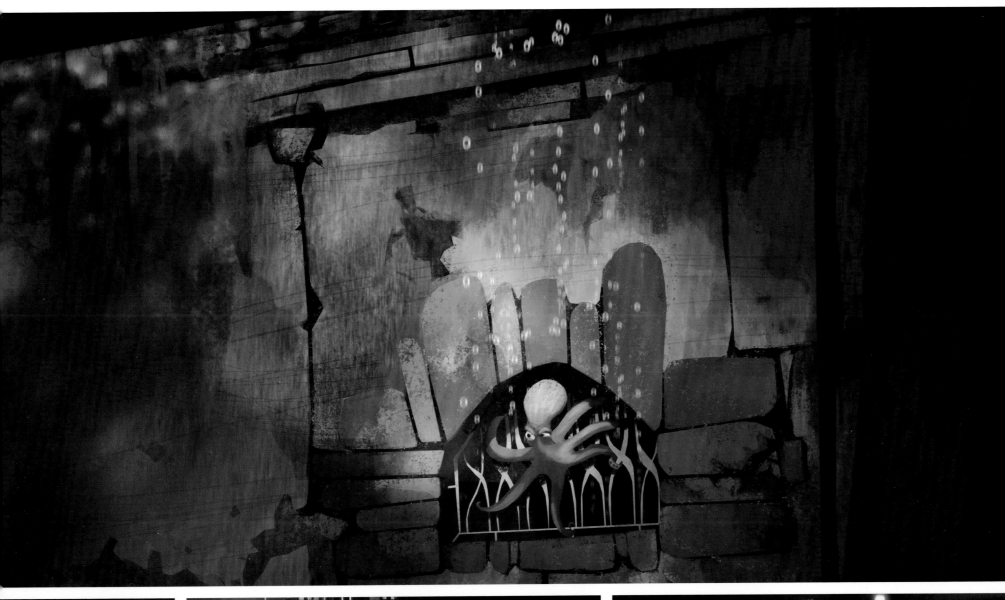

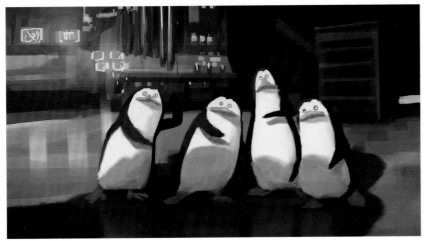

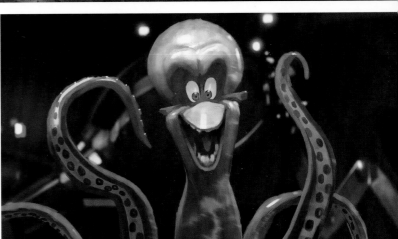

TOP ›› GORO FUJITA
ABOVE ›› PRISCILLA WONG

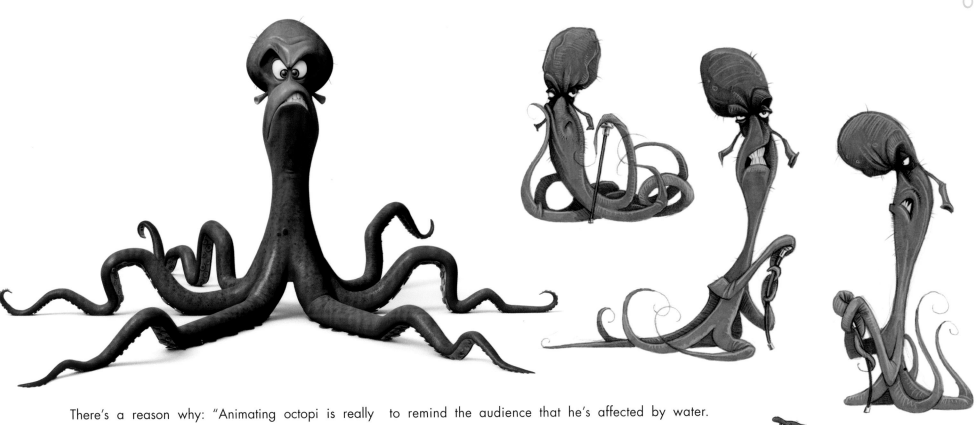

There's a reason why: "Animating octopi is really hard," Breay says. "So we don't typically use characters like that. But because there is so much you can do physically with the character and because it's so difficult technically, it felt like fresh ground for us—something special. And tons of fun."

They named their villainous octopus Dave, installed him in a submarine, and gave him an evil plot: to capture all the cute penguins in the world and mutate them into creatures even creepier than he is.

In addition to giving the animation team new and interesting challenges, the creature provided production designer Shannon Jeffries with a chance to steer the Madagascar world into new, watery territory.

"Because he's an octopus, we wanted his world to reflect him," Jeffries says. "Everything in Dave's world is based on curves. We have curves, spirals, and circular shapes. There are no straight edges. His suction cups led to the idea of repeated patterns. You see lots of small textural details that you wouldn't see with the Penguins or in the North Wind headquarters. We wanted

to remind the audience that he's affected by water. Often when we see Dave, there are caustics [lighting effects that suggest a watery environment] around him to add that fluidity."

The colors in Dave's submarine also reflect his aquatic habitat. "His general colors are greens, an eggplant purple, and hints of orange," Jeffries says. "To make it feel like we're in different environments within the sub, we slanted the colors slightly. Some locations are a little bluer than others, but the colors are all within the same world."

Like the North Wind characters, Dave has embraced technology, but his equipment is neither modern nor sleek.

"His technology is less polished and slightly more outdated than that of the North Wind," Jeffries says. "And his world is a little darker. Things don't quite line up. You see exposed scaffolding, twisted pipes, and wires that cross over and wrap each other. But we're still in the Madagascar world, where straights meet curves. Dave's world is a challenge because it's all curves, but we're still not doing S-curves. We're doing curve into curve to create his world."

TOP & ABOVE » GRIS GRIMLY

115

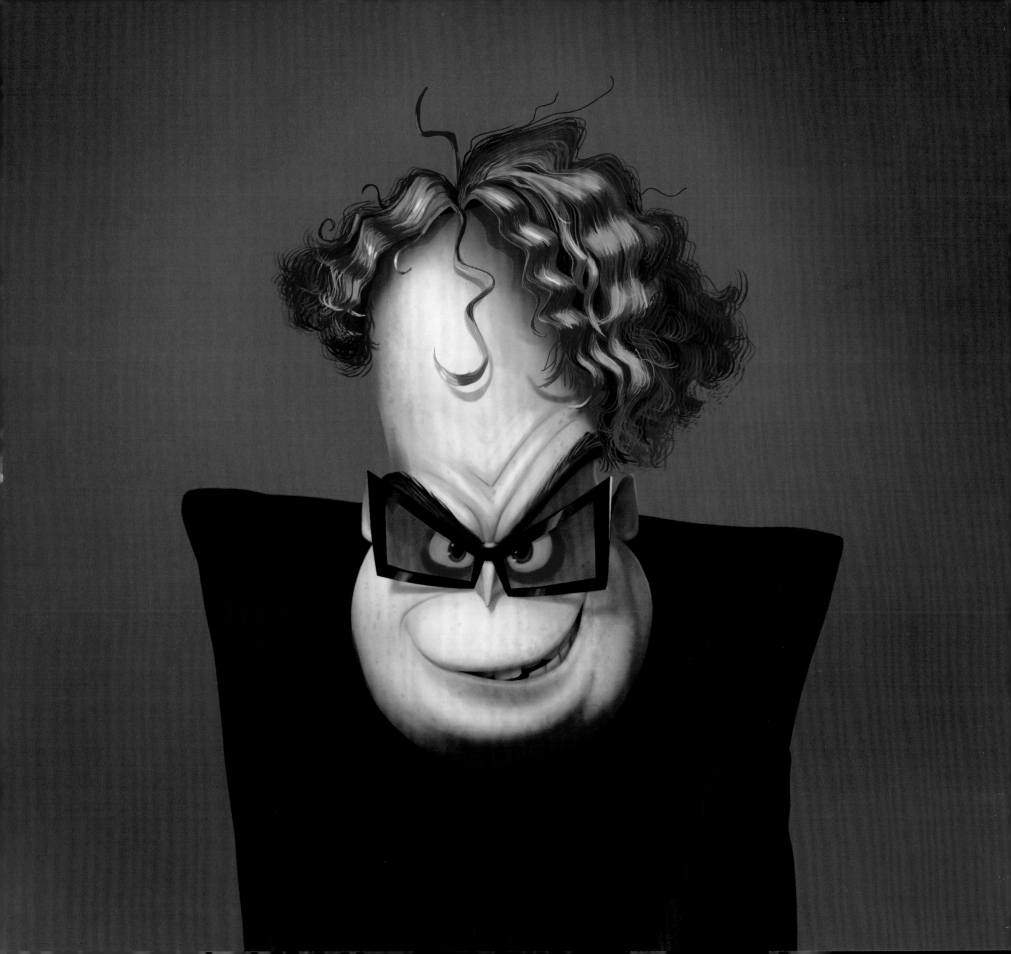

BRINE

The Penguins' enemy appears first in his human disguise, as Dr. Octavius Brine—renowned geneticist, cheese enthusiast, and frequent donor to pledge drives. As part of his nefarious plan to capture all the penguins in the world, Dr. Brine sucks our protagonists into a vending machine at Fort Knox, flies them to his submarine, and deposits them inside a cage—in which Rico pops the lock with a paperclip. When the Penguins look up, they see Dr. Brine walking upside down near the ceiling. He drops to the floor and lands in a heap, limbs bent at impossible angles, and then lifts himself up like a marionette, arms and legs tangled around his body.

"He leans forward in an unbelievable way that's not even possible. But for him, anything is," says head of character animation Olivier Staphylas. "We found footage of extremely flexible gymnasts who could put their legs behind their heads. We knew that if humans in our world could do that, then an octopus inside a human needed to do more. We had to make the audience believe he's weird from the get-go."

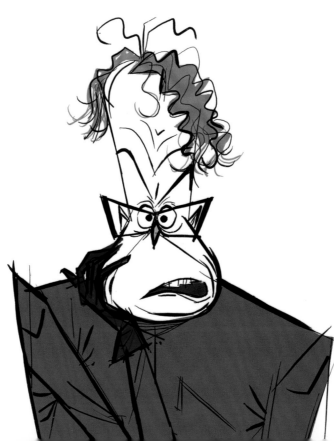

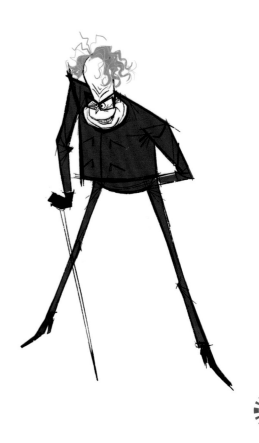

OPPOSITE » STEVIE LEWIS
THIS PAGE » JOE MOSHIER

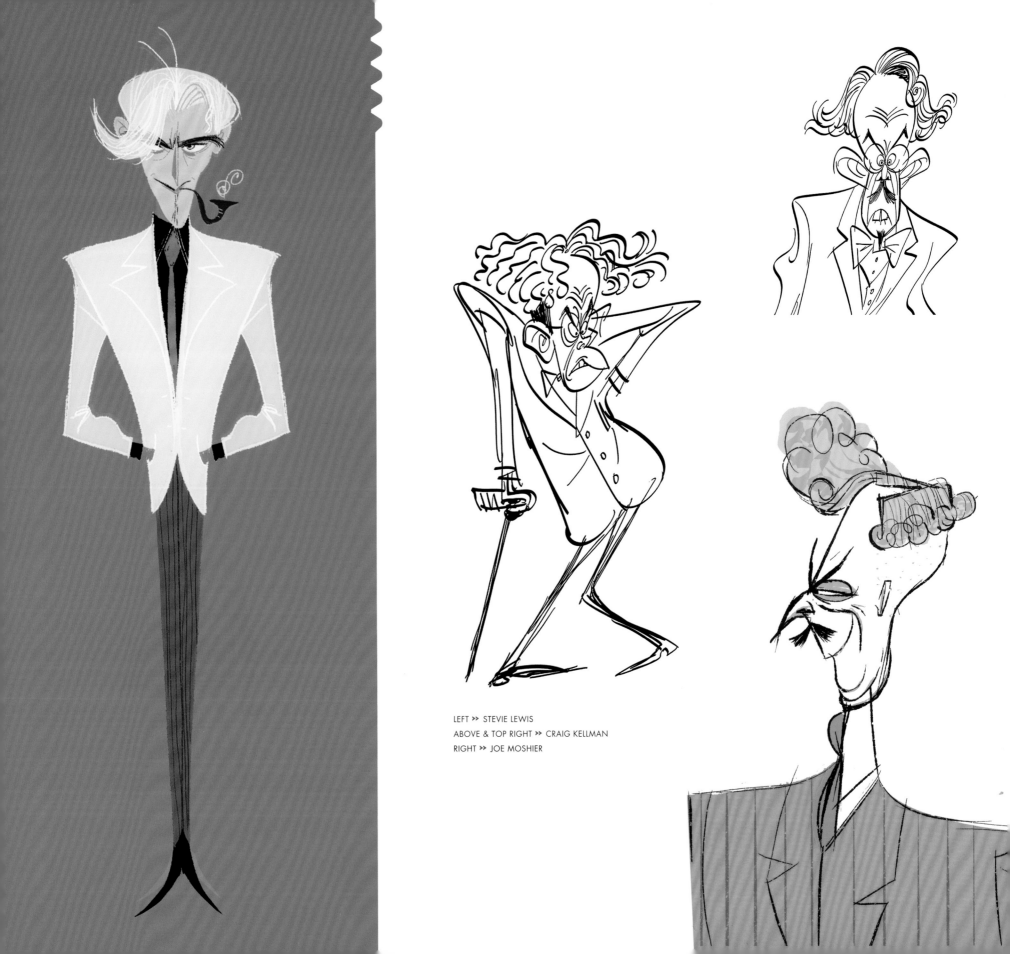

LEFT ›› STEVIE LEWIS
ABOVE & TOP RIGHT ›› CRAIG KELLMAN
RIGHT ›› JOE MOSHIER

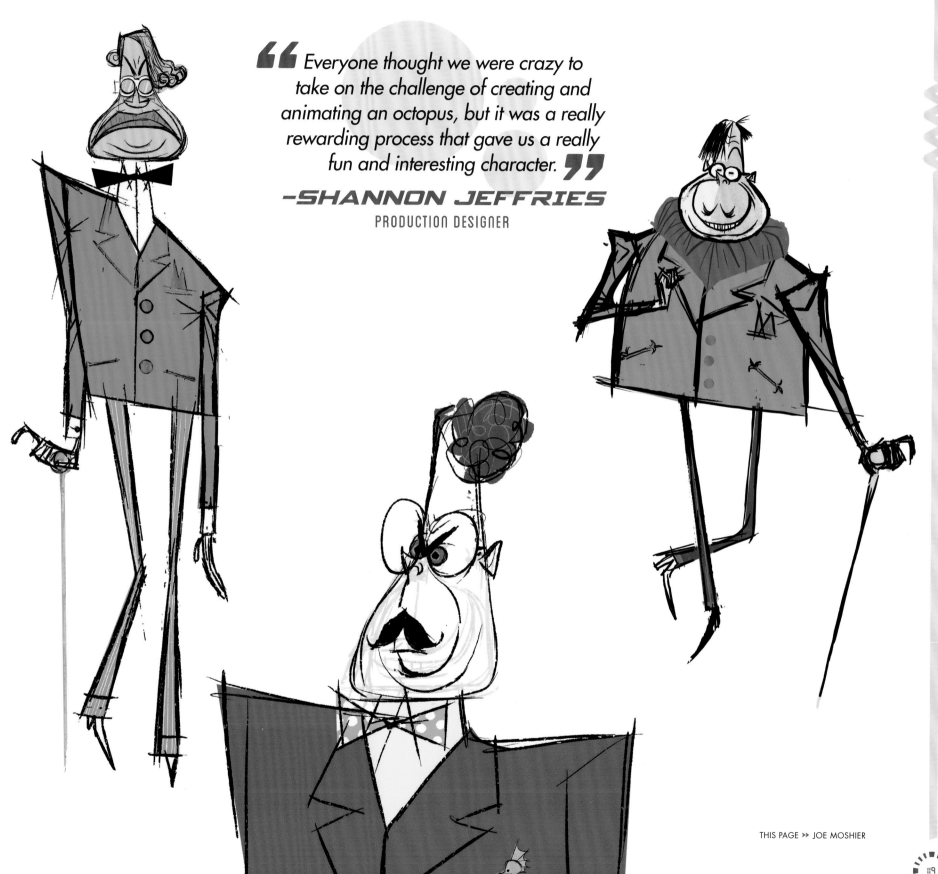

> *Everyone thought we were crazy to take on the challenge of creating and animating an octopus, but it was a really rewarding process that gave us a really fun and interesting character.*
>
> **—SHANNON JEFFRIES**
> PRODUCTION DESIGNER

THIS PAGE >> JOE MOSHIER

Because Dr. Brine is an octopus disguised as a human, his shape is a little off, too. "You can't quite tell what's head and what's body," says Shannon Jeffries. "His body is compact because the octopus body is shoved into his torso, and then he has these long extremities."

Another problem the DreamWorks team had to address was Dr. Brine's clothing. "We had to make the cloth simulations work despite his absurd motion," recalls visual effects supervisor Philippe Gluckman. "Cloth simulators like to create physically accurate movement, which would have put folds in his lab coat. We wanted to create clean images, as if they had been drawn. That was an interesting challenge."

After Dr. Brine introduces himself to the Penguins, he rips apart his lab coat and transforms into his true octopus form: Dave. "At first, we waited longer for the reveal, but he was so entertaining in octopus form, we decided it would be fun to reveal him early and enjoy the physicality," Staphylas says.

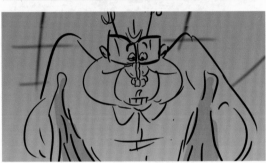

ABOVE ❯❯ SEAN CHARMATZ
LEFT ❯❯ OLIVIER TOSSAN

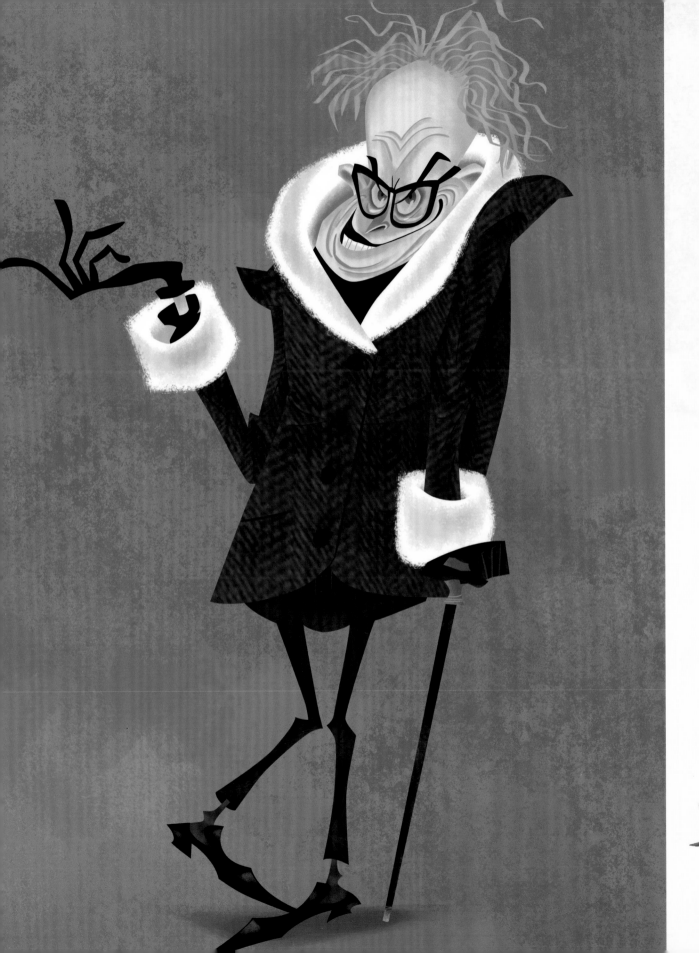

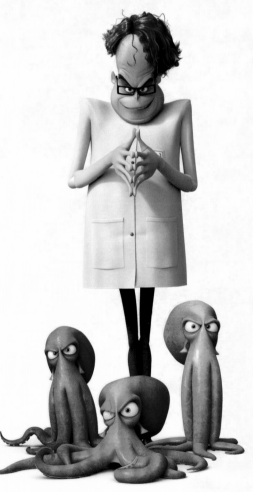

LEFT » CRAIG KELLMAN

TOP » JOE MOSHIER

DAVE

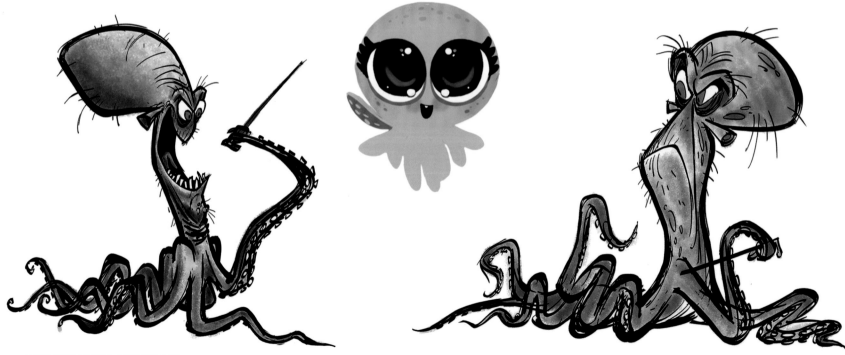

"There are moments where Dave softens a bit, but for the most part, he is grumpy," says Shannon Jeffries. "Some early images that [character designer] Craig Kellman did describe him best. We see the Madagascar style in his lower jaw. It's a cartoony approach to character design. We drop the jaw and expand the mouth much bigger than it would be if it were realistic. He has teeth we rigged so that when he gets angry and starts screaming, they can get gnarly, space apart, and move around in his mouth to accentuate his expression. And he's very rubbery."

Although the rubbery creature is made of curves, Dave's design still fits within the Madagascar style of straights against curves.

"'Straights against curves' is about hitting a line and then stopping and starting another line," Jeffries explains. "It's the starts and stops that create the curves and straights. You can see that even in the drawings of him. They're all based on curves, but one curve stops and another comes in and stops. And there's always a slight angle change within the curves. They aren't perfect circles or curves. There's always an angular quality to them."

ABOVE LEFT & RIGHT » CRAIG KELLMAN
ABOVE MIDDLE » STEVIE LEWIS
OPPOSITE » CRAIG KELLMAN & STEVIE LEWIS

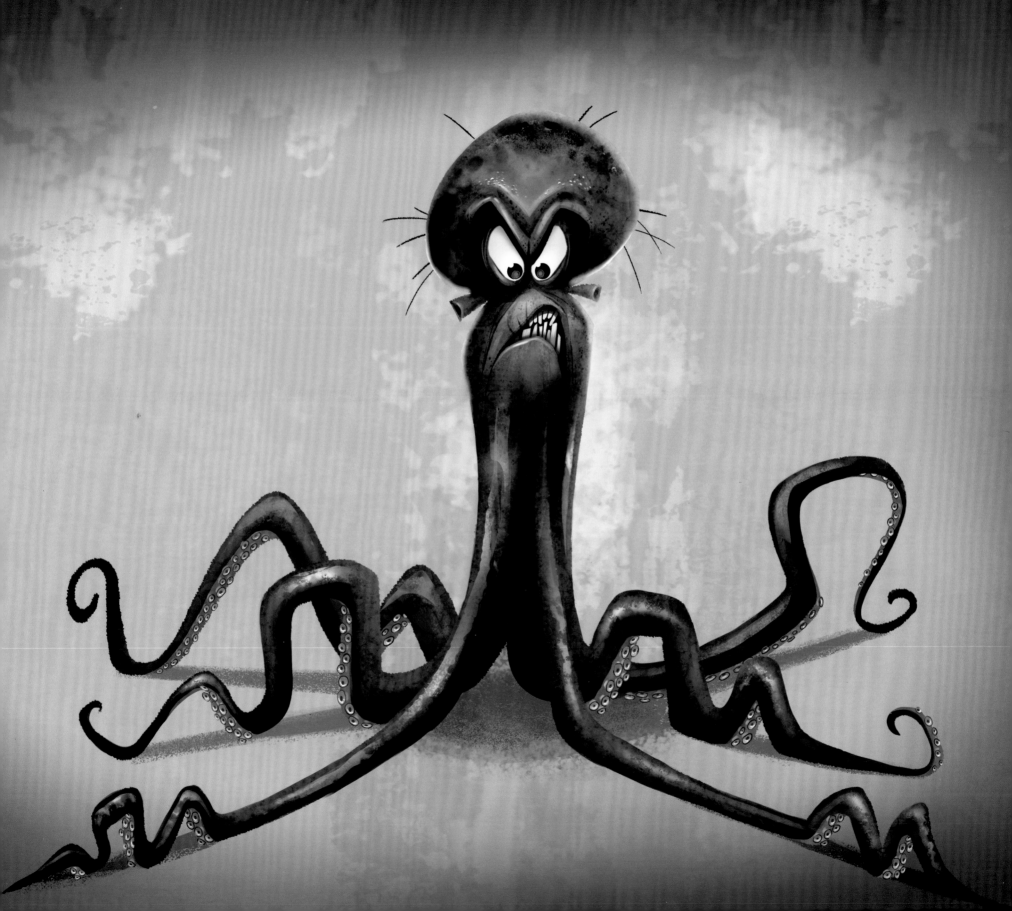

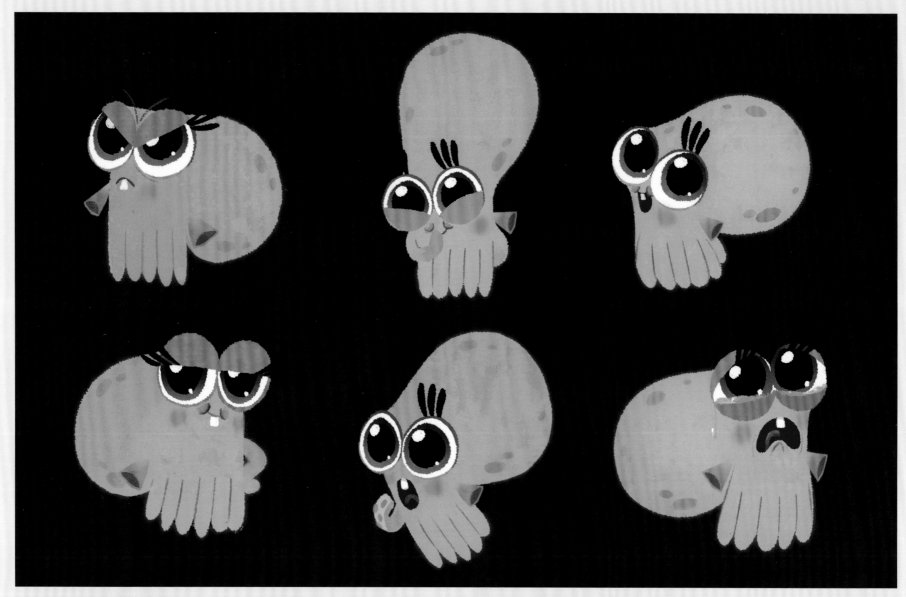

THIS PAGE ➤ STEVIE LEWIS

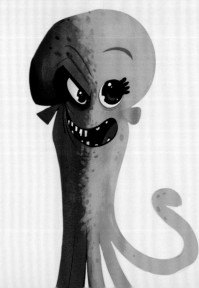

> " We had to come up with a special backlit setup to design lighting for Dave in order to make sure his translucency worked when he was lit from behind. We knew he would be backlit in a harsh way. "
>
> **—JONATHAN HARMAN**
> HEAD OF LIGHTING

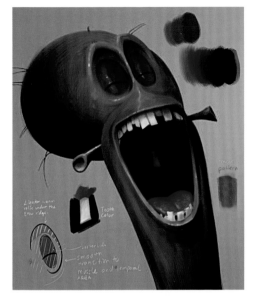

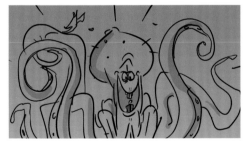

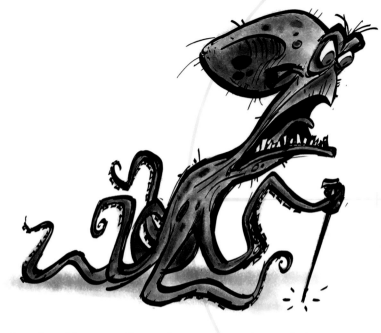

Dave's rubbery quality and curvaceous shape challenged the animators tasked with performing the slinky octopus in the snappy animation style so famously employed in the Madagascar films.

"In real life, you assume an octopus to be a boneless, squashy, goopy creature," says Olivier Staphylas. "But Dave has to do kung fu and carry boxes, so he has to have straight lines once in a while. When he has straight tentacles, you believe there is power and tension. We use that to make it believable that he can stand upright. By accepting these parameters, we could have a boneless creature next to a snappy Penguin and fit him within the timing of the other characters."

Making Dave's movements work was a major challenge for the film's character riggers: "They had to figure out how we could move those limbs, get that jelly feeling, change his shape, have him swim, stand, and walk," says Staphylas. "He was a technical research problem second to none—extremely difficult, extremely exciting, and very rewarding."

And Dave's performance is made even more convincing by his voice actor, the inimitable John Malkovich. "Dave's character really came alive as we recorded John Malkovich," says director Eric Darnell. "He made sure that Dave was having fun, and that changed the whole tone of the villain and the film. We realized that a brooding dark villain was not as interesting as one with a reason for what he's doing and who doesn't see himself as evil. When Dave comes into the room, you brighten up."

"Dave has one of the biggest facial ranges we've ever tried to achieve at DreamWorks," Staphylas says. "If you apply the rule that he's boneless and it's a stylized universe, you have to force yourself to go beyond what's expected in a face."

He adds, "We decided to have Dave's body do the opposite of what Dave's voice leads you to believe. If the voice is low, quiet, and dark, you might picture a character who is slow, menacing, and angry, but we give him a happy performance. If he is thinking about getting ice cream, we make his body quiet and still. Dave is a mixture of creepy, eccentric, and flamboyant, and when you add in John Malkovich's voice, it's an explosive mix. Dave always takes you by surprise."

DAVE'S BACKSTORY

During a dream sequence, we learn why Dave became the villain. His flashback takes him into zoos from San Diego to Brazil—and the Central Park Zoo in New York City where he met our Penguins. There, in the Central Park Zoo, children ignored Dave, flocking to see the cute Penguins instead.

The DreamWorks team paid close attention to the visuals and how they would represent Dave at different points of his life. "In the beginning of his memories, he has a positive frame of mind, so his world is colorful and saturated," says Shannon Jeffries. "But his world falls apart. As his story ends, the colors go into desaturated ochers, eggplant colors, and greens. We keep him in that color space for the rest of the film."

The logic behind this is simple and relatable: "When someone remembers something, they visualize the things that are important while everything else becomes unnecessary detail," explains Jeffries. "We wanted to treat Dave's memories in that same way. The things that affected him most are saturated and have more detail. Everything else falls off into a distorted, slightly desaturated world."

RIGHT ›› PRISCILLA WONG
FAR RIGHT ›› TODD KUROSAWA

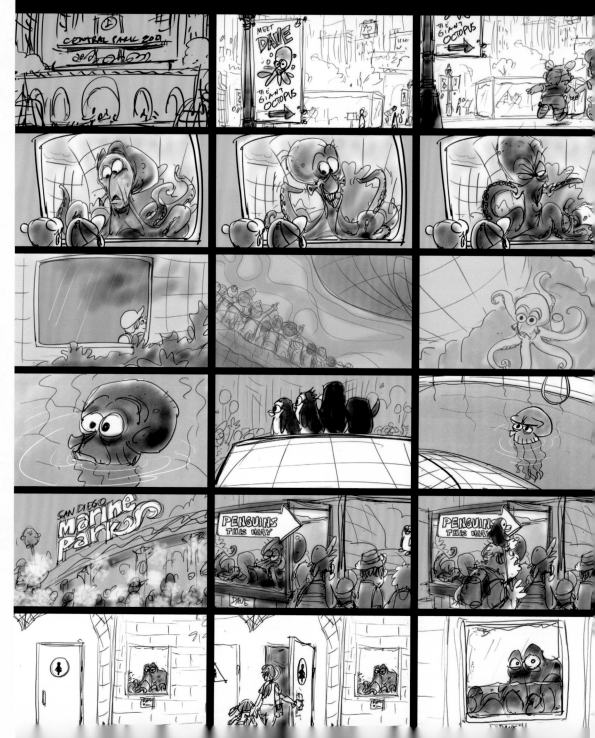

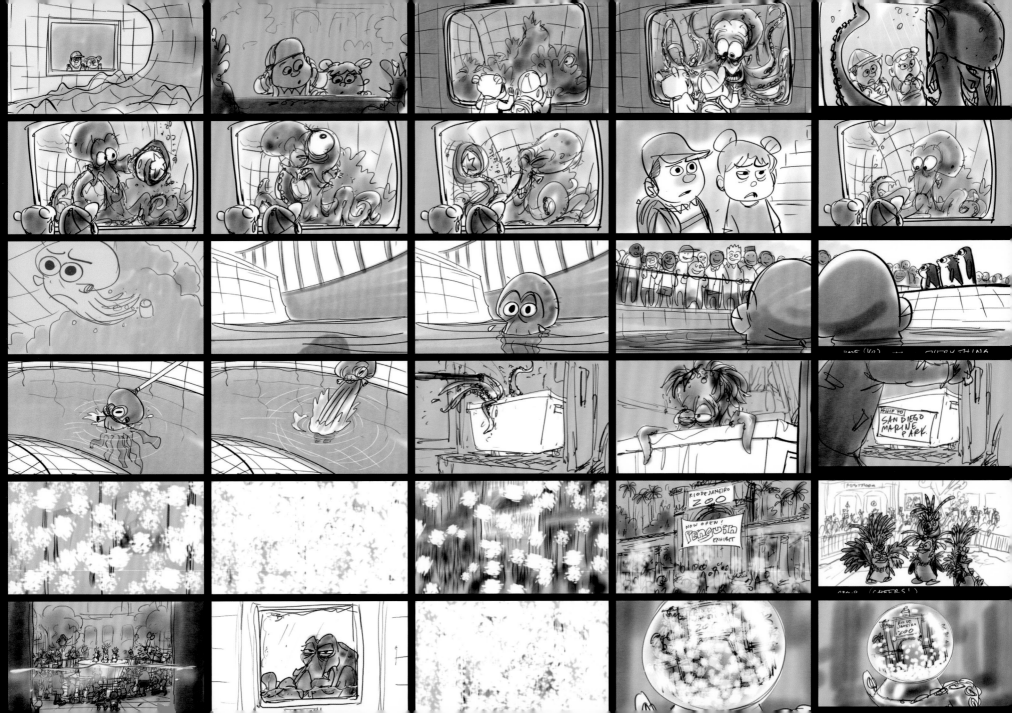

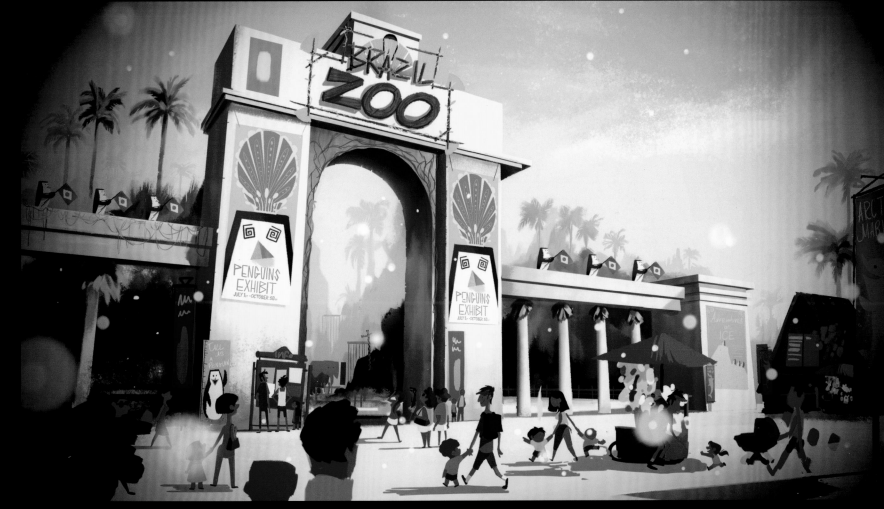

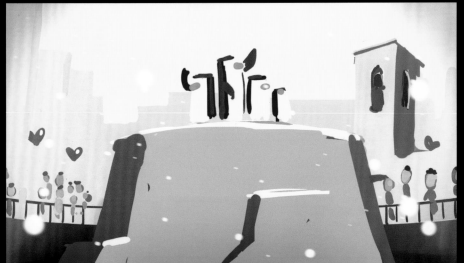

While Private wants to be something bigger than himself, Dave just wants to be appreciated. He wants to be loved.

—SIMON J. SMITH

DIRECTOR

DAVE'S HENCHMEN

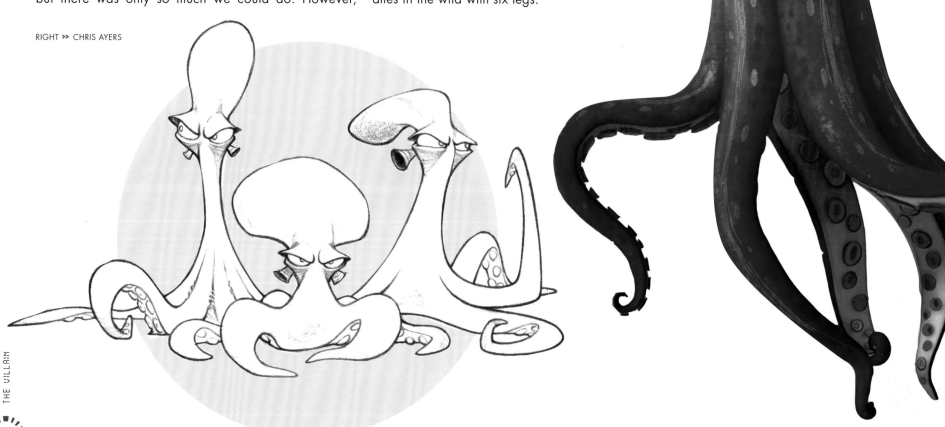

Like any villain worth his salt, Dave has loyal octopus henchmen who carry out his commands. But unlike Dave, these henchmen never disguise themselves as humans.

"I love the henchmen," says director Simon J. Smith. "They're like octopus ninjas."

"They had already been designed and rigged by the time I came onto the film," says Shannon Jeffries. "We tried to push them more into the Madagascar style, but there was only so much we could do. However, because they are octopi, they seem to work fine. Each has a slightly different, unique design. They aren't Dave clones. From these, we built hundreds of generics, so you'll see a mix of them."

In fact, there's something unique about these octopus characters altogether: "All our octopi have six legs," says director Eric Darnell. "An octopus has eight legs, but it was hard to find good, clean poses with eight legs. But we still call them octopi, since we found some anomalies in the wild with six legs."

RIGHT ≫ CHRIS AYERS

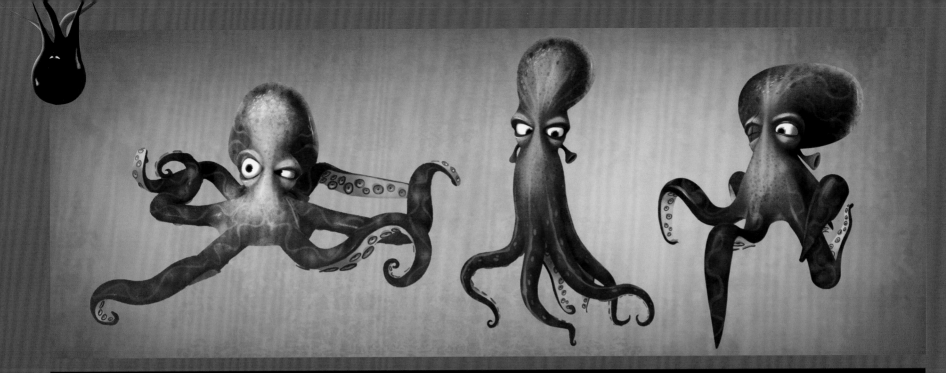

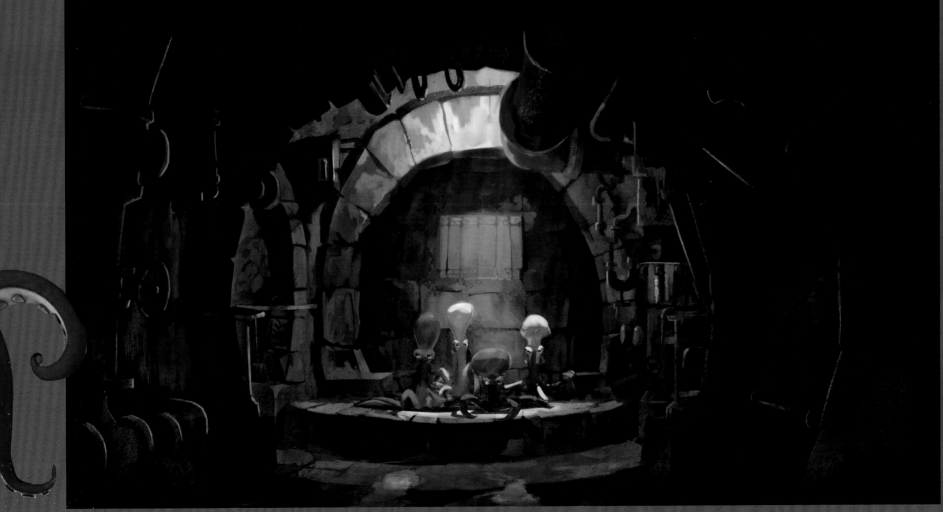

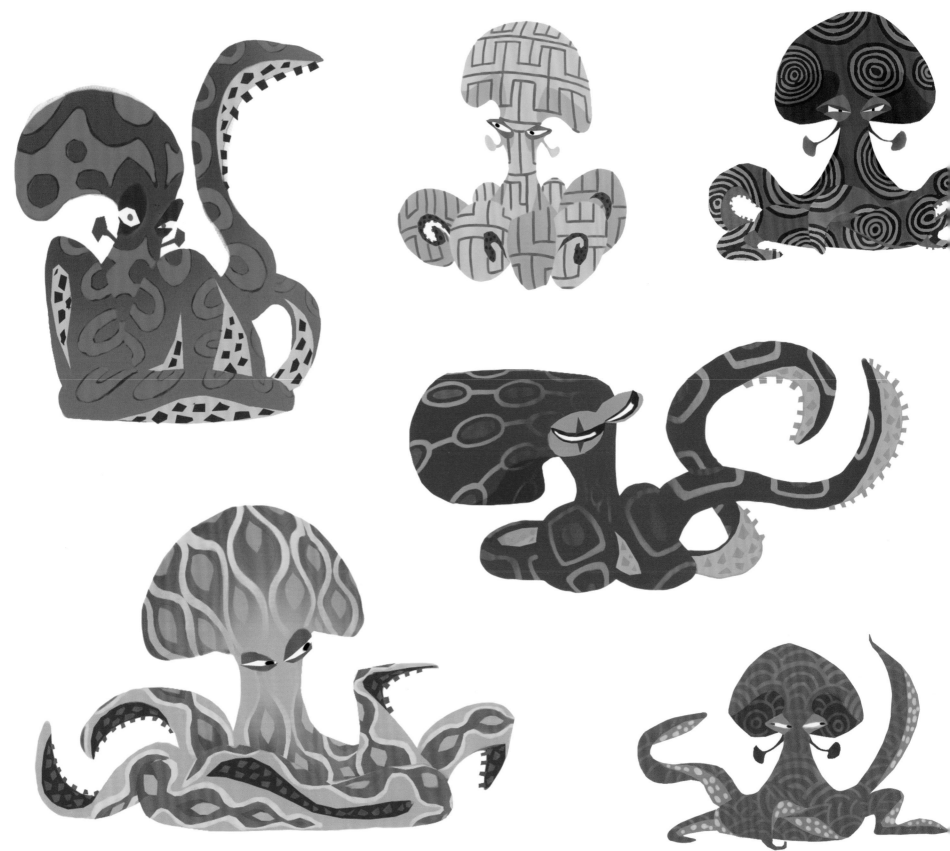

THE VILLAIN

THESE PAGES ≫ FLORIANE MARCHIX

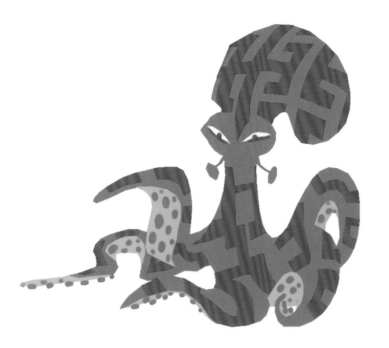

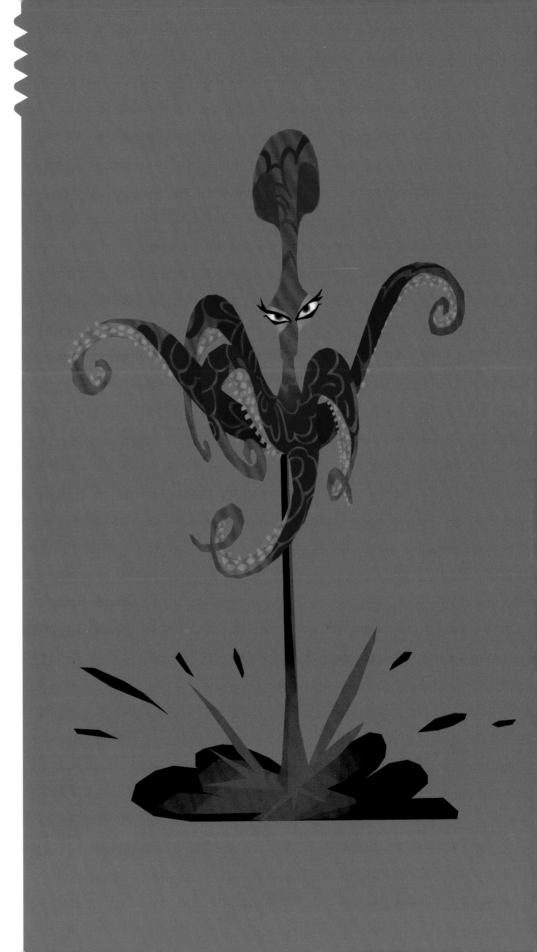

> **“** *We were so proud to show off our first octopus animation tests to the executives at DreamWorks Animation. After seeing them, they said, 'They'll have their own cartoon!'* **”**
> **—OLIVIER STAPHYLAS**
> HEAD OF CHARACTER ANIMATION

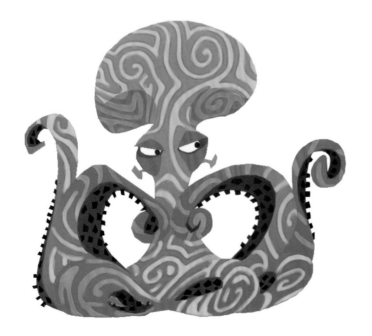

DAVE'S SUBMARINE

E arly in the film we see only the top part of Dave's submarine, the conning tower. "You only catch shadowy images of the side of the submarine," says Shannon Jeffries. "But at the end, it comes out of the water and reveals itself as an octopus."

Co-producer Tripp Hudson remembers: "The look of the submarine changed through the nature of discovery as the artists got notes from production designers and directors about what it might look like and how it would fit into the Madagascar world—but it was always an octopus."

"We didn't want to go too dark and scary; we wanted to be kind of silly," explains Jeffries. "The body rotates up, and the windows become this goofy smile. The teeth open up at different rates, so the octopus ends up with buck teeth."

Inside the submarine are four environments: the bridge, a lab, interior hallways, and the cage room, each with a slightly different tone. Inside those environments are Dave's weapons: a ray gun and a death machine.

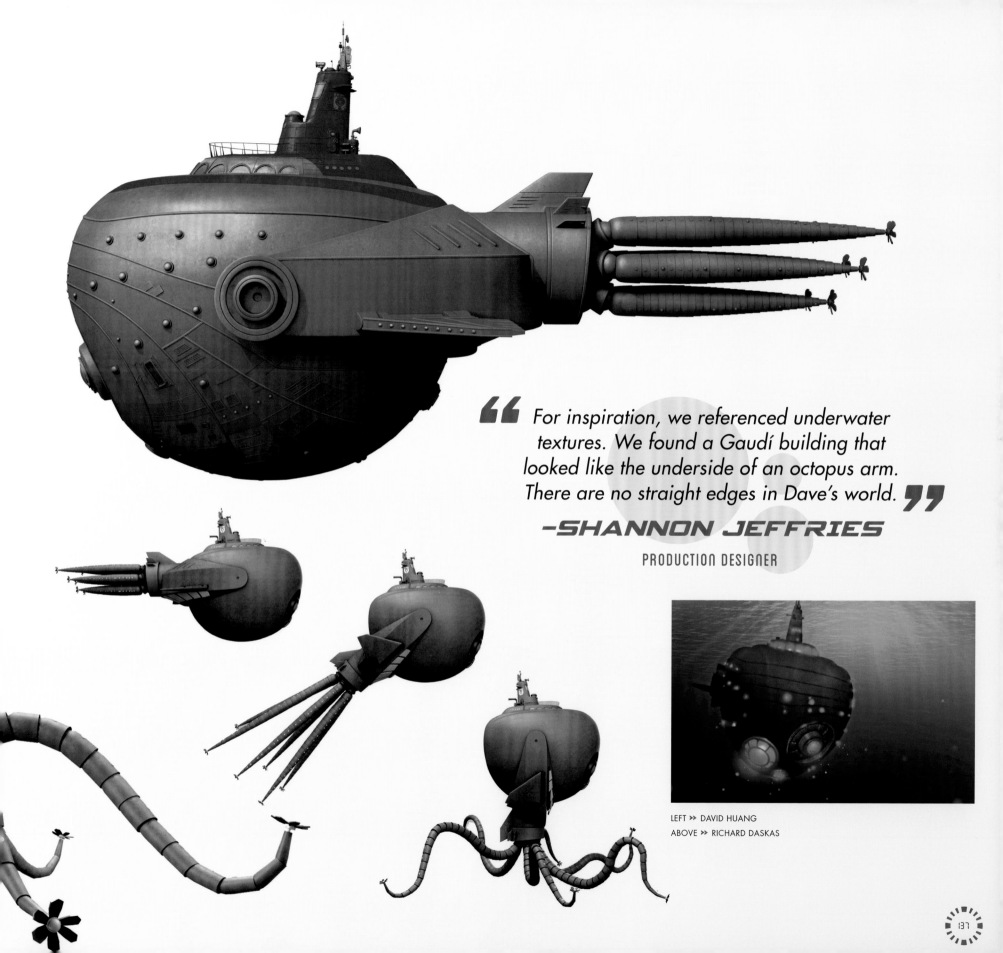

> " For inspiration, we referenced underwater textures. We found a Gaudí building that looked like the underside of an octopus arm. There are no straight edges in Dave's world. "
>
> **—SHANNON JEFFRIES**
> PRODUCTION DESIGNER

LEFT » DAVID HUANG
ABOVE » RICHARD DASKAS

137

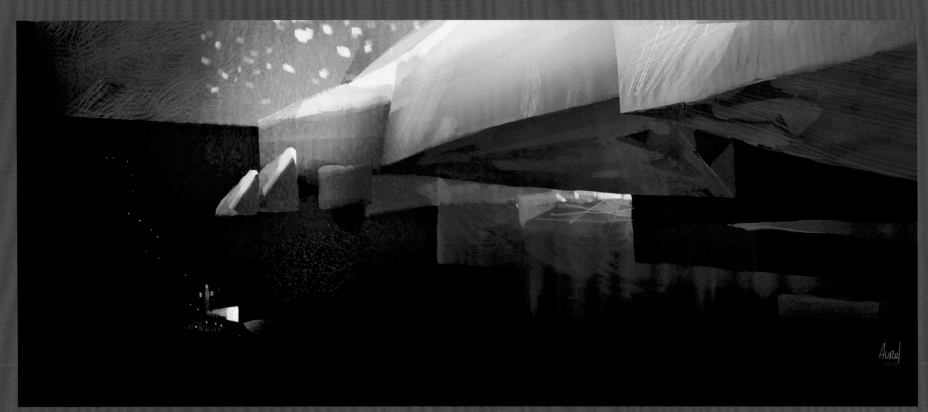
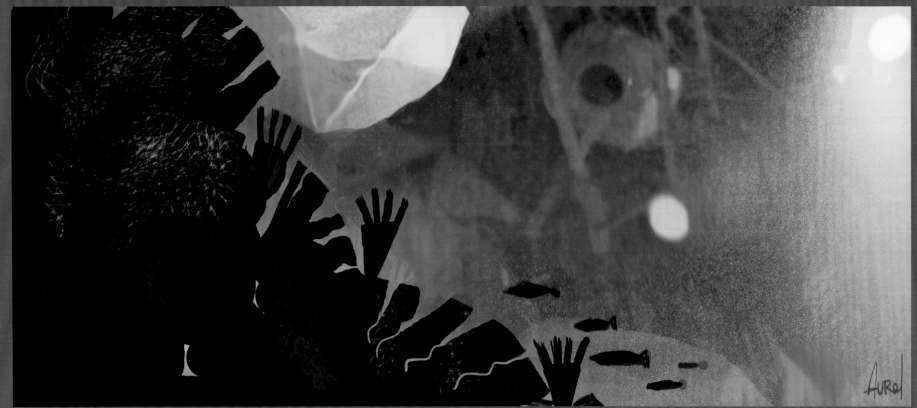

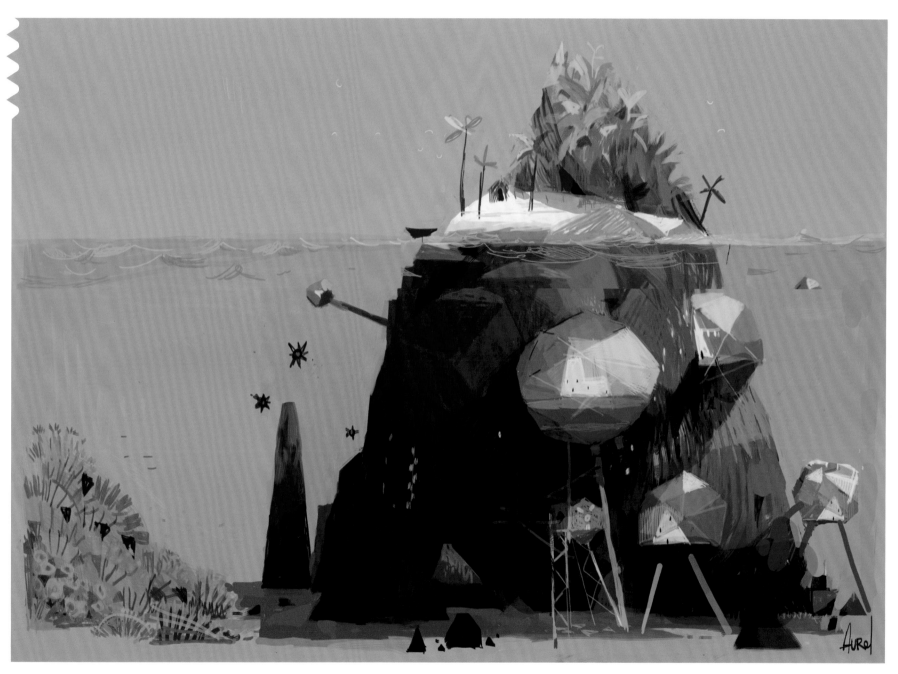

THESE PAGES » AURELIAN PREDAL

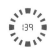

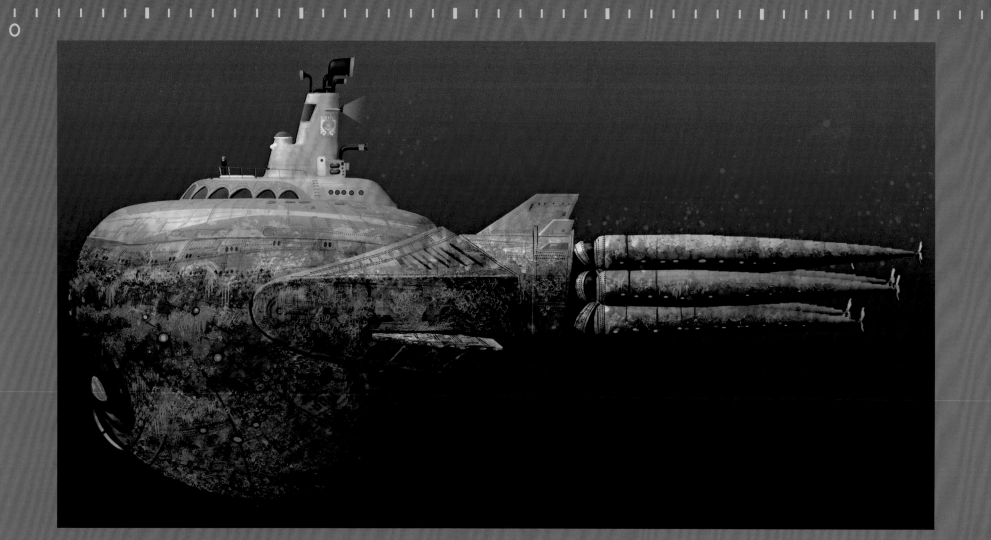

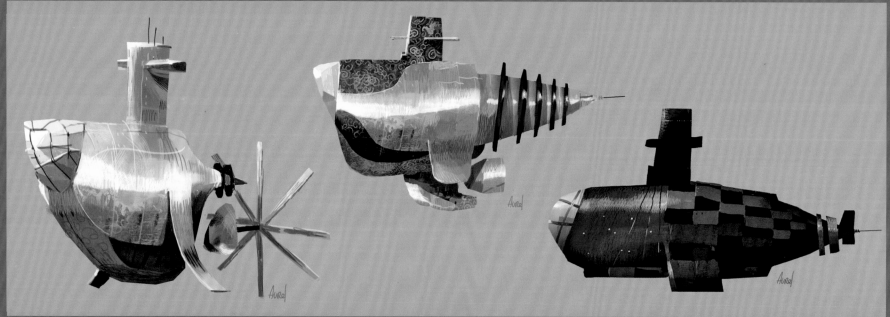

TOP ≫ RUBEN PEREZ
ABOVE ≫ AURELIAN PREDAL

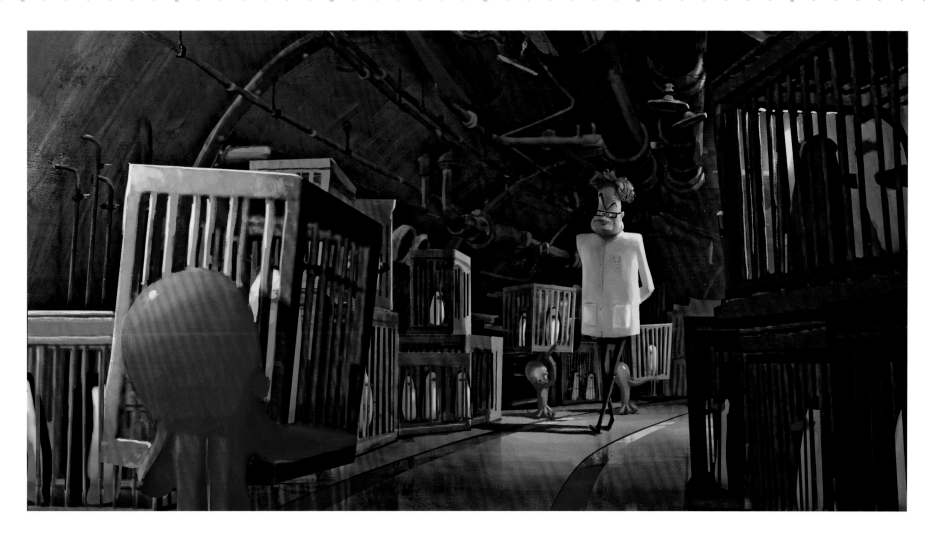

> **"** *We aren't being very literal about what's inside the sub, but early on we imagined that the legs would be the halls.* **"**
> **—SHANNON JEFFRIES**
> PRODUCTION DESIGNER

HALLWAYS

Deep into the movie, we see Dave's octopus henchmen carrying cages of captured penguins through the submarine's hallways while Dave, dressed as Dr. Brine, strides past them. Like the bridge, the hallways have repetitive lights, and the use of lights and shadows gives the scenes a film-noir quality.

"We have shadowy areas that Dave moves from into the light," says Shannon Jeffries, "like an octopus that camouflages itself with its ink to hide, and then comes back out."

ABOVE » GORO FUJITA
LEFT » PRISCILLA WONG

BRIDGE

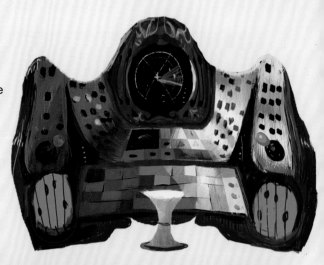

The bridge from which Dave drives the submarine is probably the brightest and warmest place on the ship.

"We have some blue bounce from the water, and the interior is lit with an orange light," says Shannon Jeffries.

Dave sits in his captain's chair and issues orders to his octopus henchmen, who man the consoles. Following the visual structure that represents Dave and his world, the captain's chair is curved, and the bridge has circular windows. We also see control panels with repetitive patterns created with buttons and colored lights.

"The colors we chose for the villain's world are unappetizing, polluted, decayed colors," says art director Ruben Perez. "But we combine them with a sprinkle of starburst colors and rich glowing gels on all his consoles, because otherwise it becomes too much of a dark, stark, and scary place."

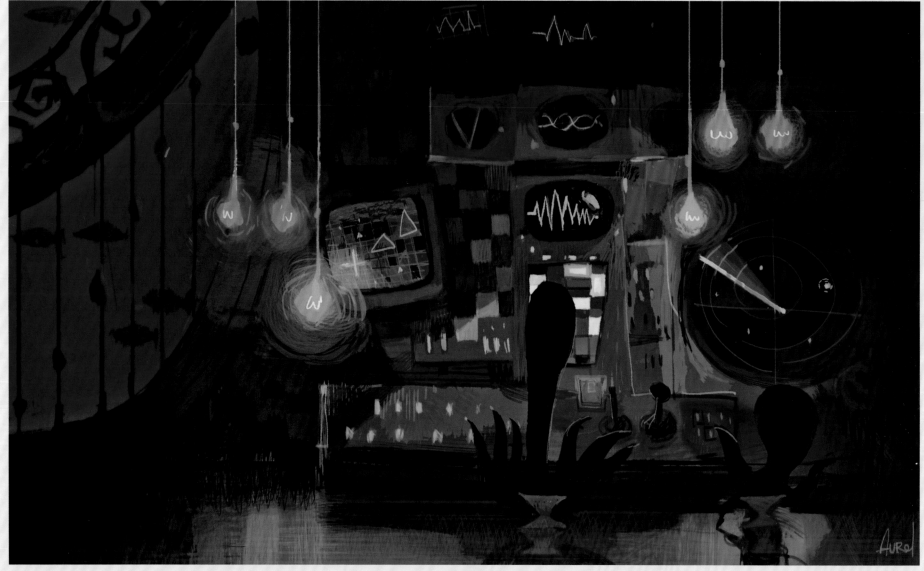

TOP & ABOVE ▸▸ AURELIAN PREDAL

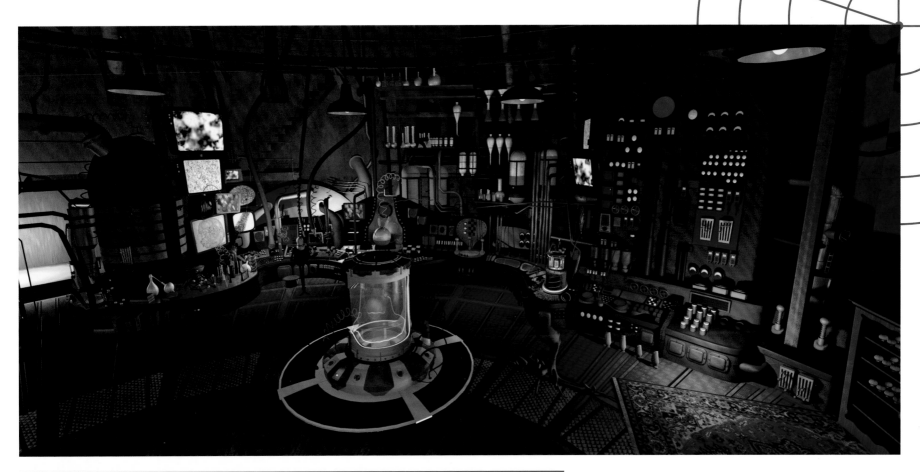

LAB

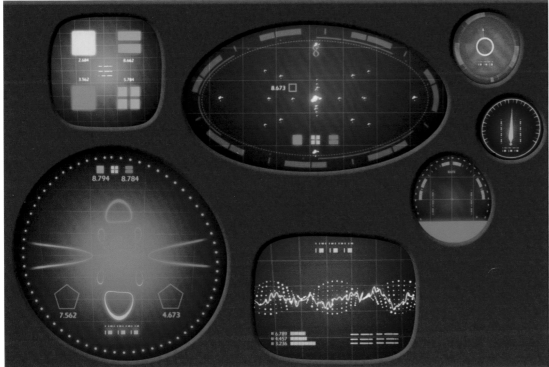

The lab is a crucial setting in the film: It's where the Penguins first encounter Dr. Brine and witness his transformation into Dave, where Dave developed the feared Medusa serum to warp cute penguins into mutants, and where we first see Dave's ray gun, the instrument of his revenge.

The lab is a visually complex, richly detailed environment with colors pushed toward greens and ochers. "When Dave is in the lab, he has a saturated color because of all the light from the consoles and laboratory equipment," Shannon Jeffries says. "We added little bits of color to him, almost like confetti."

In addition, the DreamWorks team cleverly used caustics to communicate the fluidity of Dave's world.

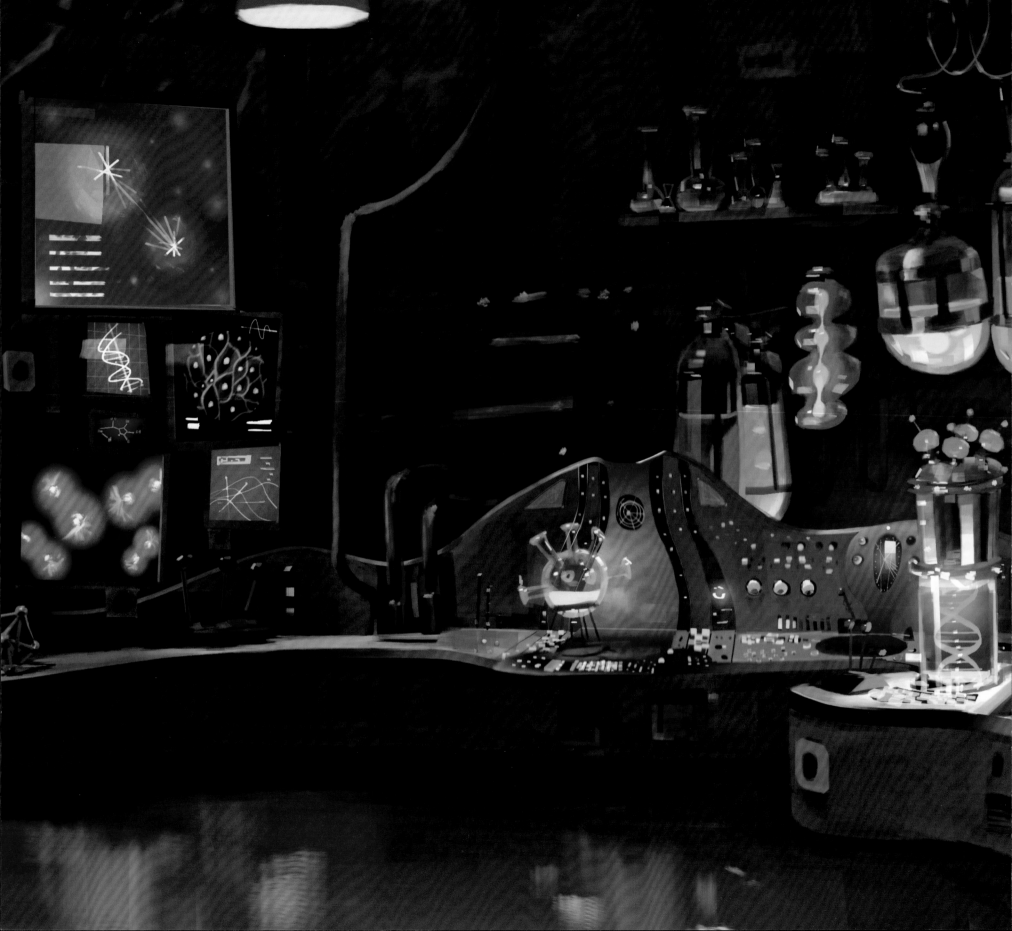

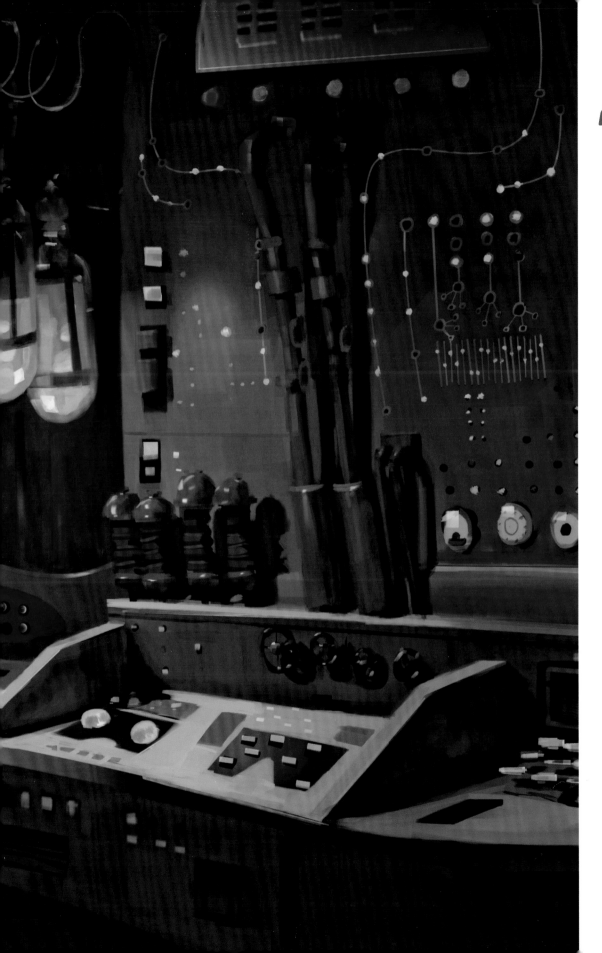

"We cheat them; we don't treat them literally at all," Shannon Jeffries confesses. "If you see caustics projected on a wall, you think there must be water somewhere. So you'll always see caustics in Dave's environment, keeping his world in motion. In the lab, you'll see a lot of caustics that lean slightly toward green."

Although Dave's lab is filled with equipment, the technology feels old. "His technology is institutional seventies," Jeffries says. "It's not very polished; you see exposed wires and the inner workings of things. The exposure of the workings gives it a slightly steampunk look, but we definitely were not going for steampunk."

Head of lighting Jonathan Harman adds, "The lab has a mad scientist feeling: It has all these crazy chemicals and liquids, and it's inside a giant submarine. As a filmmaker, you can't help but be excited about environments like these."

LEFT ›› CARLOS FELIPE LEÓN
BELOW ›› PRISCILLA WONG

CAGE ROOM

The cage room is the submarine's prison and the center of Dave's diabolical plot. As Dr. Brine captures penguins from aquariums and zoos around the world, we see a buildup of characters in the cage room. Inside, like prisoners anywhere in the world, the incarcerated penguins tattoo each other, play harmonicas, and do pushups.

Although still colored in Dave's ochers and greens, this room is pushed more toward the blues. In an early design, the cage room was a tall cylinder lined with cages all the way around. Later, it became rows and rows of caged penguins that line a vast hall. Finally, the artists expanded the design to house the giant ray gun for the finale.

"We see this room a few times during the film as more and more penguins are captured," says Shannon Jeffries. "When Dave has all the penguins caged, we have high-frequency detail here."

Essential to the story, the room and its atmosphere were important to establish through visuals. Jeffries says, "Inside the cage room, we created a film-noir world. We played off shadows and caustics on the wall. It's always a little mysterious until Dave comes into the light, and then we play up the silliness."

> **“** *We wanted to be very graphic in our approach. We drop out textural details to draw the eye where we want the audience to look.* **”**
> **–SHANNON JEFFRIES**
> PRODUCTION DESIGNER

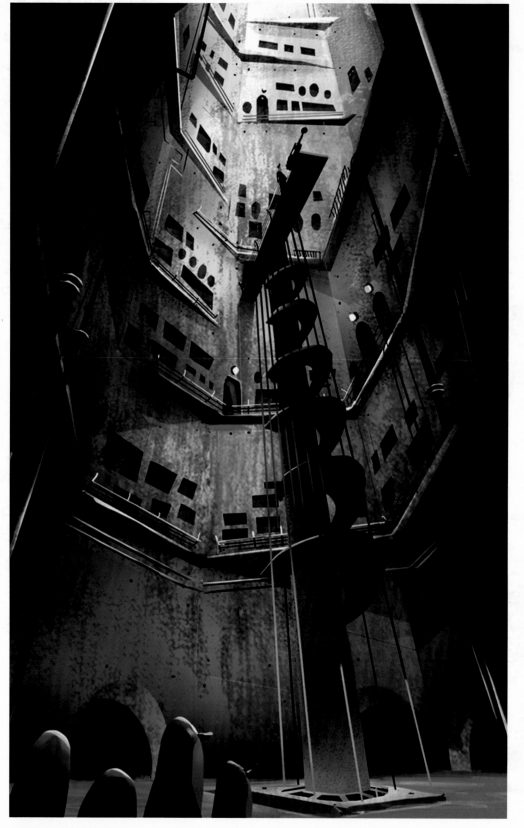

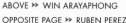

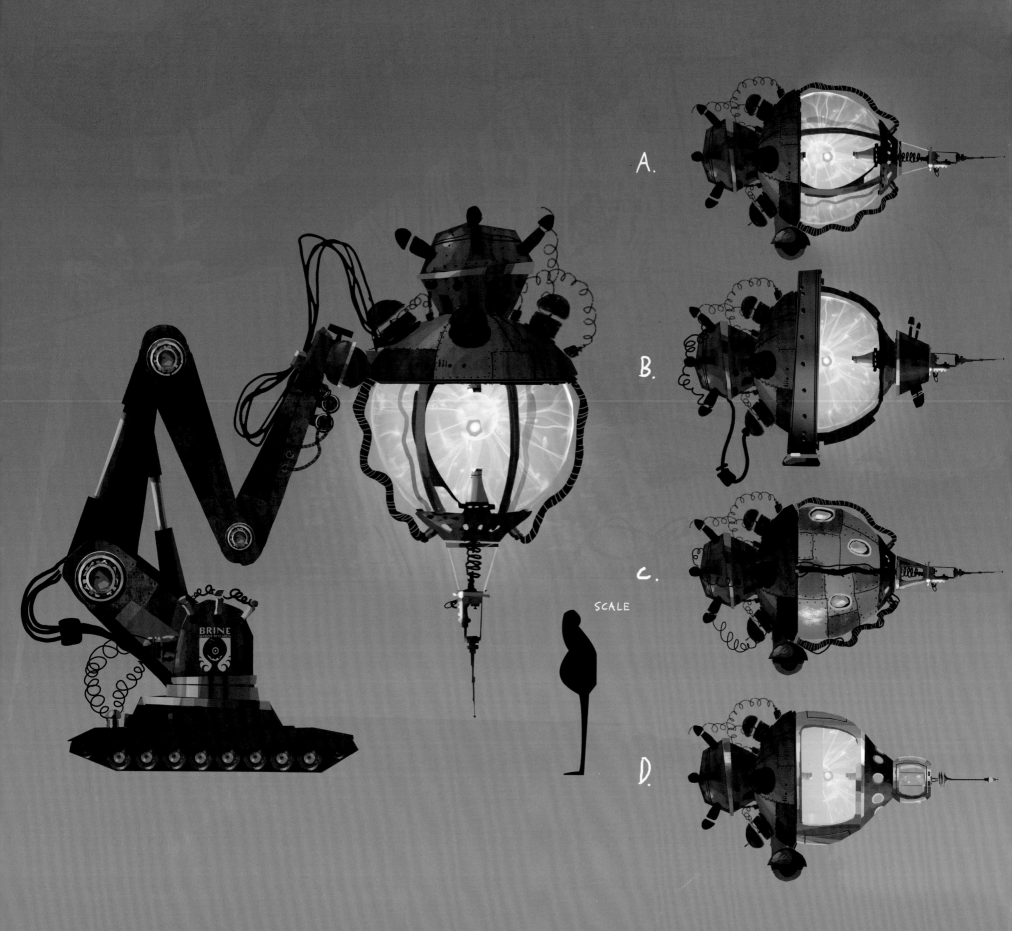

A.

B.

C.

D.

SCALE

BRINE

RAY GUN

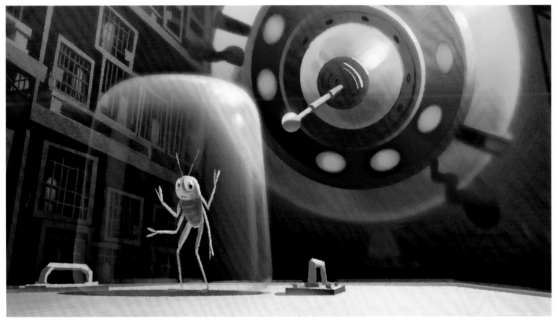

Once it's loaded with Dave's Medusa serum, the ray gun has the power to transform a cute penguin into an abhorrent mutant.

"We first see the ray gun in the lab, and we designed it to fit in that space," says Shannon Jeffries. "Then, we had to retrofit the cage room to hold the gun because it's seen there."

The ray gun is not only a powerful weapon but also incredibly massive. "In real-world terms, the ray gun is fifty feet tall," says head of lighting Jonathan Harman. "It was fun for our lighters to play with." Visual effects supervisor Philippe Gluckman adds, "We had to create a 2-D animation to show our artists how to operate this thing. It's humongous."

As with everything in Dave's world, the artists designed the wicked zombie machine using curves and rounded shapes and exposed the inner workings.

"We danced a fine line," Jeffries says. "We didn't want to go steampunk or too Victorian."

OPPOSITE & BELOW ›› GORO FUJITA
ABOVE ›› RUBEN PEREZ
FAR RIGHT ›› TODD KUROSAWA

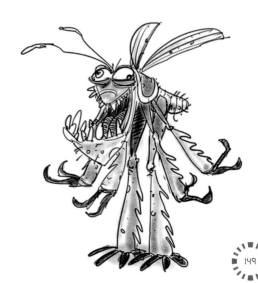

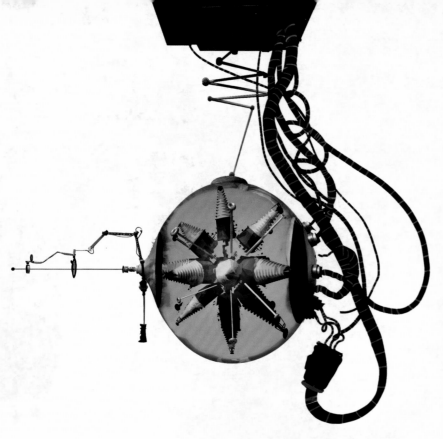

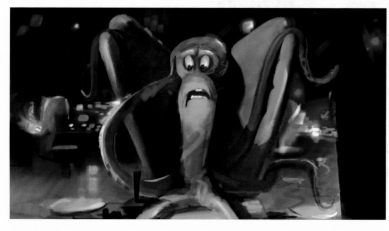

TOP ❯❯ GORO FUJITA
ABOVE ❯❯ RICHARD DASKAS
RIGHT ❯❯ NIC HENDERSON

DEATH MACHINE

After Dave captures the North Wind characters, they think they're going to be fed into the giant death machine. We see the superslick agents lose their cool for the first time, before Private swoops in to save them. Art director Ruben Perez drew many of the death machine designs himself. "It was super fun," he says. "I think I did twenty-five different designs of the death machine. We had some that looked like a glowing shark. Others didn't have a ground, so the characters were in the middle of nowhere."

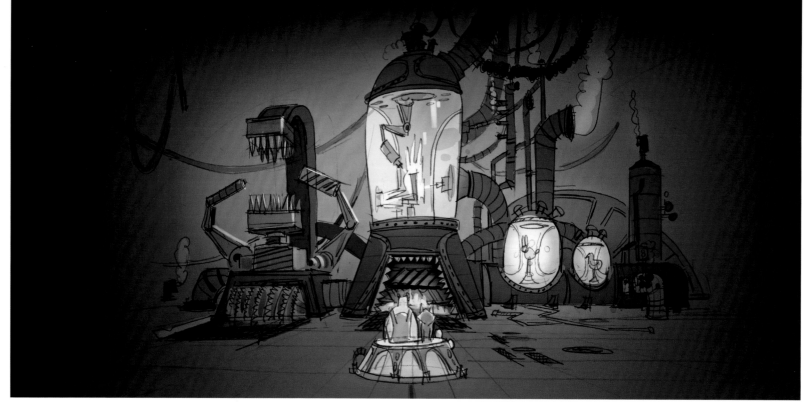

TOP LEFT & TOP RIGHT ≫ PRISCILLA WONG
ABOVE ≫ RUBEN PEREZ

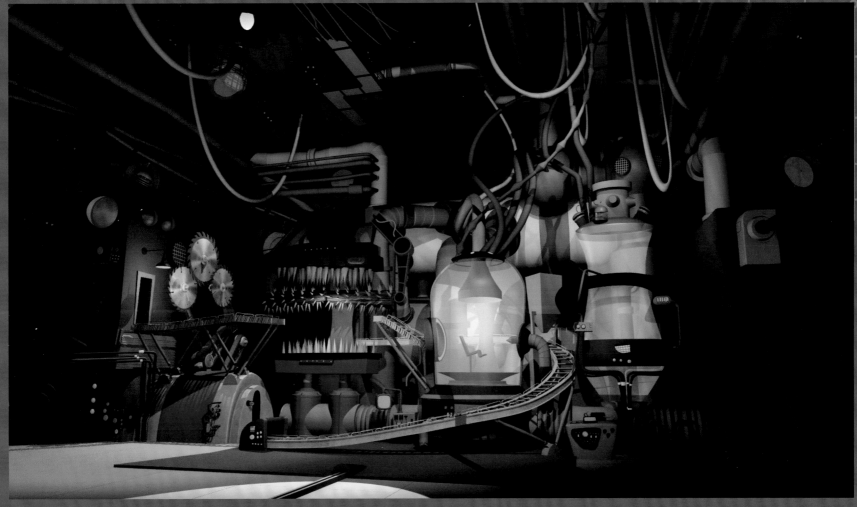

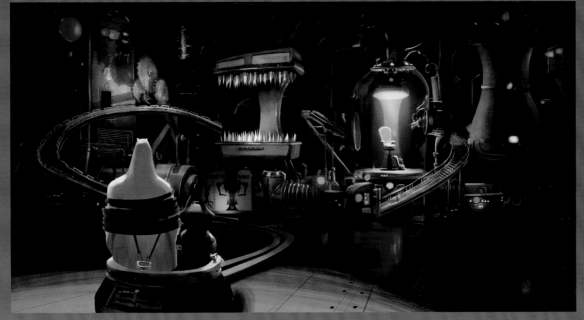

TOP ➤ NIC HENDERSON
ABOVE ➤ BRYAN LASHELLE

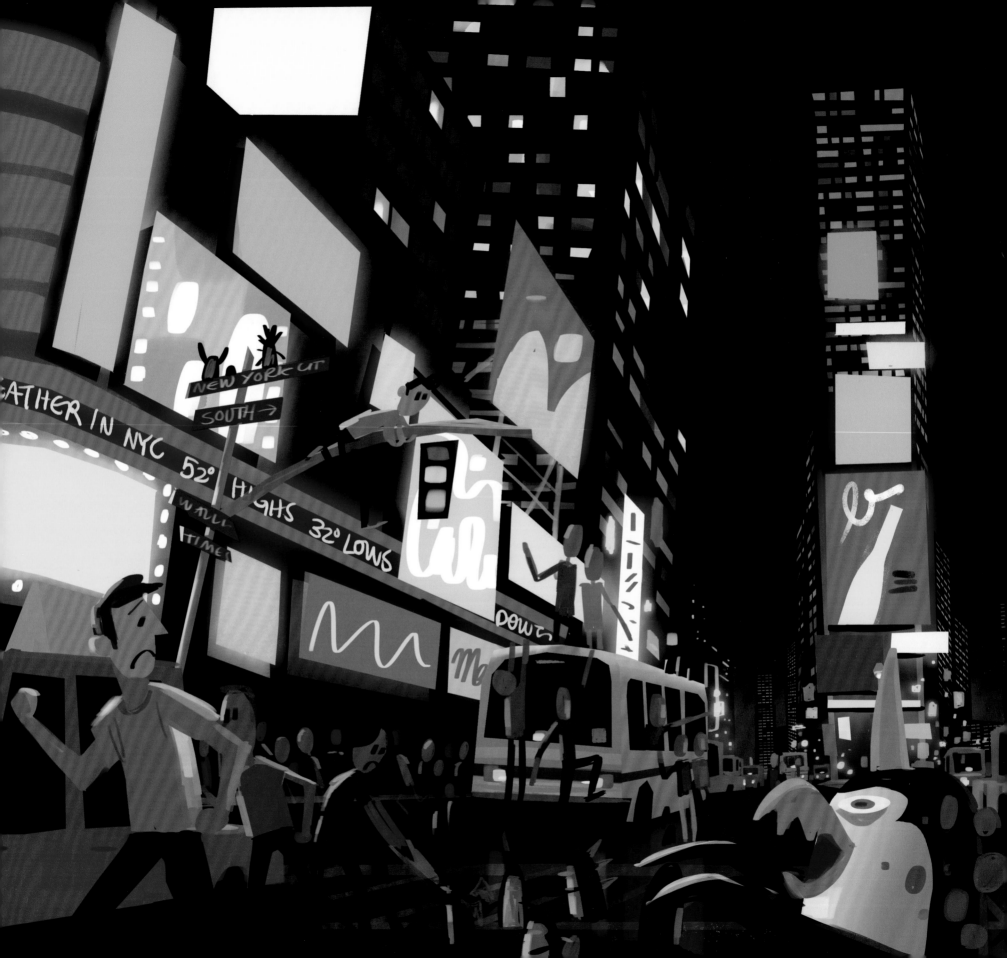

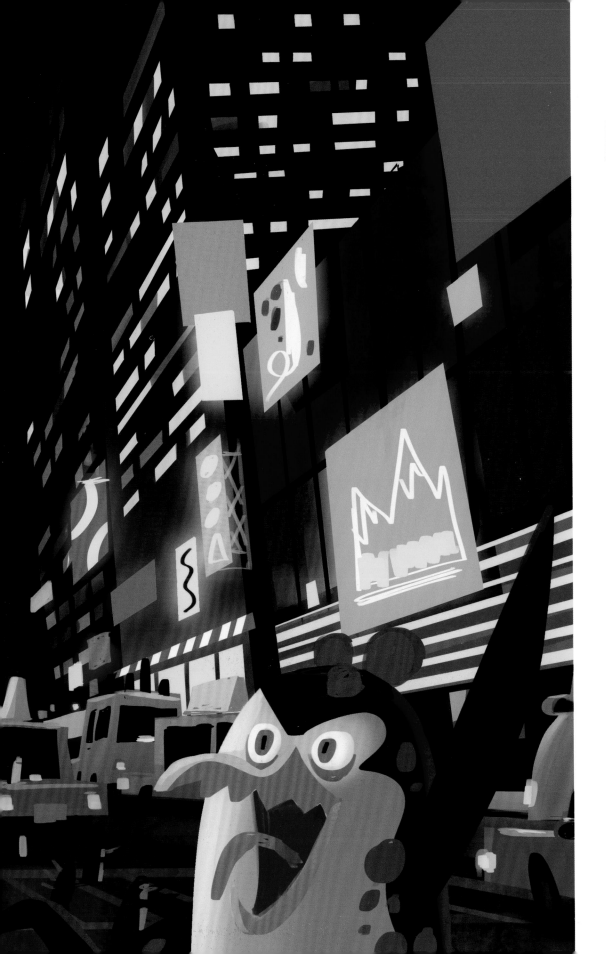

NEW YORK

It seems only right that a Madagascar film should end in New York City, where the franchise began. In this film, the climax takes place in Battery Park. Dr. Brine, who people believe is a human, claims to have rescued the kidnapped penguins, but as Dave, he has parked his submarine in the harbor and has another plan. He dumps thousands of mutant penguins onto the streets of New York City. People recoil in horror, just as they did to poor little Dave when he was a baby octopus in the Central Park Zoo. And it's up to Private, the littlest, cutest penguin, to save the day.

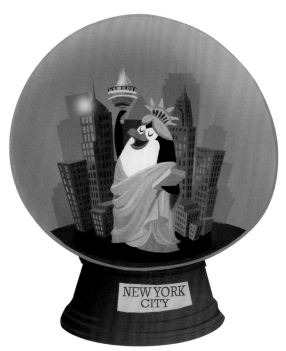

THESE PAGES ›› STEVIE LEWIS

155

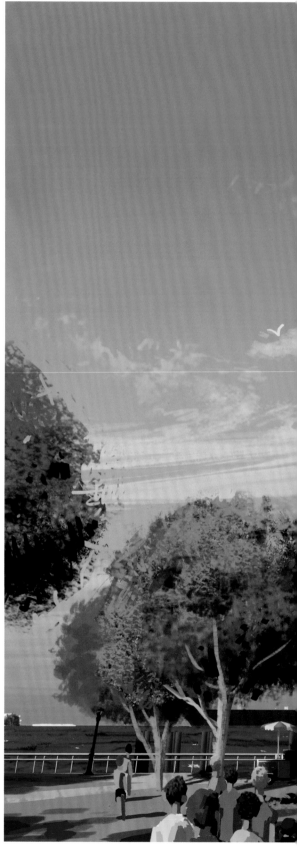
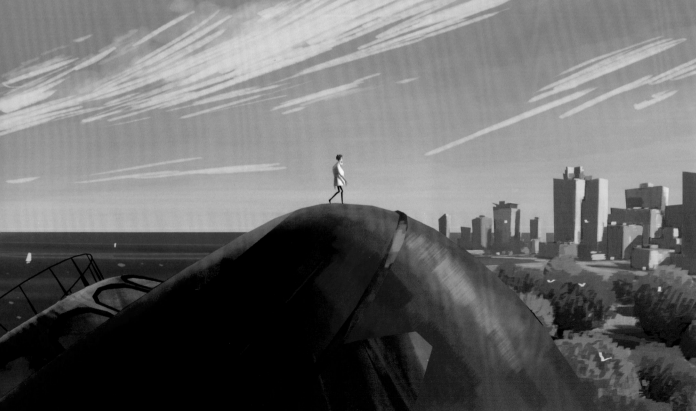

THESE PAGES >> MIKE HERNANDEZ

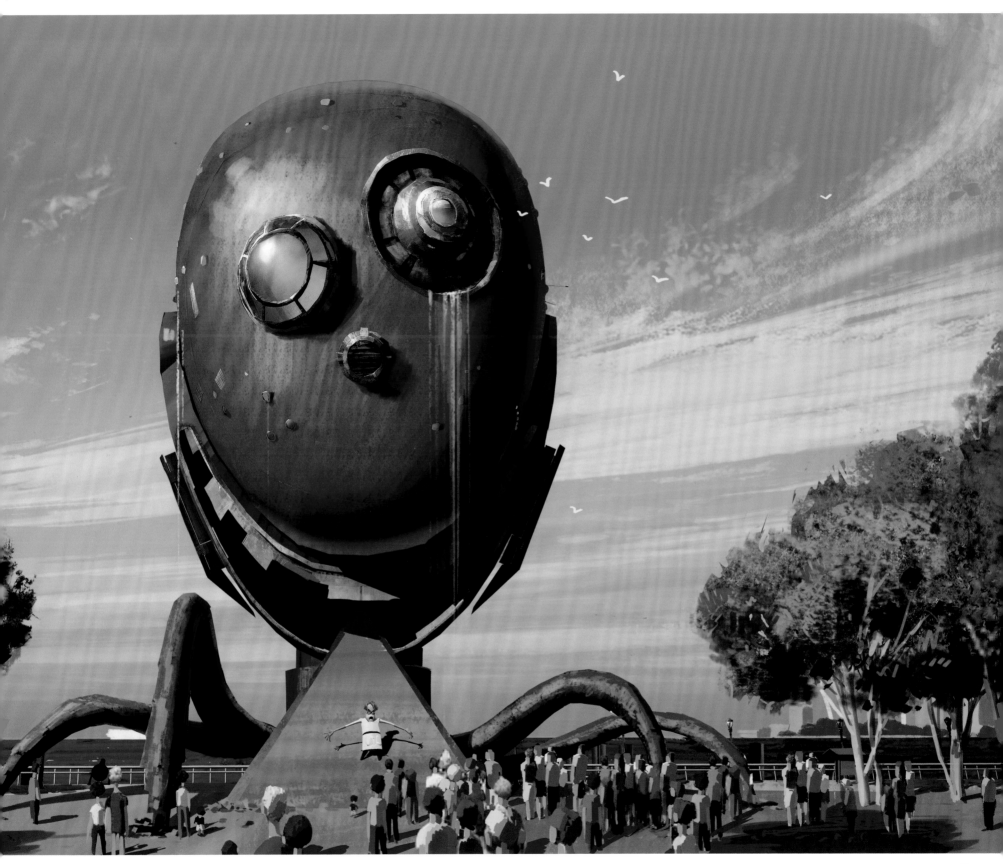

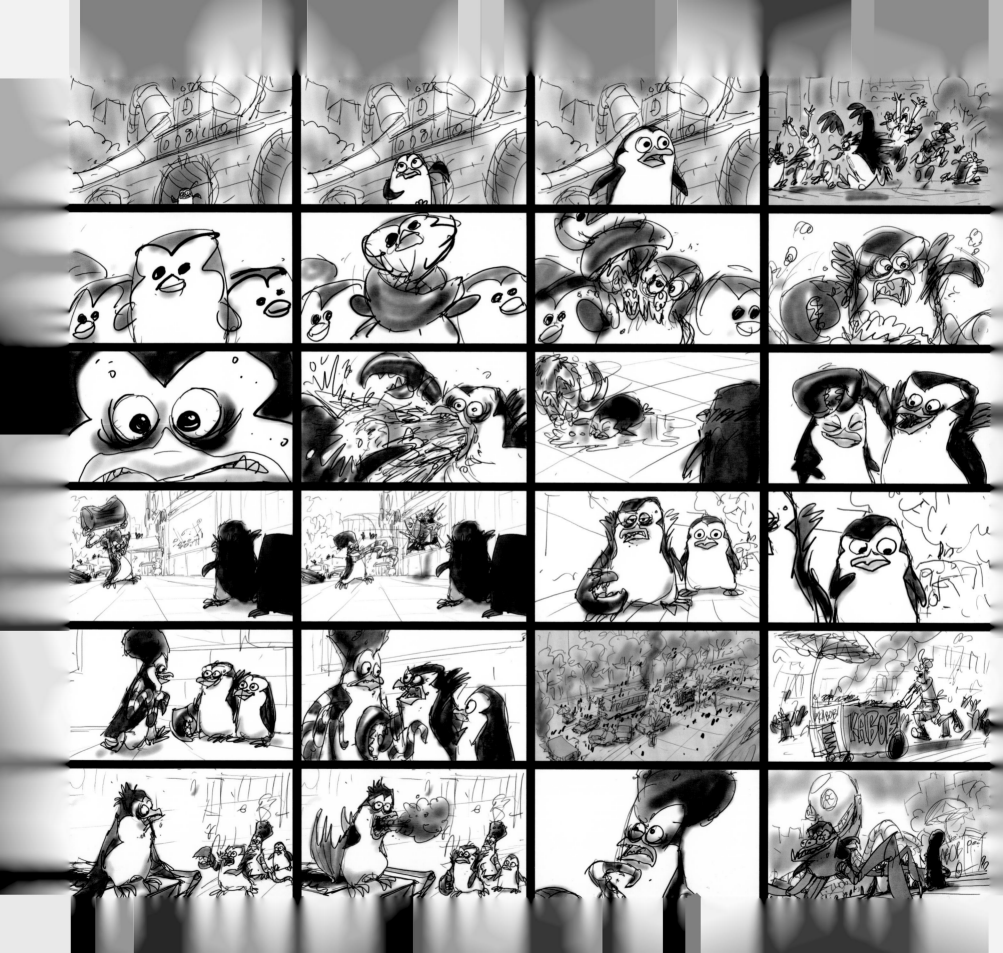

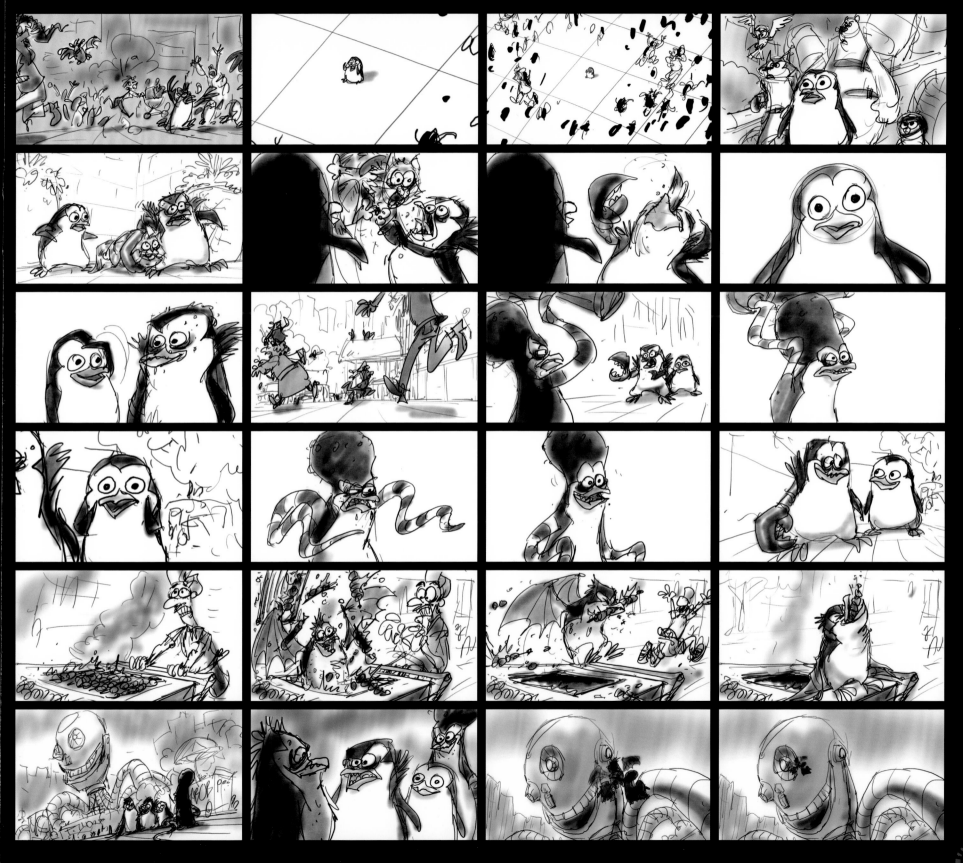

LOCATIONS NOT FEATURED

Like in all animated features, as *Penguins of Madagascar*'s story evolved, so too did the production designs: Characters and locations appeared and then disappeared. "Some of the first drawings and paintings I worked on were of an abandoned theme park called Octoworld on an island," says art director Ruben Perez. The villain's octopus-themed amusement park included a mirror house, Ferris wheel, roller coasters, and other rides.

Entire cities were left behind as well. "At one time, we were going to Hong Kong, but we changed that to Shanghai," director Simon J. Smith says. "And we had shots in Shanghai that were like the ones in the James Bond movie *Skyfall*, before we even knew what *Skyfall* was about. It was uncanny."

TOP ROW » CHIN KO BELOW » FLORIANE MARCHIX
RIGHT & OPPOSITE TOP » STEVIE LEWIS

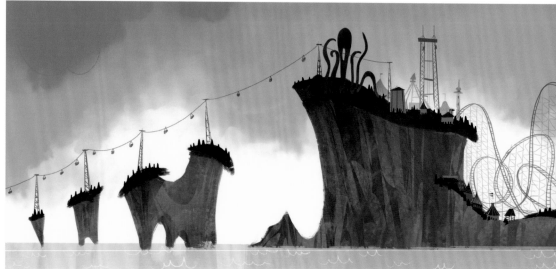

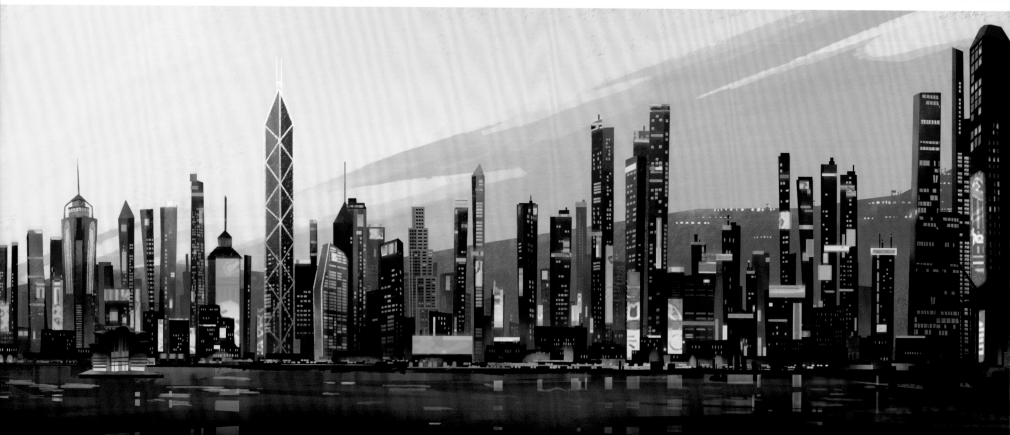

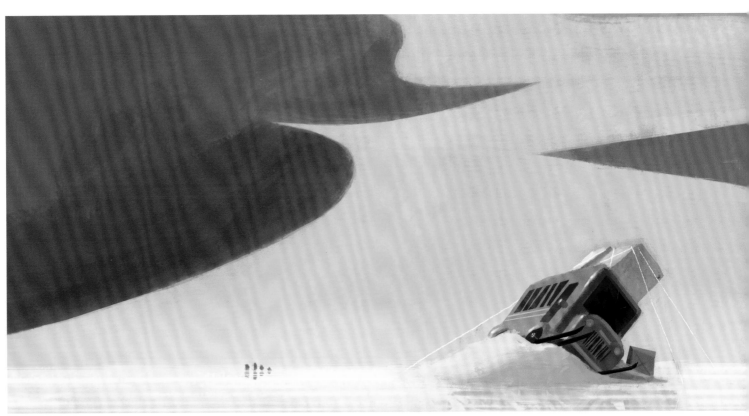

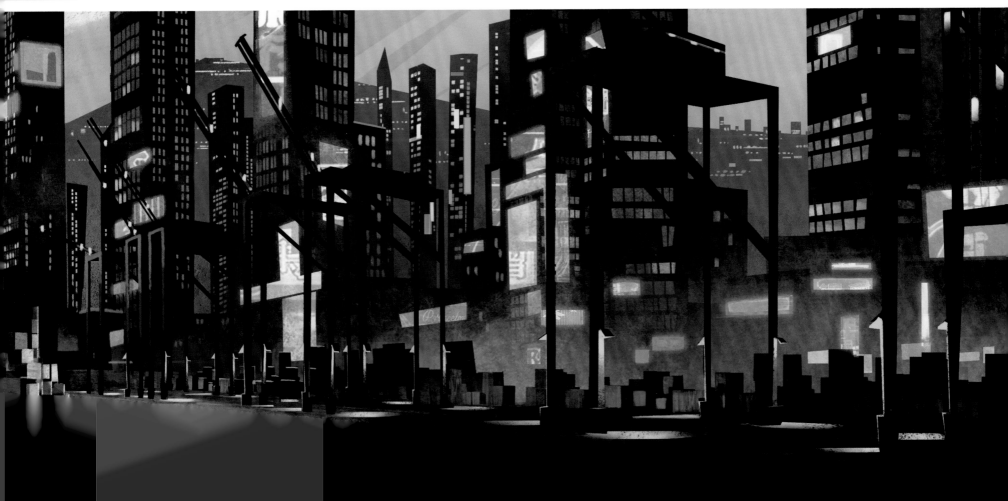

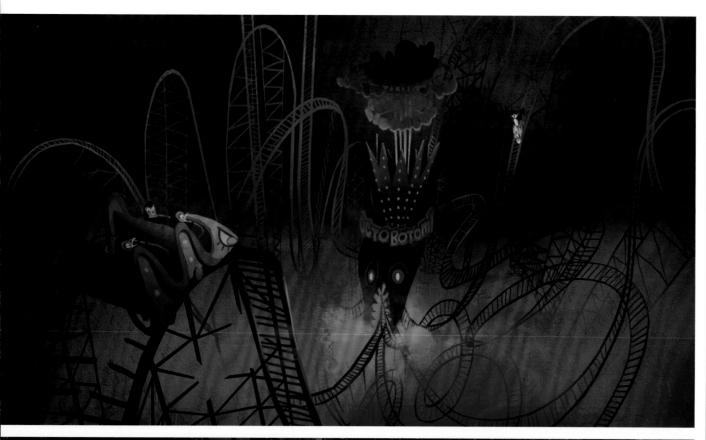

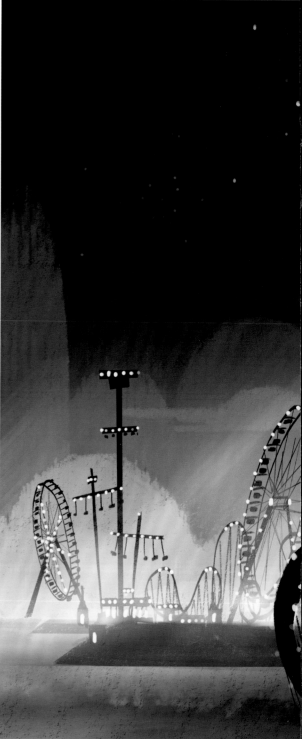

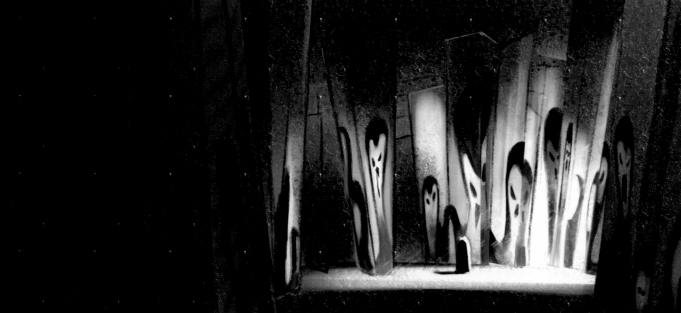

THESE PAGES ›› FLORIANE MARCHIX

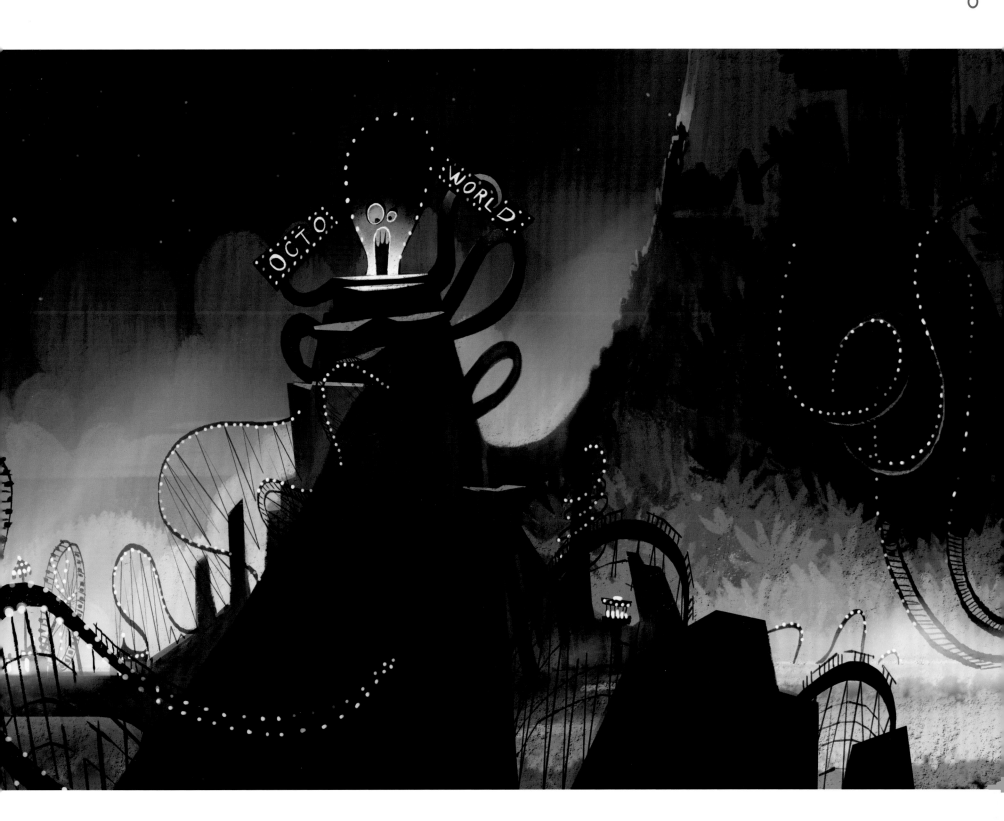

CONCLUSION

Like many of Skipper's finest missions, *Penguins of Madagascar* came together through the ingenuity and innovation of a crew that fully embraced the exciting challenge of creating the film.

As sophisticated and high tech as any North Wind spy, these enthusiastic, talented artists produced a stunning and hilarious animated feature. Working to get the story on screen were crews in Redwood City and Glendale, California, and Bangalore, India.

"This was our first full feature created largely in India," says producer Lara Breay. "Between our locations in Bangalore and California, production ran twenty-four hours a day."

"Even with a huge part of the team on the other side of the world, we came together to make an amazing film," says co-producer Tripp Hudson. "I'm incredibly proud of the work we've done."

Creative leads Philippe Gluckman (visual effects supervisor), Jonathan Harman (head of lighting), and Olivier Staphylas (head of character animation) led teams in Bangalore. Based in Redwood City were producers Lara Breay and Mark Swift, co-producer Tripp Hudson, directors Eric Darnell and Simon J. Smith, and creative leads Shannon Jeffries (production designer), Ruben Perez (art director), Conan Low (head of layout), and Pete Billington (matte painting supervisor). Videoconferencing kept the team cohesive and in constant communication.

"Everyone working on this film had a lot of fun," says Low, a ten-film veteran at DreamWorks Animation.

But then, who could be grumpy around the Penguins?

"We have a high level of comedy and still have characters you care about," Darnell says. "You want to see what happens to them. And there are some really hilarious scenes. My favorite thing about this movie is that it's funny."

"We tried to find a story where the audience would invest in the Penguins and buy into their emotions so we could pull heartstrings at the end," Smith says, "while keeping it fun for everyone."

"I am in love with this film," says DreamWorks Animation chief creative officer Bill Damaschke. "It's such a great combination of funny and absurd, and it has great heart in the right places. It's really a treat."

"It's been a privilege to be a part of taking these iconic characters to the next chapter of their adventures, and exciting to see the Penguins at the heart of their own story," says producer Lara Breay. "It's confirmed what we suspected all along—that these boys were meant for the bright lights of center stage. As Skipper would say, 'Time for a high-one!'"

RIGHT ≫ ROBIN JOSEPH
OPPOSITE ≫ RAJARAJAN RAMAKRISHNAN

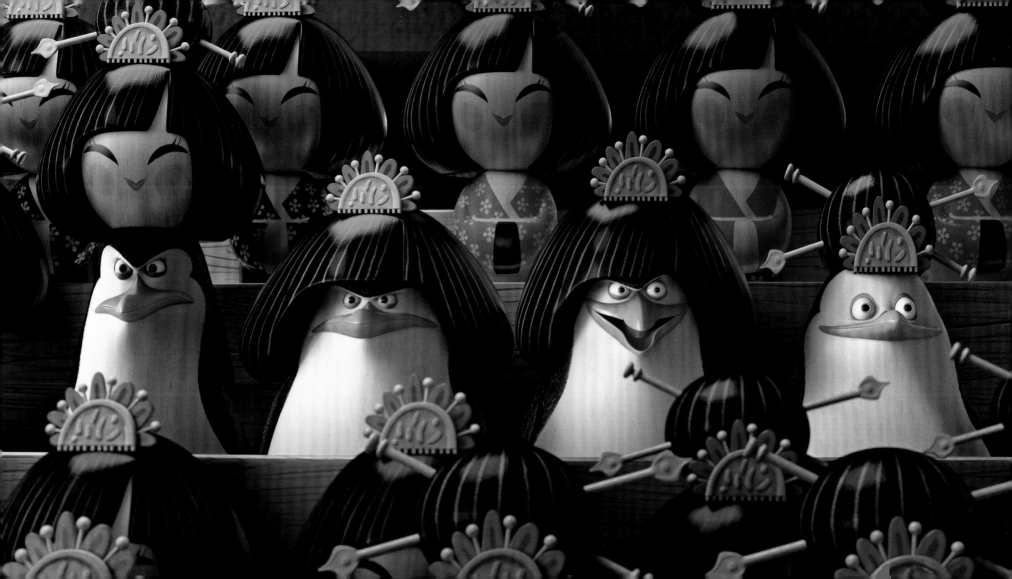

ACKNOWLEDGMENTS

The artists and producers at PDI/DreamWorks and DreamWorks Animation in Redwood City and Glendale, California, and in Bangalore, India, who worked on this film are among the finest in the world, and I thank them for helping me understand how they transformed imagination into visual magic. A special tip of the hat to the extraordinary production designer Shannon Jeffries. I am immensely grateful to Insight Editions' unflappable editor Elaine Ou and brilliant designer Jenelle Wagner, who made this book possible and beautiful. Thank you also to DreamWorks' Debbie Luner for her guidance and Camille Leganza for organizing all those interviews.

I want to send special thanks to Jim who keeps me centered, to George for his constant support, and to Amaya, Campell, Hudson, Arissa, and Ian who always remind me to have fun.

OPPOSITE TOP >> GLENDALE CREW
OPPOSITE BOTTOM >> INDIA CREW
ABOVE >> PDI CREW

INSIGHT
EDITIONS

PO Box 3088
San Rafael, CA 94912
www.insighteditions.com

Find us on Facebook: www.facebook.com/InsightEditions
Follow us on Twitter: @insighteditions

Library of Congress Cataloging-in-Publication Data available.

ISBN: 978-1-60887-492-7

Insight Editions, in association with Roots of Peace, will plant two trees for each
tree used in the manufacturing of this book. Roots of Peace is an internationally
renowned humanitarian organization dedicated to eradicating land mines world-
wide and converting war-torn lands into productive farms and wildlife habitats.
Roots of Peace will plant two million fruit and nut trees in Afghanistan and provide
farmers there with the skills and support necessary for sustainable land use.

Manufactured in Hong Kong by Insight Editions

10 9 8 7 6 5 4 3 2 1

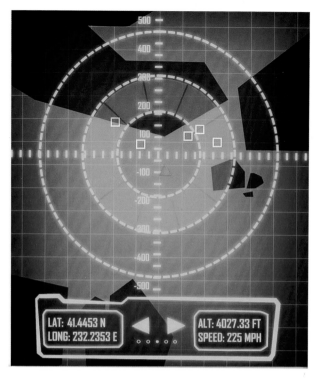

INSIGHT EDITIONS

PUBLISHER Raoul Goff
ACQUISITIONS MANAGER Robbie Schmidt
ART DIRECTOR Chrissy Kwasnik
DESIGNER Jenelle Wagner
EXECUTIVE EDITOR Vanessa Lopez
PROJECT EDITOR Elaine Ou
PRODUCTION EDITOR Rachel Anderson
PRODUCTION MANAGER Jane Chinn

INSIGHT EDITIONS would like to thank
Debbie Luner, Lisa Baldwin, Jess Linares,
Camille Leganza, Katie Kibbee, Brendan
Thompson, Lara Breay, Caitlin Cooper,
Jennifer Dahlman, Bill Damaschke, Eric
Darnell, Michael Francis, Michael Garcia,
Jeff Hare, Tripp Hudson, Shannon Jeffries,
Tom McGrath, Ruben Perez, Simon J. Smith,
Mark Swift, and Dawn Taubin.

ABOVE » GORO FUJITA